AN ARTIST'S GUIDE
MAKING IT
IN NEW YORK
CITY

AN ARTIST'S GUIDE
MAKING IT IN NEW YORK CITY

DANIEL GRANT

ALLWORTH PRESS
NEW YORK

© 2001 Daniel Grant

05 04 03 02 01 5 4 3 2 1

Published by Allworth Press
An imprint of Allworth Communications
10 East 23rd Street, New York, NY 10010

Cover and interior design by Jelly Associates, NYC

Page composition/typography by SR Desktop Services, Ridge, NY

Library of Congress Cataloging-in-Publication Data
Grant, Daniel
 An artist's guide: making it in New York City / by Daniel Grant
 p. cm.
 Includes bibliographical references and index.
 ISBN 1-58115-195-0 (pbk.)
 1. Art—Vocational guidance—New York (State)—New York. 2. Artists—New York (State)—
New York—Economic conditions. 3. Artists—New York (State)—New York—Social conditions.
 I. Title. N6535.N5 G73 2001 702'.3'7471—dc21

Printed in Canada

TABLE OF CONTENTS

ACKNOWLEDGMENTS

Some books are said to write themselves, which refers to the rush of words that an author feels and the effortlessness of the writing. In truth, a book requires far more than an author with an idea or two in his or her head. For my part, it involved my wife, Alexandra Chesner, tending to some chores that I was too preoccupied to do, as well as a number of advisors who read the manuscript and offered guidance, suggestions, and occasional fact-checking. Among these were Elliott Barowitz, Peter Plagens, Harriet Shorr, Marjorie Grant, Donna Dennis, and Jon Wiener. Thanks also to Tad Crawford, who has put his trust in me for many years now.

INTRODUCTION

"I came to New York to be a famous artist," said L.J. Lindhurst, a Brooklyn painter and freelance designer. There's only a hint of irony in her remark, perhaps because any number of other artists in New York have either said out loud or in their thoughts the very same thing. New York City draws artists who see the opportunity to show their work to a larger, more knowledgeable audience than could be found wherever they currently are living, who welcome the chance to meet and talk with an enormous community of artists, who want to compete with thousands of others.

At times, it seems as though entire graduating classes from art schools have moved en masse to certain sections of Brooklyn. The New York question ("Shall I pull up roots and try to establish myself in New York?") is one that every professional fine artist confronts at one time or another in his or her career. Clearly, New York has a meaning to artists beyond a location where a large number of art museums, galleries, critics, and people like themselves can be found: New York offers a community where artists are understood and supported, as well as a platform on which artists may achieve individual recognition of the highest level. Both the community and opportunity to achieve motivate artists to do their best.

If New York art is thought of as whatever is avant-garde and challenging, one can be a New York artist without ever living in New York, and artists can live their lives in New York City without ever creating work that is exhibited there. Certainly, there is no one type of artist in New York—all manner of media and artistic styles are on view, with galleries, nonprofit spaces, and museums that cater to each type—but most of the arrivals are young, not so fixed in their lifestyles that they won't put up with the small apartments or the need to have a roommate or two (or three).

New York City has been the center of the art world for over half a century. Artists now are apt to think of New York in the same way that William Merritt

Chase dreamed of Paris in the late nineteenth century ("I'd rather go to Europe than go to heaven"). Before that, Rome was the destination of choice for artists looking to learn and make their mark in the world. This is not to say that New York art schools are more correct in their teaching than academies elsewhere or that the world follows where New York artists lead. Like the business world and the general flow of ideas, the art world has become global: There are international biennial exhibitions in such places as Brazil, Germany, Italy, Korea, South Africa, and Turkey, where work by artists from all over the world is likely to appear. Recognizing that many collectors don't come to New York, the world's largest auction houses—Christie's and Sotheby's—regularly hold auctions in Tel Aviv, Moscow, and Japan, selling work that may or may not be indigenous to the area. Looking to create an alternative art market, a growing number of artists have sought to display and sell their work over the World Wide Web. Living and showing in New York might seem to have less urgency than in years past.

New York's continued relevance rests on the fact that so many artists and collectors want to be part of its art world, that the best new work discovered somewhere on the planet eventually will be shown and talked about in New York. The idea of art—what it is and can be, how it can be analyzed and discussed—is more central to New York than to any of the world's other art centers, and the level of conversation is certainly higher than that found in any Internet chat room.

The thrill of becoming part of the art scene and soaking up what New York has to offer may enable people to put up with repeated rejections from gallery owners who have seen too many artists and to override the desire for creature comforts. Another facet of New York is that it is a tough and expensive place to live, where that same community of artists creates competition for every exhibition opportunity and for the limited housing and studio spaces. Great aspirations and an obsession with what things cost dominate the consciousness of New Yorkers, none more than the members of the artist community.

This book is intended as a guide to the experience of living and working in and around New York City and establishing a presence in the art world. A large part of the information is presented through the experiences of artists who have come from somewhere else, needing a place to live, a job, a way to meet other artists, and an understanding of how the New York art world works.

Chapter 1.
ARE YOU READY FOR NEW YORK?

When painter Bryony Romer moved to Brooklyn from Lenox, Massachusetts, and began looking at apartment shares, "a friend of a friend of a friend showed me a room that I could rent. It was nine feet by seven feet; it was tiny. Anywhere else, it would be a closet, and I felt, 'I can't do this.' But then I started looking at other apartment shares and found that the rooms were all about the same size. I kept thinking about that first apartment, and the pros started to stack up. I really wanted to be in New York."

Older New York artists who have attained success in terms of showing and selling their work, on the other hand, often have another place elsewhere where they spend part of the year. "Whenever I get together with my artist friends in New York," said Janet Fish, a painter with homes in both Manhattan and Vermont, "all we seem to talk about is our septic systems." Tom Christopher, a painter who used to live in Manhattan but now has a home and studio in South Salem, New York, just north of the city, noted that he's "close enough to get in any time I want and far enough away that I don't have to deal with it on a daily basis."

For artists in the five boroughs (or even thousands of miles away), New York is both an ideal and a tangible thing that needs to be reckoned with. Certainly, one has to be temperamentally and financially ready to move there and understand this central fact: it costs a lot of money to live in New York. There are very few inexpensive apartments in areas that are both safe and easily accessible to the Manhattan art world, and high-salaried jobs that could pay for a nice apartment in a nice neighborhood are not so easy to get, especially for people wanting to have time to create art. "As an artist, I always wanted to come to New York," said Eric Pryor, a painter and director of the Skylight Gallery of the Center for Art and Culture of Bedford Stuyvesant, who moved from

1

Philadelphia to Brooklyn in 1994, "but it was this job that gave me a vehicle to come. As much as I wanted to be in New York, I wanted to come to New York in a circumstance that would afford me a quality of life that allowed me to be an artist."

Not everyone is quite so picky about the entrance they make. When Donato Giancola moved to New York from Colchester, Vermont, with $3,500 in his pocket in 1992 ("At the time, I thought that was a lot of money"), he lived in a questionable neighborhood with some college friends from Syracuse University. "At night, we sometimes heard gunfire," he said. Within three months, most of his money had been spent, and he was fortunate to find a job at the Society of Illustrators. Over time, he developed a feel for how the gallery system worked and how to earn a living as a book illustrator. Perhaps more importantly, he began to develop a sense of where artists lived and how he could fit into New York's art world. Still, making $3,500 last almost three months may be the real wonder.

The cost of New York weighed especially heavily on Grisha Bruskin, a Russian artist who emigrated to the United States in 1988 at the age of forty-three. "As an artist, I was always interested in working in New York," he said, "but when I finally came, it was like coming to the moon." While in Russia, he had been selling his paintings to private collectors in Europe, "but the prices were very different. They would buy my work for 1,000 rubles—that's maybe $330—and that was a lot of money in Russia. I could live for half a year on that. But you can't live for half a week on that in New York, so I had to raise my prices in order to be able to live and to pursue new art projects. That was a scary period of time for me."

TESTING THE WATERS BY VISITING FIRST

"It was never a question for me about moving to New York City—you go where the artists are," said Rob Davis, an artist living in Brooklyn who paints at night and works during the day as an art handler at the Metropolitan Museum of Art. In 1996, at the age of twenty-six, he moved to New York from Chicago, where he had gone to art school and held a couple of entry-level jobs (stocker in a bookstore, data entry for a publisher). And why not? He was young, unattached, ready for adventure, undeterred by repeated rejections from gallery owners who had seen too many artists, and had not yet developed a lifestyle he needed to maintain. He grabbed an apartment—"a wretched, wretched dump that I

worked on for two months," costing him $1,050 per month and which he shared with two other people—in what struck him as a questionable neighborhood, all for the privilege of being where so many artists and so much art is.

Not everyone is willing to make those sacrifices. Ridiculous rents for crowded space (then there may be the question of renting a studio) or a loft that actually may be illegal to use as a residence (how many meals would anyone want to cook on a hot plate?) will not strike everyone as worth the price of being in New York. Still, a rational choice about lifestyle may conflict with an artist's ambitions. Of course, even some artists whose work is associated with New York City (for instance, Jasper Johns and Robert Indiana) don't have a New York address, and some artists who live in New York City sell the majority of their artwork elsewhere, such as painter Peter Halley, whose main buyers are in Europe.

BECOMING A REGULAR VISITOR

Certainly, one can be an artist anywhere, but can an artist anywhere gain the type of attention and volume of potential buyers that are available to those associated with New York City? Some out-of-town artists attempt to straddle the decision by living elsewhere but visiting New York on a regular basis. Painter Wayne Thiebaud, who has lived in Sacramento, California, for much of his life, has come to New York at various times in order to see the art and meet artists. In 1956, he took a year's leave from Sacramento City College, where he was an art instructor, to "meet the people I was interested in. I met [Willem] de Kooning, [Franz] Kline, Barnett Newman, Clement Greenberg. I attended the Club [the Waldorf Cafeteria at 39 East Eighth Street, which was the unofficial meeting place for the New York School artists]. It was interesting and valuable to me to meet these artists and to hear them talk about how they felt about their work and what was said about their work." After returning to California and teaching, he began to lead student tours to New York City. "I did a bit of lecturing and lined up studio tours. I met Claes Oldenburg, Alex Katz, and a number of other artists. These trips represented a chance to be at the center of what's happening in the art world and to see prime examples of art in the museums and commercial galleries that inspire and challenge you. My art wouldn't be what it is today if it hadn't been for the times I was able to come to New York, seeing the art and meeting the artists."

Living permanently in New York, however, was not for him. Thiebaud found the art scene "overwhelming" and missed the "open spaces" of the West.

He had spent enough time in New York to identify and ultimately reject the politics of the art world—"this is how things are done, this is what I must do, these are the alignments you must make, as opposed to doing what you need to do as your own person, as an artist in your own right," he said. "You can get easily trapped in situations that work against you as an artist."

Since his first visits to New York City, there has been a great dispersal of artists around the United States and the development of art centers in the Southwest, the Plains states, Chicago, New England, the Southeast, and elsewhere, each with its own indigenous character. Degree programs in art have been instituted at colleges and universities throughout the country, taught by professional artists with a stake in those communities. Still, Thiebaud regularly visited New York because of the specific art, the artists, the high level of critical discourse, and the overall artistic environment found there, which could not be matched elsewhere.

Daniel Greene, a gallery artist and portrait painter, moved from Cincinnati, Ohio, to New York City in 1953, ostensibly to attend classes at the Art Students League, "but really because I wanted to be in New York. As far as I was concerned, that's where everything important in the art world was." Besides an apartment, he had a studio in the city, and most of his portrait subjects came there for sittings. In 1980, however, Greene was divorced, "and I lost my studio." The process of finding another studio was long and arduous: "I couldn't find anything satisfactory; the rents were too high, the spaces not large enough; some spaces were not legal, and I didn't want to find myself having to search for another place to work every year or two."

He drew a circle around New York City, representing a commute that was no more than an hour and fifteen minutes away from downtown Manhattan, and began a search of towns in Connecticut, New Jersey, and New York's Westchester County, which is slightly north of the Bronx. After inspecting gas stations, private homes, and even a Knights of Columbus building, Greene found a barn with a carriage house in North Salem in Westchester County that became his home and studio. There are many attractive qualities to where he lives and work—"I love being in the country; I never thought I could live anywhere other than in Manhattan," he said—but there also have been some trade-offs. "People are less willing to come to North Salem, so I have to travel now to where my subjects live, and that changed my method of painting," he noted. Because there are virtually no professional models in North Salem, he has also "leaned toward subject matter that relied less on the human figure" for his

gallery pictures. There are companies in North Salem that will pack and ship the art that he wants to send, but "there are no professional photographers out here and certainly no one I would trust to do framing. For those things, I have to go into Manhattan."

Although he is still within that seventy-five-minute distance to New York City, the commute can be wearing, and Greene became a regular (once-a-week or once-every-two-weeks) visitor to Manhattan, resigning from the board of the National Academy of Art and from his teaching position at the Art Students League. His ability to get to as many art galleries and to "network with other artists" is less, but "I wouldn't want to be any further away from New York than I am now," he said. "I would feel completely disconnected."

Staying within the geographical orbit of New York works for some artists; with others, the issue is maintaining a New York mindset. "It's hard to show nudes in some of the more conservative areas of the country," said Terry Rodgers, a painter in Columbus, Ohio, who has earned a good living from portrait painting and mural commissions. Those works, however, "are not at the core of my interests. I don't only want to please clients who commission me. I want to make my own artistic statement." He also looks to expand his audience from primarily the Midwest to one that is more international.

Towards that end, Rodgers comes to New York City between four and six times per year, visiting galleries and meeting dealers, hoping that both he and his work can stay fixed in their minds. "Maybe half of the dealers I see will remember me from past visits. Maybe they'll say, 'Nice to see you again,' and some even ask me about what's gone on with my work since the last time I was there."

Similarly, Jack Dowd, a sculptor in Sarasota, Florida, sells a lot of pieces through galleries to buyers in vacation spots, such as Aspen, Colorado, Hilton Head Island, South Carolina, Laguna Beach, California, and Maui, Hawaii, "but I've been stuck in that market, and I haven't been able to get beyond it," he said. "I want to show my work in major galleries and in museums. I think that could happen if I could be in New York." That is, he would like it if his *work* were in New York City. In Sarasota are his wife and home, long-time friends, children, and grandchildren. While he enjoys New York and visits half a dozen times per year for as long as several weeks at a time (he even shares a studio in SoHo that he rents with another sculptor), "it might be too much if I lived in New York full-time. Living in New York, you need a break; every time I'm in New York for a month, I'm ready to get out."

Like Rodgers, Dowd regularly visits galleries and attempts to insinuate himself into the Manhattan art world through repeated exposure. He also enters art competitions in which the juror is affiliated with a museum in New York. "Every time I get either rejected or picked, I know that my work has been seen by one of these curators," he said. "And being rejected doesn't mean that the juror dislikes your work. It may just mean that it wasn't appropriate for the particular show, but that person might remember anyway." One such competition, in which he won first prize, was an Art in Public Places contest held in Chatanooga, Tennessee, whose juror was a former *New York Times* art critic.

Both artists participate in the New York Presence Program run by Katherine T. Carter & Associates [P.O. Box 2449, St. Leo, FL 33574; (352) 523–1948; *www.ktcassoc.com*], in which artists spend an intensive three-day weekend in New York City, touring galleries, meeting artists, dealers, critics, and independent curators. Speakers address the group on such topics as "Gallery Etiquette & Relationships," "Cultivation of the Critic," "The Real Story of How Museums Work," and "Formula for Success." The cost of the program is $1,120, not including meals and accommodations. Both Dowd and Rodgers also work privately with Carter, who creates press packages, brochures, and catalogues (including an essay by an art critic) of artists' work and makes personal contact with dealers and curators in order to interest them in an artist's work. "Most of my older clients live outside New York City," she said, "but those who work in a manner that is consistent with contemporary issues want to come to New York to be part of the mainstream."

For artists living elsewhere, New York City means more than just a larger art market. To Claudia Clon, a former Eileen Ford model who has houses in Wilton, Connecticut, and Los Angeles, as well as a studio in Chelsea, there is the "excitement" of being where other artists are. "I can be in painting clothes in Chelsea, with paint all over my clothes and hair, and people don't think I'm a junkie," she said. "There are a lot of people who look like that. If I dress like that in Wilton, people will take my children away from me." She drives into New York from Wilton several times per week in order to work or, when she is living in California, visits Manhattan every few months.

Chuck Lawson, an art teacher and painter at Georgia Southwestern State University in Atlanta, has sought since 1997 to have his work shown in New York "for professional reasons, because having exhibits in New York helps you when you look for raises and promotions." He regularly has had between six and ten (sometimes as many as twelve) shows of his work every year at galleries

and other art spaces in the South and Midwest, and there has been an occasional sale. However, "galleries outside New York appreciate me more because I've shown inside New York. It gives me cachet and prestige. If you're accepted there, other galleries worry that they might be missing the boat if they pass you over and figure, 'Oh, he's shown in New York, we better show him here.'" His evidence for that is the "raised eyebrows" on the faces of the people back in Atlanta and elsewhere when he mentions that he has shown in New York ("Then they ask me, 'Oh, where in New York?'"). Exhibiting in New York City, he added, has also elevated his standing at his school: "I'm thought of more and more as a New York artist, which means something down here."

FINDING A PLACE TO STAY

New York City is an expensive place to visit as well as to live, and artists who plan to visit for short or longer periods of time need to have a budget and an idea of where to stay. Jack Dowd spends between $2,000 and $4,000 per visit, staying either at bed-and-breakfasts or short-term (two to four weeks) rental apartments, which he finds either through Web sites or notices in the *New York Times*.

Room rates at the same hotels vary based on the time of year and the day of the week; more popular times, such as the spring, fall, and weekends, are likely to be more expensive. There are a number of hotel reservation services that may be contacted by telephone or through a Web site, including:

Hotel Reservation Network
(800) 846–7666

A Hospitality Company
(800) 987–1235
www.acompanies.com
Furnished apartments, starting at $115 per night, $795 per week, and $2,375 per month for a studio apartment; $125 per night, $995 per week, and $3,395 per month for a one-bedroom; $295 per night, $1,975 per week, and $5,975 per month for a two-bedroom.

Accommodations Express
(800) 991–7666
www.accomodationsexpress.com

Accommodations Plus
(888) 805–3030
(516) 798–4444

Big Apple Lodging
(877) 368–4549
www.b-apple.com
Bed-and-breakfast registry and short-term rental service.

Budget Hotel Finders
(888) 382–7213
(516) 771–7213
www.bookahotel.com
Rooms starting at $110 per night.

Central Reservation Service Corporation
(800) 950–0232

City Lights Bed and Breakfast
(212) 737–7049
www.citylightsbandb.com
Over 200 bed-and-breakfasts, with rooms as low as $95 per night.

Educational Housing Services
(800) 297–4694
(212) 977–9099
(212) 307–0701
www.studenthousing.org
This company owns or leases single- and double-room accommodations in hotels and apartment buildings in Brooklyn and Manhattan, which are then rented to students from various colleges in the metropolitan area.

Express Reservations
(800) 356–1123
www.express-res.com

Hotel Con-X-ions
(800) 356–9991
(212) 840–8686
www.taketime.com
Rooms starting at $125 per night.

Hotel Reservations Network
(800) 964–6835
(800) 511–5743
www.hoteldiscount.com

HOTRES.com
(203) 353–4358
www.hotres.com

New York City Sublets
http://NYCsublets.com

Oxbridge Property Services
(212) 348–8100
Furnished apartments. Rooms starting at $110 per night, $2,500 per month

Quikbook
(800) 789–9887
www.quikbook.com
Rooms starting at $100 per night.

Reservations Plus
(800) 915–9931

Roomfinders USA
(800) 473–STAY
www.roomfinders.com

Travel Planners
(800) 221–3631
(212) 532–1660

For those who are willing to forego some of the finery of a hotel, there are hostels in and around New York City, which are much more affordable. The rooms in a hostel are clean, but there is usually more than one bed in a room (sometimes as many as ten or more), and they may be bunk beds. In addition, bathrooms are shared. Sheets and towels are often—although not always—pro-

vided, and some serve continental breakfasts. Frequently, hostels have rules governing how late one may stay out at night, when lights must be turned off at night (sometimes as early as 9:00 or 10:00 P.M.), and when one must leave in the morning. Some hostels have safe deposit boxes for valuables, as well as recreation rooms (with ping-pong and pool tables, as well as television), bicycle rentals, telephones, laundry facilities, and Internet access. A valuable source of information on hostels is found on an Internet site, *www.hostels.com*.

CONNECTICUT

Mark Twain Hostel
131 Tremont Street
Hartford, CT 06105
(860) 233-1767
$15 per night.

NEW JERSEY

Fleming Guest House
118 East Maple Avenue
Wildwood, NJ 08260
(609) 522-2340
$12 per night.

BROOKLYN

New York Connection
197 Humboldt Street
Brooklyn, NY 11207
(718) 624-7199
$15 per night.

MANHATTAN

Aladdin Hotel and Hostel
317 West 45th Street
New York, NY 10036
(212) 246-8580
http://aladdinhotel.com
$25 per night.

American Dream Hostel
227 Lexington Avenue
New York, NY 10016
(212) 779-3974
$40 per night.

Manhattan Youth Castle
1596 Lexington Avenue
New York, NY 10029
(212) 831-4440
$25 per night.

New York Bed and Breakfast
134 West 119th Street
New York, NY 10027
(212) 666-0559
$25 per night.

Big Apple Hostel
119 West 45th Street
New York, NY 10036
(212) 302-2603
www.bigapplehostel.com
$24 plus tax per night.

Blue Rabbit
730 St. Nicholas Avenue
New York, NY 10031
(212) 491-3892
www.hostelhandbook.com/bluerabbit/
$20 per night.

Central Park Hostel and Inn
19 West 103rd Street
New York, NY 10025
(212) 678–0491
www.centralparkhostel.com
$22 per night.

Chelsea Center
313 West 29th Street
New York, NY 10001
(212) 643–0214
$20 per night.

Chelsea International Hostel
251 West 20th Street
New York, NY 10011
(212) 647–0010
www.chelseahostel.com
$25 per night.

Chelsea Star Hotel
300 West 30th Street
New York, NY 10001
(212) 244–7827
$19 to $33 per night.

Gershwin Hostel
7 East 27th Street
New York, NY 10016
(212) 545–8000
www.gershwinhostel.com
$35 per night.

Guesthouse
63 Audubon Avenue
New York, NY 10032
(212) 781–1842
$25 per night.

Hosteling International—New York
891 Amsterdam Avenue
New York, NY 10024
(212) 932–2300
www.hinewyork.org
$26 to $33 per night. The world's largest hostel with 624 beds.

International House
500 Riverside Drive
New York, NY 10027
(212) 316–8436
$30 per night.

International Student Center
38 West 88th Street
New York, NY 10024
(212) 787–7706
$20 per night.

Jazz on the Park Hostel
36 West 106th Street
New York, NY 10025
(212) 932–1600
www.jazzhostel.com
$27 per night.

Murray Hill Inn
143 East 30th Street
New York, NY 10016
(212) 683–6900
www.murrayhillinn.com
$37.50 per night.

Sugar Hill International House
722 St. Nicholas Avenue
New York, NY 10031
(212) 926–7030
$20 per night.

The Park View Hostel
55 Central Park North
New York, NY 10024
(212) 369–3340
$22 per night.

Uptown Hostel
239 Lenox Avenue
New York, NY 10027
(212) 666–0559
$15 per night.

Tomodachi Ryokan
129 Lexington Avenue
New York, NY 10016
(212) 686–4753
www.tomodachiryokan.com
$39 per night.

Wanderer's Inn Hostel
341 West 30th Street
New York, NY 10001

West Side Inn
237 West 107th Street
New York, NY 10025
(212) 866–0061
$20 per night.

Similar to youth hostels are YM and YWCAs, which are also inexpensive and often have rules for noise, how late one may stay up (or out), and how long one may stay.

BROOKLYN

Brooklyn YWCA
30 Third Avenue
Brooklyn, NY 11217
(718) 875–1190
Women only.

Greenpoint YMCA
99 Meserole Avenue
Brooklyn, NY 11222
(718) 389–3700
Men only; maximum stay is 28 days; $35 for a single room, $50 to $70 for a double.

Judson Post Hall YWCA
30 Third Avenue
Brooklyn, NY 11217
(718) 875–1190
Women only; kitchen, laundry, and maid service.

Prospect Park YMCA
357 Ninth Street
Brooklyn, NY 11215
(718) 768–7100
Men only; maximum stay 21 days.

Twelve Towns YMCA
570 Jamaica Avenue
Brooklyn, NY 11208
(718) 277–1600
Co-ed; $30 for single rooms.

MANHATTAN

Harlem YMCA
180 West 135th Street
New York, NY 10030
(212) 281–4100
Co-ed; laundry and maid service.

McBurney YMCA
206 West 24th Street
New York, NY 10011
(212) 741–9226
Co-ed; no maximum stay for full-time students.

Vanderbilt YMCA
224 East 47th Street
New York, NY 10017
(212) 756–9600
(212) 752–0210
Co-ed; rooms from $65 to $100 per night.

West Side YMCA
5 West 63rd Street
New York, NY 10023
(212) 787–4400
Co-ed; must fill out applications for stays of twenty-five or more days; laundry and maid service.

QUEENS

Central Queens YMCA
89–25 Parsons Boulevard
Queens, NY 11432
(718) 739–6600
Men only; single rooms only; laundry facilities across the street; $43.10 per room.

Flushing YMCA
138–46 Northern Boulevard
Queens, NY 11354
(718) 961–6880, extension 45
Co-ed; $46 for a single room, $65 for a double.

Somewhere between a fine hotel and a hostel are residential hotels, which are available on a monthly or semester basis. These hotels generally offer private rooms or shared occupancies, meal plans, and laundry services. The rooms are furnished. Minimum and maximum stays vary from one hotel to the next, and there is often a waiting list. One should make a reservation well in advance and reconfirm it before arriving in New York.

DeHirsch Residence
1395 Lexington Avenue
New York, NY 10128
(212) 415–5650
Co-ed; minimum stay is three nights, maximum is one year; laundry and maid service.

Henry Street Settlement
301 Henry Street
New York, NY 10002
(212) 766–9200
Co-ed; restricted to full-time students.

International House
500 Riverside Drive
New York, NY 10027
(212) 316–8436
Co-ed; restricted to college graduates working on a graduate degree; laundry and maid service.

International Student Center
38 West 88th Street
New York, NY 10024
(212) 787–7706
Co-ed; only available to foreign students, age 18 to 30; $10 daily.

Leo House
332 West 23rd Street
New York, NY 10010
(212) 929–1010
Co-ed; maximum stay is two weeks.

Pennington Friends House
215 East 15th Street
New York, NY 10011
(212) 673–1730
Co-ed; residents must share in housework;
interview required.

Union Theological Seminary
3041 Broadway
New York, NY 10027
(212) 662–7100
Co-ed; six-week minimum stay; apply in person.

Centro Maria Residence
539 West 54th Street
New York, NY 10019
(212) 757–6989
Women only; laundry and maid service.

El Carmelo Residence
249 West 14th Street
New York, NY 10011
(212) 242–8224
Women only, age 18 to 30.

Jeanne D'arc Residence
253 West 24th Street
New York, NY 10011
(212) 989–5952
Women only, age 18 to 40; must be employed
or a student.

Katherine House
118 West 13th Street
New York, NY 10011
(212) 242–6566
Women only; interview required.

Markle Residence
123 West 13th Street
New York, NY 10011
(212) 242–2400
Women only; application required; five days
minimum.

Martha Washington Hotel
29 East 29th Street
New York, NY 10016
(212) 689–1900
Women only.

Parkside Evangeline
18 Gramercy Park South
New York, NY 10003
(212) 677–6200
Women only, age 18 to 35; thirty-day
minimum stay; interview required.

Roberts House
151 East 36th Street
New York, NY 10016
(212) 683–6865
Women only, age 18 to 25; three-month
minimum stay.

Sacred Heart
432 West 20th Street
New York, NY 10011
(212) 929–5790
Women only.

Webster Apartments
419 West 34th Street
New York, NY 10001
(212) 967–9000
Women only.

Kopling House
165 East 88th Street
New York, NY 10128
(212) 369–6647
Men only, age 18 to 35; two letters of recommendation required.

Lexington Residence Club
120 East 31st Street
New York, NY 10016
(212) 685–3060
Men only; must be employed or full-time students.

One company, Assured Accommodations, Inc., also assists people looking for short-term rentals (from three days to six months, and sometimes longer). Contact them at 225 Lafayette Street, New York, NY 10012; (212) 431–0569; *www.assurednyc.com*. In addition, some colleges and universities rent out their dormitories during the summer months.

Realtors also may have listings of apartments for brief sublets. Otherwise, it is helpful to have friends or relatives in or around New York City whom one may visit. For instance, George Fitzpatrick's wife has relatives in Summit, New Jersey, with whom the Cleveland Heights, Ohio, painter stayed while visiting galleries; eventually, Salander-O'Reilly Galleries on East 79th Street began to represent his work. Marthe Keller's friends from the Maryland Institute College of Art, who had already moved to New York, put her up for her once-a-month visits from Baltimore, while she scouted out the art scene and dropped off slides of her paintings with galleries.

For some artists, the lure of New York simply becomes too great. "I had a cheap place to live in Baltimore and had a certain comfort level there that I thought I'd lose if I moved to New York," Keller said. "Moving is always very disruptive." She also had a job in Baltimore, working as an art therapist (for which she had received a degree from George Washington University). Still, those same friends went to work on her behalf and eventually found her an apartment when she moved up permanently in 1978.

Barbara Rachko, a painter and pastel artist living in Alexandria, Virginia, also was a regular visitor to New York City during much of the 1990s. Employed by the Department of the Navy as a computer analyst, she found Washington, D.C., to be a frustrating city in which to try to exhibit her work. "It's basically a one-industry town—government—and that one industry is all people seem to want to think about," she said. "After people are finished work, they don't want to stay around and look at an art show." Being a weekend visitor to New York was no less frustrating to her, because "I met other artists, who invited me to other things during the week, but I couldn't do them because I had to go back

to Virginia. It was all backwards: I should have been spending the week in New York and going back to Virginia on the weekend."

Fortuitously, an aunt living in the West Village decided to move in 1997, and she offered to let her niece take over the lease. "I couldn't say 'no,'" Rachko said. "The rent was only $650 a month. Other apartments in that same building were going for $2,000 a month. I'd never get such a good deal again." At age forty-four, Rachko was willing to change her life when the right apartment at the right price came along.

Katherine T. Carter's is not the only organization that brings artists to New York. Nurture Art—located at 160 Cabrini Boulevard, PH 134, New York, NY 10033–1145; (212) 795–5566; *www.nurtureart.org*—is a nonprofit organization that selects artists to be given studio space and exhibition sites in Manhattan. The New York Studio Program, which is administered for the San Francisco-based Association of Independent Colleges of Art and Design [3957 22nd Street, San Francisco, CA 94114–3205; (415) 642–8595; *www.aicad.org*] by Parsons School of Design, brings art school students (juniors and seniors, primarily) to New York for one semester in order to work with artists and experience the art world. Another college-based program, the New York Arts Program, administered by the Great Lakes Colleges Association [535 West William, Ann Arbor, MI 48103; (734) 761–4833; *www.newyorkartsprogram.org* or *www.glca.org*], offers a semester for fifty college students with an interest in communications or the visual and performing arts to work as apprentices in Manhattan. Additionally, both the Marie Walsh Sharpe Art Foundation [The Space Program, 711 North Tejon, Suite B, Colorado Springs, CO 80903; (719) 635–3220] and The Elizabeth Foundation for the Arts [P.O. Box 2670, New York, NY 10036; (212) 956–6633] run programs that provide studio space to fourteen artists for a period of twelve months in lower Manhattan.

ARE YOU PSYCHOLOGICALLY PREPARED FOR NEW YORK?

Fresh off the boat from Oklahoma, twenty-three-year-old painter Phillip Sherrod came to New York City in 1959, raring to start making his mark as an artist. Three months later, he was back home in Oklahoma. "I didn't like the people," Sherrod said of the New Yorkers he met. "They don't do what they want to do, and no one had time for me. I felt like such an outsider—maybe I had made a rash decision to come here in the first place. This city eats people, and I hadn't adapted; I hadn't made the orientation. I wasn't ready." Within a month

or two of returning to Oklahoma, Sherrod decided he had been right the first time and moved back to New York, this time for good. "Now, I know the city like the palm of my hand."

Many people in new situations and surroundings experience what psychologists call "adjustment reaction"—feeling disoriented, out-of-place, unsure how to proceed next—which tend to be short-term. New York City may be a shock to the senses and sensibilities of artists coming from out of town, who find the noise, the dirt, and roaches, the high rents for small, unkempt apartments and studios, the overcrowding, the competition for attention with countless other artists, the crime, and the hierarchical, mandarin culture of the New York art world overwhelming. "I came to New York in 1974, and it took me ten years to get used to things," said Sarah Benolken, a Manhattan psychologist who regularly counsels fine and performing artists. "It's easy for people to feel out of place, because of the way they dress, their accents, their tastes, and how much money they have or don't have. It's very easy to feel like a hick."

Before picking up and moving to New York, artists should make a number of visits and talk with artists already living there about their experiences, their jobs, the cost of entertainment, the neighborhoods in which they live and the rents they pay, their success in showing (and selling) their artwork, and how they feel about their future prospects. Artists might choose to make a checklist of general concerns to be sure that they are psychologically prepared for New York.

• Can you clearly articulate your visions and expectations for a life and career in New York? "New York is seen as a mecca for the arts, and artists may hope and believe that their art will be appreciated and affirmed in some way," said Graham Jelley, a psychologist in Providence, Rhode Island, who regularly counsels students at the Rhode Island School of Design. "Artists should check those dreams against what people in New York say life is like. The reality is, there are a whole lot of people with the same dream in New York."

• Are you able to produce a lot of work under circumstances that may not be conducive to producing art? Rents are high for apartments, and studio spaces are no less expensive. Unless artists can swing two rents, they are likely to find themselves attempting to create work in a small corner of their apartments. Add a job during the day, and artists find themselves trying to create something meaningful when they are tired (and, perhaps, more likely to be discouraged).

• Are you willing to market your work, introducing yourself to dealers, collectors, critics, and curators and talking about your art? Most artists face rejection far more than acceptance, which is true for even the most established stars of the art world (more people don't want to buy a Rauschenberg than do). Fear of rejection makes some artists stop trying to exhibit their work and, quite often, to stop making art entirely. Learning how to talk about their work, how to handle criticism and not take rejection personally are major steps in the maturation process of artists. Mary DeVincentis, a painter who moved to New York from Wilmington, Delaware, in 1975 "soon realized that, although I knew what I wanted to do in my art, my social skills—salesmanship and knowing how to connect to people—were not up to snuff." Having an interest in psychology, she entered an art therapy program at Pratt Institute the following year and currently has as clients fine and performing artists, as well as children and schizophrenics.

• Are you prepared for the sheer number of competing artists in New York? The art critic Donald Kuspit once wrote about "the aesthetic of the oversupply of artists in New York, which tended to favor the increasingly outrageous, as artists try desperately to direct attention to themselves amidst the throng." Certainly, most New York artists are not engaged in a can-you-top-this approach to their work, but the city places a premium on individuality and an assertive personality. Caroll Michels, an artists' career advisor, noted that artists often pin their hopes on a good work ethic: "They think, 'If I work hard enough, I'll be able to make it,' and I don't see that as true in New York. You do have to work hard, but you have to be aggressive in other ways, too."

• Are you willing to sacrifice material comforts for the sake of your art? "Poverty is a real issue for artists," Benolken said. "It sometimes gets romanticized, but not having money grinds you down physically and emotionally. New York is about displaying wealth. Artists who have been working for years as janitors, unable to show or sell their work, can get very depressed."

Poverty, of course, is not a psychological condition; however, the interplay of psychology and the physical and cultural environment of New York City may make one unable to produce art. Besides a psychological assessment, Jelley also recommended a basic skills assessment for artists: "What kind of work can I do, what should my day job be, and how could I get a better return for my time?"

• Is your vision of being an artist a healthy one? Benolken said that there is a "history and tradition of dissolute behavior in the arts," in which context artists are seen as inherently bohemian and mentally unbalanced. Attempting

to conform to that vision, some artists engage in risk-taking behaviors, such as taking illicit drugs and drinking to excess, "which makes people less able to create their art. It has never enhanced anyone's art."

• How have your expectations and missed opportunities and disappointments been handled in the past? Those who are easily frustrated or have a low level of tolerance for crowds, noise, inconvenience, temptations, and general overstimulation "may get into trouble, or just get into something that's hard to get out of," according to Donald Schiermer, a licensed psychotherapist and a family physician with the Miller Institute for the Performing Arts. He said that "if a person is inclined to have vulnerabilities to mental illness, depression, or substance abuse, that could be triggered almost anywhere. But the assault that New York makes on your senses is so very intense that an individual may succumb to psychological problems sooner and more severely."

In many instances, the adjustment reaction disorders vanish after an artist settles in and develops relationships with other artists who are supportive of his or her work. "I had one patient, a guy who recently moved here, who went to art openings and thought, 'I don't know anybody here,' so he'd just leave and feel depressed that he wasn't meeting people, which made him stop making art. He thought he was a failure," DeVincentis said. "After awhile, he met another artist, who was more connected to the art world. Through this friend, he met other people and got into the swing of things. The depression disappeared."

A range of therapies and psychologists are available to New Yorkers. Some psychologists work regularly or exclusively with fine and performing artists. Professional art schools and universities offer counseling services for their current students and alumni, and some provide referrals to artists who seek a practitioner experienced with artists. The Institute for Artists of the Postgraduate Center for Mental Health [138 East 26th Street, New York, NY 10010; (212) 576–4100] and the Miller Institute for the Performing Arts [425 West 59th Street, New York, NY 10019; (212) 523–6200] both provide psychotherapeutic counseling to artists on a sliding-fee scale (based on their incomes), starting at $50 per session. Artists undergo a screening over the telephone, followed by an in-person discussion of the individual's presenting issues with an intake worker, who will make a match with an appropriate psychologist. Another source of help is the Artists' Health Insurance Resource Center [c/o The Actors' Fund, 729 Seventh Avenue, New York, NY 10019; (800) 798–8447], where, again, an assessment, intake, and referrals are made. One may also contact the toll-free referral

services of the American Psychological Association at (800) 964–2000 or the New York State Psychological Association at (800) 445–0899 for a suitable psychologist.

ART THAT DOESN'T FIT THE MOLD

DEFINITION OF THE NEW YORK ARTIST: THE ATYPICAL IS TYPICAL

New York attracts artists who want to be part of its art scene, who want to be New York artists, yet New York art is widely associated with avant-garde, edgy, difficult-to-understand, shocking-the-sensibilities work, a description that doesn't apply to a lot of the art produced there. It certainly doesn't apply to the landscapes of Manhattan-based Joseph P. Grieco or the images of boats and other maritime scenes of Brooklyn painter Jason Larsen. Nor is the customary portrait of the New York artist applicable to Donato Giancola, another Brooklyn painter, who specializes in fantasy art. For all the available stereotypes, New York welcomes a wide range of artists who live there by choice, even though their markets may be elsewhere.

Grieco, for instance, spends months of the year out of the city, setting up his booth at juried art shows in Florida (February and March), New England (April, May, June, September, and October) and the Midwest (July), where he is able to meet the visitors and collectors who regularly come to these exhibitions and to whom he sells his paintings directly. He describes his work as "tonalist, impressionist with a Hudson River flare." "Eventually, I want to be a gallery artist," he said, noting that having dealers sell his work would eliminate the need for him to do so much driving and free up his time to paint. Still, there are benefits to selling work himself ("All the money I make is mine. I don't have to pay a commission."), and he is not convinced that his work is the sort that New York gallery owners want. "Being a landscape painter in New York City is a bit of a paradox," he said. "I love to be in nature. When I'm in the city, I tend to be in Central Park. When I go out of New York, people say, 'Wow, you're a New York artist. That must be great.' I tell them, 'You don't want to be there.'"

It is the galleries, museums, and a rent-stabilized apartment in Manhattan that keep him coming back; otherwise, it might be easier for him to live and paint closer to where his shows are. "I get to see some of the greatest landscape paintings in the world in the galleries and museums of New York," Grieco said. "New York has that to offer, which you won't see anywhere else."

The "wide variety of art in all forms" also keeps Jason Larsen in New York, despite the fact that his paintings of boats on the water and other maritime subjects might be more appropriate for seaside resort communities. "You see art in the subways, sculptures in Central Park, paintings on the walls of restaurants, and then there are the galleries and museums. You always feel challenged to try something new and to do your best." Like Grieco, his market is also not a New York City gallery audience; rather, he sells much of his work to the Manhattan-based Intergovernment Philatelic Corporation (better known simply as IGPC), which commissions artists to create images for postage stamps for countries around the world that do not have in-house postal service artists.

Larsen learned the nuts and bolts of this field while in his senior year at New York's Fashion Institute of Technology, where he earned a B.F.A. in 1998. FIT has a mentorship program for seniors, and Larsen worked as an apprentice to Joel Iskowitz, a professional illustrator in Woodstock, New York, who has been creating images for IGPC since 1978. Iskowitz has created pictures of the Beatles for Tanzanian stamps and a series of portraits of famous black athletes for the Congo, among thousands of other images. "It's mainly a collector's market," Iskowitz said. "They can be used as postage stamps, and I believe they are, but the images are often commemorative and sought after by collectors all over the world." Neither Larsen nor Iskowitz have many of the originals in their possession, because stamp images are considered a high security item (the stamps are printed at secure facilities in order to prevent counterfeiting), and the originals are usually "struck" (defaced) or stored in vaults.

Also like Grieco, Larsen occasionally muses about being a gallery artist—"You think, wouldn't it be great to be in galleries and have everyone know me"—but looks upon the galleries not as a reproach to his current work but as a form of inspiration. "It's very helpful to have all this art to see," he said.

There is no typical New York artist or New York art. Pluralism, now in its fourth decade, encompasses an ever-expanding range of styles, media, and audiences, and it is the job of professional artists to create a body of work and find their particular audience. A form of test marketing, this is accomplished by exhibiting work and eliciting reactions and comments (some artists make mistakes by assuming who their audience should be in advance rather than finding out who actually responds favorably to their work). Certainly, there are different approaches that artists may take: Academic realists generally do not concern themselves with art openings in Chelsea, reviews in *Artforum,* or meeting trendy collectors, while installation artists can't live without those; those who

create public artworks need to be very conscious of the community, because they cannot afford to offend anyone, while neoconceptualists strive to offend somebody. Then, of course, there are people who cross over from one to another: Fred Tomaselli, who came to Brooklyn from Los Angeles in 1985 as an installation artist, switched to painting because "there was a commodifying aspect to that. I could make some money that way."

The portrait of the artist—or, how the artist is viewed by the public and even accepted by artists themselves—has changed over time. Early in the twentieth century, Paul Gauguin was the romantic ideal, a bohemian who put artistic liberty above societal conventions and morality. That was replaced around mid-century by Jackson Pollock, the hard-drinking, tortured soul in T-shirt and work boots who expended himself in his art. More recently, the figure who stands out is Jeff Koons, the smart, glib, publicity-seeking postmodernist who reaps the benefits of his often crass hucksterism while seeming to comment upon such art world commercialism. However, no one perception of the artist defines all artists, and fewer artists feel the need to fit themselves into these roles.

New York is crowded with artists, but perhaps it is also easier to be an artist in New York rather than somewhere else, where artists are more anomalous. Because there are so many others sharing the same experiences (where to show work, where to find an affordable studio, where to find a job), artists in New York are surrounded by colleagues who know exactly what they are going through. "When I'm in New York, I'll tell people I'm a painter, and they'll ask me, 'What do you paint?'" said Claudia Cron, who spends part of the year in Manhattan and the rest in southern California. "When I'm in Los Angeles, people ask me, 'Do you sell?'" In addition, there is so much variety to the art created in New York that few people feel like outsiders.

Stained glass artist David Strouse, for instance, moved from Joplin, Missouri, to Brooklyn, "because there is a lot more opportunity to learn the craft in New York than elsewhere. There are all types of stained glass done here—glassblowing, fusion, people who paint on glass. There is nowhere else that has so much." His work, however, is almost entirely sold in shops outside of the city, and occasionally he gets commissioned for larger pieces. Colleen Rowan Kosinski, a painter who lives in Cherry Hill, New Jersey, works completely by commission, selling pet portraits to people all over the country who find her through her Web site. In the mid-1990s, she had been a scientific illustrator, working for an entomologist at the Academy of Natural Sciences in

Philadelphia, making drawings of the reproductive organs of mutated crane flies while looking through a microscope, when a neighbor "asked me to do a portrait of his dog. The dog had died, and this person wanted a special picture to remember him by. I liked doing it so much that I quit my job and concentrated on getting more commissions."

Yet another artist whose audience is largely out-of-town is Donato Giancola, a painter of fantasy images that he sells to book publishers for covers and increasingly at shows of fantasy art, which take place around the country. He had moved to Brooklyn from Colchester, Vermont, in 1992 for the same reasons that so many artists before and after him have done ("I just knew that New York was the center of the art world") and found a job through a friend at the Society of Illustrators doing various odd jobs, "checking coats, sticking address labels on mailers, hanging shows, cleaning up, whatever they needed me to do," he said. During the year-and-a-half that he worked there, he was "opened up to the world of illustration. I started thinking, 'I could do this kind of work, too.'"

Giancola began to create sample book covers and sent them to several artist representatives. After a number of these submissions, demonstrating his skills and his commitment to keep trying, he began to receive book cover commissions through an agent. In time, he joined the Arlington, Texas-based Association of Science Fiction and Fantasy Artists and started to submit work for its shows, which led to sales and a waiting list. For him, being a New York artist does not mean showing in galleries there or elsewhere ("they take too high a commission"); rather, like Grieco and Larsen, New York allows him to see art that challenges him to try something new all the time. "I visit museums and galleries constantly," he said. "I look to incorporate what's happening around here into my work."

Chapter 2.
GETTING AROUND IN NEW YORK

Although it is physically a vast place, New York is a city of distinct neighbor-
hoods, and residents identify with those neighborhoods sometimes more than
with the city as a whole ("I live in Long Island City," someone might say, rather
than "I live in Queens"). For some unexplained reason, all addresses in the
Bronx, Brooklyn, Manhattan, and Staten Island are for the respective bor-
oughs—for instance, "Brooklyn, New York" or "New York, New York"
(Manhattan)—whereas in Queens, one may send a letter to a particular neigh-
borhood, such as "Jamaica, New York" or "Little Neck, New York."

MANHATTAN NEIGHBORHOODS

Many neighborhoods throughout the five boroughs are given their own names
(Little Italy, Chelsea, Red Hook) or acronyms (SoHo, NoHo, Tribeca, DUMBO).
Starting from the northern end and moving downtown or south in Manhattan,
one finds:

WASHINGTON HEIGHTS. Located to the north of 155th Street all the way to the
top of Manhattan, Washington Heights (sometimes called Hudson Heights or
Inwood) only *seems* to be inaccessible and far away. In fact, it is only a twenty-
minute train ride on the A train to midtown. An area of formerly large estates,
and also the one-time home of the Polo Grounds, it was transformed into a res-
idential neighborhood in the first decades of the twentieth century. Lower rents
and river views have attracted artists and professionals from downtown. The
most popular cultural attraction in Washington Heights is The Cloisters, the
Metropolitan Museum's medieval collection located in Fort Tryon Park.

HARLEM. Bordered by 125th Street to the south and 155th Street to the
north, Harlem has long suffered from an image problem. Closer inspection

reveals still-elegant neighborhoods and brownstones that are in very good shape, both in Harlem proper and in East Harlem (sometimes called El Barrio for its largely Latino population). Harlem has made a terrific resurgence in the past decade, and a growing number of lofts are being advertised, bringing in more artists. Of particular interest are the Abyssinian Baptist Church, African Arts Cultural Center, the Apollo Theatre on 125th Street, the Black Fashion Museum, the Hispanic Society of America, the neo-gothic campus of City College at 137th Street, and the Studio Museum of Harlem.

MORNINGSIDE HEIGHTS. Columbia University dominates this area, which extends from 110th to 125th Streets, with Morningside Park to the east and the Hudson River to the west. The university owns a large amount of the real estate in this neighborhood, including many apartment buildings (some of which are not dorms). Grant's Tomb and the gothic-styled Cathedral of St. John the Divine are among the cultural attractions. There are also a sizeable number of restaurants and cafes frequented by students.

UPPER EAST SIDE. One of Manhattan's wealthiest (and most expensive) areas, the Upper East Side extends from 59th to 96th Streets, from Fifth Avenue to the East River. At one time, Fifth Avenue was lined with mansions, most of which no longer exist, but those that do have been turned into museums, such as the Cooper-Hewitt National Design Museum (home of Andrew Carnegie), the Frick Collection (Henry Clay Frick), and the Jewish Museum (Felix Warburg). Other museums in the area are the Guggenheim Museum, the International Center of Photography, the Metropolitan Museum of Art, and the Whitney Museum of American Art. Additionally, there is a sizeable number of art galleries on or near Madison Avenue. Within the Upper East Side is a smaller neighborhood pocket called Yorkville, around 86th Street and Second and Third Avenues, where Czechs, Germans, Hungarians, and other central Europeans congregated earlier in the century. Many of them have moved on, but their restaurants have remained. A little to the north are the Museum of the City of New York at 103rd Street and El Museo del Barrio at 105th Street.

UPPER WEST SIDE. Bordered on the east by Central Park, the Hudson River on the west, 110th Street to the north and 59th Street to the south, the Upper West Side can boast of being (on the whole) a little less expensive than the Upper East Side. Here can be found the American Museum of Natural History, Lincoln Center, the Museum of American Folk Art, and the New York Historical Society.

CLINTON/HELL'S KITCHEN. Encompassing Times Square and the Theater District, this area extends from 34th to 59th Streets, from Avenue of the Americas and Broadway west to the Hudson River. In the nineteenth century, some of the poorest immigrants settled in here, and this was also the slaughterhouse and tannery part of town, which gave rise to the name "Hell's Kitchen." The ongoing cleanup of Times Square has vastly improved the character of this neighborhood, eliminating many of the drug dealers and prostitutes, but it is still far from "gentrified" and retains a working class character. However, there is a large community of people in the theater arts and a sparse but growing number of artists and other professionals residing in the area. Among the cultural landmarks are the Art Students League and the Caribbean Cultural Center.

MIDTOWN. Filled with smaller neighborhoods called Kips Bay, Sutton Place, Turtle Bay, and Murray Hill (J.P. Morgan's old address), midtown is the all-encompassing term for this area that begins at 23rd Street to the south and extends to 59th Street, from Seventh Avenue to the east all the way over to the East River. Within this district are the Empire State Building, Radio City Music Hall, the Garment District, the Diamond District, the United Nations, the American Craft Museum, the Archives of American Art, the International Center of Photography-Midtown, the Japan Society, and the Museum of Modern Art.

GRAMERCY PARK. Bordered by 14th Street to the south and 23rd Street to the north, from Fifth Avenue to the East River, Gramercy Park has the only private park remaining in the city, and one needs a key to get in. At one point, Union Square was a regular rallying point for labor meetings, but now it is just a park in a pleasant area in which to take a stroll. The School of Visual Arts is here.

CHELSEA. One of the city's many former factory districts, Chelsea is bordered by 34th Street to the north and 14th Street to the south, the Hudson River on its west flank and Avenue of the Americas on its east. Not as easily accessible to public transportation as other parts of Manhattan, its appeal in the 1980s and early 1990s, when artists and art galleries began to migrate there from SoHo, was its large industrial spaces and affordable rents. The spaces are still large, but the rents have changed. Among the arrivals is Dia Center for the Arts, as well as Barnes & Noble, Bed Bath & Beyond, and Filene's Basement. Chelsea has become the major area of art galleries in Manhattan, surpassing SoHo and the Upper East Side.

WEST VILLAGE. Part of the character of New York is that of a city continually being torn down to put up something new. One neighborhood after another is filled with scaffolding and construction sites, as the city recreates itself. On the other hand, the West Village (which is sometimes still called Greenwich Village) still looks much the way it probably did a hundred or more years ago. The West Village is an elegant area of shops, cafes, restaurants, and architecturally interesting townhouses, bordered by 14th Street on the north side and Houston Street to the south, east to Fifth Avenue and west to the Hudson River.

EAST VILLAGE. A number of neighborhoods in New York have names given to them by realtors looking for cachet (Hudson Heights uptown and Nolita downtown, among others). The East Village was part of the Lower East Side until the 1960s, when realtors thought an eastside version of Greenwich Village would improve its image. Bordered by 14th Street on the north side, East Houston Street to the south, the East River to the east, and Fourth Avenue and the Bowery to the west, the East Village still maintains the look of a grunge version of the West Village, although that is rapidly changing. The less-renovated areas of Avenues A and B have more affordable apartments. East of that is also affordable but a bit more seedy. The East Village is home to La Mama.

LOWER EAST SIDE. Neighborhood boundaries in New York tend to be more imaginary than real. The demarcations of the Lower East Side are more fuzzy than most, since SoHo and the East Village overlap. With East Houston Street to the north, the East River to the east, Brooklyn Bridge to the south, and the Bowery, Fourth Avenue, and Canal Streets to the west, the Lower East Side is where generations of immigrants to the United States lived until they could afford to move out, and it still remains a place to find a bargain (in clothes, appliances, food, and rents).

SOHO. Standing for South of Houston (pronounced HOW-stun), SoHo is bordered on the north by Houston Street and by Canal Street to the south. Once a thriving industrial zone, referred to as the cast-iron district, the City of New York seriously considered tearing down the abandoned factory buildings in the 1960s and building a crosstown expressway but instead permitted (after the fact) artists and others to use the large factory spaces for live-work purposes. Galleries followed the artists in, as did shops and restaurants. Many artists and galleries remain, but the character of the neighborhood is essentially retail now. SoHo is still the home of the Alternative Museum, Artists Space, Center for Book Arts, Drawing Center, Guggenheim Museum-SoHo, the Museum for African Art, and the New Museum of Contemporary

Art. Directly north of SoHo is the somewhat less well defined neighborhood called NoHo, home of New York University.

TRIBECA. Standing for Triangle Below Canal, Tribeca (tri-BEH-ca) is less a neighborhood than a designation of the candy corn shape of lower Manhattan south of Canal Street, where artists who were priced out of the gentrifying SoHo beginning in the 1970s began to move. Actually, the tip of Manhattan is referred to as the financial district. It is the oldest part of the city (through the colonial period, the rest of Manhattan was farmland and small villages) and contains Wall Street, City Hall, the state and federal courthouses, and the South Street Seaport area, where artists briefly seemed to hold sway during one of the exodus periods from SoHo. Tribeca is the home of the Asian American Arts Center, Franklin Furnace Archive, the Tribeca Performing Arts Center, very expensive lofts, and some of the city's hottest restaurants.

LITTLE ITALY and **CHINATOWN.** Located to the east of SoHo, these neighborhoods are not, as their names suggest, primarily havens for artists. Chinatown isn't even a haven exclusively for Chinese immigrants anymore, as other southeast Asian populations have moved in. As a community, Little Italy and the new realtor designation, NoLiTa (North Little Italy), is not primarily Italian, although the name lives on. (More authentic Italian communities can be found in Carroll Gardens and Bensonhurst in Brooklyn and on Arthur Avenue in the Bronx.) Available apartments are scarce in both Little Italy and Chinatown, but restaurants are in abundance.

THE OUTER BOROUGHS

Brooklyn, the Bronx, Queens, and Staten Island used to be referred to as the Outer Boroughs, in the same way that Parisians once described all of France outside of Paris as "the provinces." Astronomical real estate prices within Manhattan, however, have drawn these outer boroughs much more into the daily life of the city, because they are where many of Manhattan's employees now live. Artist neighborhoods have arisen in the waterfront areas surrounding Manhattan, in Brooklyn (Bay Ridge, Brooklyn Heights, DUMBO, Gowanus, Greenpoint, Red Hook, Sunset Park, and Williamsburg), Queens (Astoria and Long Island City), New Jersey (Hoboken, Jersey City, and Newark), and even further inland (the Boerum Hill, Bushwick, Carroll Gardens, and Cobble Hill sections of Brooklyn, the Flushing section of Queens, Montclair and South Orange, New Jersey), as the ripple effect of high real estate prices keeps extend-

ing further from Manhattan and forces artists to continually look for new areas to colonize. Some useful sources of information on where artists live and where they may be moving to are the Brooklyn Arts Council [195 Cadman Plaza West, Brooklyn, NY 11201, (718) 625–0080], the Queens Council on the Arts [79–01 Park Lane South, Woodhaven, NY 11421–1166; (718) 647–3377] and the New Jersey State Council on the Arts [P.O. Box 306, Trenton, NJ 08625–0306; (609) 292–6130].

BROOKLYN

BAY RIDGE. Located in south Brooklyn, this family neighborhood is ringed by the Gowanus Express and the Belt Parkway.

BROOKLYN HEIGHTS. Bordered by the Brooklyn Bridge to the north, Atlantic Avenue to the south, Cadman Plaza/Court Street to the west, and Commerce Street to the east, Brooklyn Heights was New York City's first historic district, with beautiful brownstones and other buildings dating back to before the Civil War. The rents match those of the most expensive neighborhoods in Manhattan. With one of the largest Middle Eastern neighborhoods within the five boroughs on its southern end, there is a wealth of exotic restaurants. Artistically, the Rotunda Gallery on Clinton Street (fine art) and St. Ann's church on Montague Street (music and theater) are major draws. Also, the New York Transit Museum at Schermerhorn Street and Boerum Place is worth a visit.

DUMBO. Standing for Down Under the Manhattan Bridge Overpass, DUMBO is found just to the south of the Vinegar Hill section of Brooklyn. Once a year in October, area artists open up their studios for the Arts Under the Bridge Festival, which has enticed a growing number of artists to move there. The festival is organized by the DUMBO Arts Center on Water Street, which is also a central exhibition site. Other popular art spaces are GAle GAtes and Smack Mellon.

FORT GREENE. Bordered by Myrtle Avenue to the north, Atlantic Avenue to the south, Hall Street to the east, and Flatbush Avenue to the west, Fort Greene has become yet another overflow area in Brooklyn for artists priced out of Brooklyn Heights and Williamsburg.

PARK SLOPE. With the Brooklyn Museum, Botanic Gardens, and Zoo nearby, Park Slope has attracted many artists looking for something they can afford. Bordered on the north side by Flatbush Avenue and 15th Street to the south, Prospect Park to the east (Park Slope is so named because it slopes up to

Prospect Park) and Fourth Avenue to the west, the area has seen the emergence of new art spaces, such as Kentler International Drawing Space and Feral Art Gallery. Since the mid-nineties, Park Slope rents have risen sharply, becoming a barrier to increased artist migration. Also, real estate agents eager to cash in on the value of the Park Slope address have created South Slope, which sometimes includes residences as far west as Third Avenue and street numbers that might be more properly located in Sunset Park.

SUNSET PARK. A place as well as an actual park, Sunset Park is located between 15th and 65th Streets and between Eighth Avenue and the New York Harbor. It is one of the many overflow areas of Brooklyn for artists looking for cheaper digs. A bit father out is the **RED HOOK** neighborhood, which has attracted artists with its affordable rents; alas, the lack of subway or bus routes makes it somewhat inaccessible for those without automobiles.

WILLIAMSBURG. A popular destination for artists escaping from high rents in SoHo and Tribeca (which has in turn increased the rents here), Williamsburg is the part of Brooklyn that is physically closest to Manhattan. Artists have settled in long enough to have generated a sizeable assortment of cultural fare, including commercial galleries and nonprofit art spaces, such as Arena@Feed, Cave, IM N IL, Roebling Hall, and the Williamsburg Art & Historical Center. Its main streets are Bedford, Union, Metropolitan, and Greenpoint Avenues.

QUEENS

ASTORIA. Another coastal community increasingly favored by artists on the move, Astoria is located just over the 59th Street Bridge and north, along the East River. The population is still quite mixed. On 35th Avenue at 36th Street is the American Museum of the Moving Image.

LONG ISLAND CITY. In the late 1970s, the Institute of Contemporary Art had the foresight to see that an unused school in Long Island City (P.S. 1) would make an ideal location for art exhibitions and artist studios. P.S. 1 also appealed to the Museum of Modern Art, which has taken over the operation of the facility. Artists took to the idea strongly, generating an influx of artists to the area, which is located close to Manhattan (the view of the Manhattan skyline is one of its most picturesque features), directly across the East River and easily accessible by the 7, F, N, and R trains. Besides P.S. 1, there are a growing number of art galleries, as well as the Isamu Noguchi Garden Museum and the Socrates Sculpture Garden.

With the exception of Long Island City and Astoria, Queens has not seen as great an influx of artists as have other areas, in part because "people feel they need to be accessible to Manhattan and its art activity," said David Judelson, founder and director of the New York Coalition for Artist Housing, which has been developing live-work buildings in Jersey City, Brooklyn, and Queens. "Artists believe that dealers and curators won't travel out to Queens." For the time being, the major galleries appear to be rooted in Manhattan, which is evidenced by the fact that many gallery owners who have moved to Chelsea purchased their buildings.

NEW JERSEY

HOBOKEN. Once a factory town with cold-water flats, Hoboken has developed into a bedroom community for Manhattan. Decades ago, Willem de Kooning lived there. Even with rising rents, the cost of living in Hoboken still is far less than in comparable apartments just across the Hudson River. By PATH train, Hoboken is a mere seven minutes from Manhattan. Art exhibition spaces are coming into existence slowly.

JERSEY CITY. Located directly across the Hudson River from Tribeca (the PATH train ride is three minutes to the World Trade Center and another seven to fifteen minutes to 33rd Street and Avenue of the Americas), Jersey City is the site of an eight-block, artist-only zoning district, known as WALDO (Work and Live District Overlay), created in 1996. Still in the process of development, artists will be the only permitted residents (they must be certified as professional artists by a special five-member committee, three of whom "shall be professional artists" [rather than a performer, commercial artist, or an occupation further afield in the arts], according to the city ordinance, and the selected artists must prove their need for a large loft space), and the only authorized businesses are to be art galleries and art performance spaces. Artists who are not New Jersey residents may apply to live in WALDO, and, according to Maryanne Kelleher, assistant director of the Jersey City Department of Recreation & Cultural Affairs, one-third of the applications for artist certification have come from New York.

MONTCLAIR. Similar to the city council of Jersey City, the elected officials have looked into the future of its economic development and seen the benefit of supporting the arts. The Murals in Motion program of Montclair has been one sign of the city's interest in encouraging the arts, along with an annual open studio tour. As a result, artists have been moving in. The city already has a number of art galleries and the Montclair Art Museum.

ARTISTS MOVING FURTHER AFIELD

For artists, the New York City ideal is a large, affordable loft space where they can both live and do their work, located in an area where other artists do the same. Some artists still are able to find a large, dual-purpose space at a reasonable rent, although the ongoing pressure on available housing quickly turns affordable neighborhoods into expensive ones, and these same artists may need to subdivide their lofts into ever smaller units or move on to the next low-rent part of town. Some artists are able to stabilize their situation by buying the building in which they live, but in most cases the one-time artist community loses its artists to others who can more easily pay the rents. Wedded to New York, artists migrate from one area to another that is within easy access of Manhattan, continually seeking that short-lived ideal. Location, location, location.

The situation of some artists can prove quite complex: Estelle Levy, an assemblage artist who lived in Manhattan's Upper West Side, has a studio in the Clinton Hill section of Brooklyn—forty to sixty minutes by subway from her home, depending upon the time of day—and exhibits her work in Jersey City as a member of Pro Arts, an artist membership group that sponsors shows there. Arnold Wechsler, a painter who has lived in Westbeth (New York City's first and only planned live-work space for artists) since 1968, is also a member of Pro Arts, "because you see a lot of young artists trying to do something new there, like Manhattan was in the early 1960s. Manhattan now is all about money, and that makes it hard on young artists." On the other hand, Wei Jane Chir, a printmaker who lives on the Upper West Side, commutes every day to a studio in Jersey City because "it's very quiet, nobody bothers me. I go to New Jersey when so many other people are commuting from New Jersey to Manhattan."

New Jersey's appeal is growing for New Yorkers, some of whom still think of the Hudson River as the "Hudson Ocean," because they are convinced that New Jersey is very far away. Every day, a stream of cars drive through the Holland Tunnel, connecting Manhattan and Jersey City, as New Yorkers come to supermarkets for lower-priced groceries—they save money even when the $6 toll is figured in. The cost of living was very much on the mind of painter Sol Swerdloff, who moved to Jersey City from Brooklyn in 1985 because of the ever-rising rents. "I could afford the rents, but there was never an end to how much it might go up," he said. His son, who was already living in a house in Jersey City, "said to me, 'Come on over. It's great,' and so I did. And he was right. You can buy things here you can't afford to buy in New York."

Anne Pope and Toon Botwin, an artist couple who had lived in a five-hundred-square-foot apartment in Chelsea, paying $1,300 per month, moved to Jersey City in 1998. "In our apartment in Chelsea," Pope said, "space was so tight that, when we bought a FAX, we put it in the closet and pulled it out only when we needed it." Almost immediately, the two found an apartment that was "twice as big for less money." They had thought about Brooklyn, but that "turned into a non-option, because the places near Manhattan were already becoming too expensive, and more affordable neighborhoods were getting too far away."

A disadvantage of Jersey City also solved the problem of a seeming advantage of Manhattan: "In Manhattan, there is so much going on," Pope noted, "and you are always competing with other people's events. You have to put out so much energy just to get people to come and see your work. When we came to Jersey City, we saw there wasn't much going on—in fact, it was pretty boring. People wanted something to do, and they were willing to help make your idea happen."

As one neighborhood or city after another is rediscovered by artists, it is rarely the inherent qualities of the particular places that draw artists in. Rather, it is the fact that they are relatively inexpensive, and artists have adapted to them. The large-scale work that has characterized much postwar American art itself may be attributed to the vast industrial spaces in which artists created their pieces. Whereas artists of the nineteenth and early twentieth centuries were associated with garrets, artists of the past half-century are thought of in terms of lofts, and many more recently built museums of contemporary art have a pointedly industrial look to them. Artists migrate to grittier neighborhoods where they can afford to live and work, and a critical mass develops, turning the area into an artist community. A rundown area like Jersey City gained new life through the pressure of real estate prices in New York, led by artists, but then the people who buy art replace those who create it.

Pope and Botwin, who moved to Jersey City in order to be early residents in the artist live-work district there, found that in the time they spent waiting for the first artists' buildings to be renovated and brought up to code, their rents had begun to skyrocket. Again, they needed to move, this time to Montclair, where, Pope said, "we finally have gotten the New York apartment we always wanted. It's just thirteen miles away from New York."

THE TRANSPORTATION SYSTEM

New York City is an ideal place for walkers. Unlike Boston and San Francisco, Manhattan is relatively flat until one gets to the more hilly Washington Heights,

and there is always a lot for pedestrians to see, which will be wholly missed in the subways and partially if on a bus or in a taxicab. In the early nineteenth century, city planners developed a grid system for the streets, starting at 14th Street and reaching Washington Heights. (Below 14th Street and north of Harlem, the streets are named rather than numbered and tend to meander—in the West Village, 4th and 11th Streets intersect.)

Street blocks go east-west, and avenues are north-south: They are First Avenue, Second Avenue, Third Avenue, Lexington Avenue, Park Avenue, Madison Avenue, Fifth Avenue, Avenue of the Americas (or Sixth Avenue), Seventh Avenue, Eighth Avenue, Ninth Avenue, Tenth Avenue, Eleventh Avenue, and Twelfth Avenue. On the Upper West Side, Eighth Avenue becomes Central Park West, Ninth Avenue turns into Columbus Avenue, Tenth Avenue becomes Amsterdam Avenue, and Eleventh Avenue becomes West End Avenue. On the Upper East Side, York Avenue is east of First Avenue.

In the East Village, the four north-south blocks east of First Avenue are Avenues A, B, C, and D. There are two diagonal streets running through Manhattan: the Bowery, which begins at Canal Street and goes to Astor Place, and Broadway, which runs from the Battery to the northwest tip of Manhattan and beyond. Where Broadway intersects with a major avenue, there is a public square: Union Square at 14th Street (Broadway and Park Avenue), Madison Square at 23rd Street (Broadway, Fifth, and Madison Avenues); Herald Square at 34th Street (Broadway and Sixth Avenue), Times Square at 42nd Street (Broadway and Seventh Avenue), Columbus Circle at 59th Street (Broadway and Eighth Avenue), Lincoln Square at 66th Street (Broadway and Columbus Avenue), and Verdi Square at 72nd Street (Broadway and Amsterdam Avenue).

For all its hassles, New York has a number of benefits surpassing any other city in the world. Among the most prominent is its public transportation systems in and out of the city.

BUS ROUTES. Local buses operate within a borough, while express buses (private bus companies franchised by the New York City Department of Transportation) connect boroughs. Command Bus Company [(718) 277–8100] provides service between Brooklyn and Manhattan; Green Bus Lines [(718) 995–4700] operates between southeastern Queens and Manhattan, making a few stops in Brooklyn; Jamaica Buses [(718) 526–0800] travels between Jamaica, Queens, and Manhattan; Liberty Lines Express [(718) 652–8400 or (914) 969–6900] operates between sections of the Bronx and Manhattan; New York Bus Service [(718) 994–5500] also provides transportation from areas in

the Bronx to Manhattan; Queens Surface Corporation [(718) 445–3100)] travels between northern Queens and Manhattan; and Triboro Coach Corporation [(718) 335–1000] operates between Queens and Manhattan. For a complete schedule of New York City buses: *www.mta.nyc.ny.us/nyct/maps/index.html*. Metropolitan Transit Authority bus service is also available between Long Island and Manhattan [(516) 766–6722]. Private bus lines also run between Manhattan and Dutchess, Putnam, Rockland, and Westchester counties, as well as between Manhattan and various cities in Connecticut (for information on them, go to *www.mta.nyc.ny.us/mta/phone.htm*).

FOR THE HANDICAPPED. The entire fleet of the city's buses has kneeling features, wheelchair securement devices, and seats reserved for people with disabilities. Personal care attendants accompanying disabled customers ride for free. For disabled people unable to use buses or subways, the city has Access-A-Ride, which runs twenty-four hours a day, seven days a week, and costs $1.50 per trip (call for eligibility, application, and reservations). Access-A-Ride can be contacted at (212) 374–5634 or (877) 337–2017.

SUBWAYS. There are more than 450 subway stations within the five boroughs, and rides cost $1.50 regardless of how far or how long one travels or how many times one transfers trains. To ride the subway, one may purchase a token—a coin the size of a nickel—to insert into a slot or a plastic MetroCard, which is swiped through a reader at the turnstile. Tokens and MetroCards may be purchased at most subway stations (a large red light outside the entrance to the station indicates that there is no token booth), as well as hundreds of hotels, newsstands, stores, and vending machines throughout the five boroughs.

Additionally, it is possible to get a discount on subway and bus fares by purchasing daily, weekly, or monthly MetroCards, which can be used on buses as well as on subways. One may find a complete list of places to buy MetroCards online (*www.mta.nyc.ny.us/metrocard/zipmaps.htm*) or by telephone [(800) METROCARD or (212) METROCARD], and they also may be purchased online (*www.mta.nyc.ny.us/metrocard/index.html*).

Subways operate twenty-four hours a day, although they run less frequently after 11:00 P.M. As a matter of safety, especially at night, riders should take the subway car in the middle of the train, where the conductor can be found. Very late at night, one should also consider taking a taxi or bus.

In the early years of the twentieth century, New York had three competing subway companies providing service throughout the city; one can

still identify the lingering effects of that competition in the crazy-quilt patterns of the IRT, IND, and BMT lines. Nowadays, there are nineteen different routes, all operated by the New York Metropolitan Transit Authority, carrying 3.5 million people every day. General information on New York's subways may be obtained by calling (800) 734–6772 or online at: *www.straphangers.org* or *www.mta.nyc.ny.us/nyct/service*.

One can get to the same general area by a number of different subway lines. For instance, SoHo is served by the A, C, and E trains (all stopping at Spring Street and Avenue of the Americas), the B, D, F, Q, 4, and 6 lines (stopping at Broadway-Lafayette and Houston Streets), the 1 and 9 trains (Houston and Varick Streets), and the N and R lines (Prince Street and Broadway). The Studio Museum of Harlem may be reached with the A, B, C, and D trains (all stopping at 125th Street and St. Nicholas Avenue) or the 2 and 3 trains (125th and Lenox Avenue), while one may go to the Art Students League via the A, B, C, D, N, 1, and 9 trains (stopping at 59th Street and Columbus Circle), the E train (53rd Street and Seventh Avenue), or the R train (57th Street and Seventh Avenue).

These destinations are not that far from any one subway station. In some cases, there may be a need to transfer trains, which still is part of the subway fare (one only has to pay again after going out of a turnstile), or to take two forms of transportation. Chelsea is served by the C and E lines, which stop at 23rd Street and Eighth Avenue, but that can still leave you a long way to go— the distance between avenues in New York City is far greater than between numbered streets; one may opt to take a subway to 23rd Street (or thereabouts) and take a crosstown bus west over to Chelsea.

Among the routes available to other landmarks and neighborhoods are:

BRONX

Bronx Museum of the Arts, 1040 Grand Concourse; (718) 681–6000: B, C, D, and 1 train, stopping at 167th Street and Grand Concourse.

Bronx River Art Center and Gallery, 1087 East Tremont Avenue; (718) 589–6379: 5 train, stopping at East Tremont Avenue and Boston Road.

Longwood Arts Gallery at P.S. 39, 965 Longwood Avenue; (718) 842–5659: 2 and 5 trains, stopping at Prospect and Westchester Avenues.

BROOKLYN

Brooklyn Academy of Music, 30 Lafayette Avenue; (718) 636–4100: 2, 3, 4, 5, D, and Q lines to Atlantic Avenue; B, M, N, and R trains to Pacific Street; or G train to Fulton Street.

Brooklyn Museum of Art, 200 Eastern Parkway; (718) 638–5000: 2 or 3 lines to Eastern Parkway.

Center for Art and Culture of Bedford Stuyvesant, 368 Fulton Street; (718) 636–6948: A, C, and 2 trains to Nostrand Avenue and Fulton Street.

DUMBO Arts Center, 100 Water Street; (718) 694–0831: F train to York Street or A and C lines to High Street/Brooklyn Bridge.

Gowanus Arts Exchange, 421 Fifth Avenue; (718) 832–0018: N or R trains to Union Street and Fourth Avenue.

Rotunda Gallery in Brooklyn Heights, 33 Clinton Street; (718) 875–4047: A and C trains to High Street and Cadman Plaza East, or 2, 3, 4, 5, M, N, and R trains to Court Street Station.

Waterfront Museum in Red Hook, 290 Conover Street; (718) 624–3685: A, C, F, 2, 3, 4, and 5 to Jay Street and Borough Hall; or M, N, and R trains to Court Street Station, then take B-61 bus to the last Van Brunt Street stop.

Williamsburg Art & Historical Center, 135 Broadway; (718) 486–7372: L train to North Seventh Street and Bedford Avenue; or J, M, and Z lines to Broadway and Marcy Avenue.

MANHATTAN

Asian American Arts Center, 26 Bowery; (212) 233–2154: Q line to Grand and Chrystie Streets.

El Museo del Barrio, 1230 Fifth Avenue; (212) 831–7272: 4 train to 103rd Street and Lexington Avenue.

Guggenheim Museum, 1071 Fifth Avenue; (212) 423–3500: 4 to 86th Street and Lexington Avenue.

Museum of Modern Art, 11 West 53rd Street; (212) 708–9400: E train to 53rd Street and Fifth Avenue; B, D, F, and Q lines to 47–50th Streets and Avenue of the Americas; N and R trains to 49th Street and Seventh Avenue; and 4 and 6 trains to 51st Street and Lexington Avenue.

Society of Illustrators, 128 East 63rd Street; (212) 838–2560: 6, N, and R trains to 59th Street and Lexington Avenue.

Tribeca Performing Arts Center, 199 Chambers Street; (212) 346–8510: 1, 2, 3, 9, A, C, and E trains to Chambers Street.

Whitney Museum of American Art, 945 Madison Avenue; (212) 570–3676: No. 4 train to 77th Street and Lexington Avenue.

QUEENS

Jamaica Arts Center, 161–04 Jamaica Avenue; (718) 658–7400: E train to Jamaica Center.

Langston Hughes Community Library and Cultural Center, 102–09 Northern Boulevard; (718) 651–1100: 7 to 103rd Street and Roosevelt Avenue.

P.S. 1, 22–25 Jackson Avenue at 46th Avenue; (718) 784–2084: G and 7 trains to Court Street and 45th Road; or E train to 23rd Street and Ely Avenue.

Queens Museum, Flushing Meadow/Corona Park; (718) 592–9700: 7 to Willets Point-Shea Stadium.

BY TAXI CAB. A more expensive, sometimes hair-raising form of transport, cabs are all over Manhattan and on the busier avenues of the four other boroughs. When it rains and during rush hour, one may have to wait a little longer for an available cab. An on- or off-duty light on the roof of the taxi will indicate whether or not a particular cab is taking passengers. By law, cabdrivers are required to take passengers anywhere within the five boroughs, but they sometimes don't if they don't like the neighborhood or don't expect to get a return fare. Fares start at $3 and go up 30 cents every one-fifth of a mile; after 8:00 P.M., there is also a 50 cent night surcharge.

GETTING IN AND OUT OF NEW YORK

As crowded as New York is on its own, many more people pile into the city every work day by various means.

BY AIR. Three major airports serve the New York Metropolitan area: J.F.K. International Airport [general information: (718) 244–4444] and Fiorella La Guardia Airport [(718) 533–3400] are located in Queens, and Newark International Airport [(201) 961–6000] is in New Jersey. Bus service exists

between Port Authority Bus Terminal, Pennsylvania Station, and Grand Central Station and all three airports: New York Airport Services [(718) 875–8200 or (718) 706–9658] takes passengers to Kennedy ($13) and La Guardia ($10), while Olympia Trails [(212) 964–6233] goes to Newark ($11).

J.F.K. International Airport: (718) 244–4444 for general information

Fiorella La Guardia Airport: (718) 533–3400

Newark International Airport: (201) 961–6000

New York Airport Services: (718) 875–8200 or (718) 706–9658

Olympia Trails: (212) 964–6233

BY RAIL. Amtrak [(800) USA–RAIL] and The Long Island Railroad [(718) 217–5477, (516) 822–5477, or (631) 231–5477; *www.mta.nyc.ny.us/lirr/index.html*] both operate out of Pennsylvania Station. The Long Island Railroad runs between Manhattan and eastern Long Island, with service to Brooklyn, Queens, Nassau, and Suffolk counties. Metro-North Railroad [(212) 532–4900 or (800) METRO–INFO; *www.mta.nyc.ny.us/mta/index.html*) serves the Bronx and five New York counties north of the city (Dutchess, Orange, Putnam, Rockland, and Westchester), as well as Bergen and Passaic counties in New Jersey, and Fairfield and New Haven counties in Connecticut. New Jersey Transit [(800) 772–2222; *www.njtransit.state.nj.us/railsys.htm*) offers service between Atlantic City and Philadelphia on the southern line and from Bergen and Mercer counties to Pennsylvania Station on the northern route. PATH trains [(800) 234–7284; *www.panynj.gov/path/pathmain.htm*] operate between Hoboken or Newark on the New Jersey side of the Hudson River and the World Trade Center or 33rd Street on the Manhattan side. The Staten Island Railway [(718) 966–7478; *www.mta.nyc.ny.us/nyct/maps/simaps.htm*] runs between the St. George and Tottenville stations on Staten Island.

BY WATER. Ferry service is available between Manhattan and Staten Island [Staten Island Ferry, (718) 815–BOAT; *www.ci.nyc.ny.us/html/dot/home.html*] and between New Jersey and New York, including Brooklyn and Queens: New York Waterway [(800) 53–FERRY], Seastreak [(800) 262–7433], New York Fast Ferry [(800) 693–6933] and Ft. Lauderdale Water Taxi [(201) 985–1164].

BY CAR. New York always looks jam-packed with automobiles, until there is a taxi strike, at which point one discovers that not that many people drive cars after all. Those New Yorkers who do own cars quickly learn about alternate-side-of-the-street parking regulations and the high cost of renting garage space. The City offers information for car owners in the form of a list of gas and service stations (*www.ci.nyc.ny.us/html/dca/pdf/gasstations.pdf*) and lists of private and municipal parking facilities (*www.ci.nyc.ny.us/html/dca/parkguide.html* and *www.ci.nyc.ny.us/html/get_around/park/parkframe.html*). One may also call the New York City Planning Commission at (212) 225–5368 or (718) 225–5368 for detailed maps of Manhattan's parking garages.

NEW YORK'S CULTURAL OFFERINGS

New York City, one is often told, is the "culture capital of the world." Besides the four hundred or so art galleries in the five boroughs, there are scores of museums, most of which are in Manhattan. But, if asked to name some of them, most people think of the Metropolitan, the Museum of Modern Art, the Guggenheim, the Whitney, and uh, uh. . . . It's easy to get stuck. We only hear about museums, which are otherwise quiet, contemplative places, when they have a big exhibit or spend some enormous amount of money to buy a picture. Money talks, and it generally buys our attention.

There are, in fact, more than eighty museums within the five boroughs, most of which tend to be more intimate in size and have more specialized collections and exhibitions than the largest institutions that receive the lion's share of the media's attention. A complete and free listing of the museums in Manhattan, entitled *Cultural Manhattan,* is available from the New York City Department of Cultural Affairs at 330 West 42nd Street, New York, NY 10036; (212) 643–7770.

Unlike the city's museums, the count of New York's commercial art galleries and nonprofit art spaces is an ever-changing one, as galleries go in and out of business at a fast clip. Information needs to be updated regularly. A few publications that do keep track of galleries and other art venues, providing a reasonably complete listing, are:

Free Expressions (available for free from the New York City Department of Cultural Affairs), *Art in America*'s annual *Sourcebook to the U.S. Art World* ($15.00), Brant Publications: 575 Broadway, New York, NY 10012; (212) 941–2800

Art Now Gallery Guide ($10): P.O. Box 888, Vineland, NJ 08360; (201) 322–8333

New York Contemporary Art Galleries ($16.95): Manhattan Arts, 200 East 72nd Street, New York, NY 10021; (212) 472–1660

EMERGENCIES AND EVERYDAY PROBLEMS

Everyone plans for things to go well, but sometimes problems and even catastrophes arise. Perhaps, the only way to prepare for the unexpected is to know how and where to get help:

CRIMINAL CONDUCT

Arson Hotline: (718) 722–3600

Battered Women (seeking help and refuge): (800) 942–6908

Child Abuse: (800) 342–3720

Civilian Complaint Review Board (malfeasance by police): (212) 442–8833

Crime Victims Hotline: (212) 577–7777

Domestic Violence: (800) 942–6908

Lesbian and Gay Anti-Violence Project: (212) 807–6761

Rape Hotline: (212) 267–7273

Runaway Hotline: (212) 966–8000

Sex Crimes Reports: (212) 267–7273

CONSUMER FRAUD

Better Business Bureau: (212) 533–7500

Department of Consumer Affairs: (212) 487–4444

New York State Attorney General: (212) 416–8000

MEDICAL ASSISTANCE

AIDS Hotline: (800) 825–5448

Animal Bites: (212) 676–2483

Dental Emergencies (referrals to twenty-four-hour dental clinics): (212) 677–2510

Physicians on Call (licensed doctor comes to your home for a fee): (718) 238–2100

Poison Control: (212) 340–4494

Suicide Prevention: (212) 673–3000

Suicide Hotline: (718) 389–9608

CITY MAINTENANCE

City Sanitation (for problems with trash pickup): (212) 219–8090

Gas Leaks: (212) 683–8830

Lead Poisoning: (212) 226–5323

Reporting Potholes: (212) 225–5368

Steam and Electrical Problems: (212) 683–0862

GENERAL HELP

Bronx Borough President's Office
851 Grand Concourse
Bronx, NY 10451
(718) 590–6000

Brooklyn Borough President's Office
209 Joralemon Street
Brooklyn, NY 11201
(718) 802–3832

Manhattan Borough President's Office
Municipal Building
New York, NY 10007
(212) 669–8300

Queens Borough President's Office
120–55 Queens Boulevard
Kew Gardens, NY 11424
(718) 286–3000

Staten Island Borough President's Office
10 Richmond Terrace
Staten Island, NY 10301
(718) 816–2000

Chapter 3.
FINDING A HOME

In New York City, the world's art capital, the home of more artists and art galleries than anywhere else, the most prevalent topic of conversation is . . . real estate. How did you find your apartment? How much did you pay for your loft? Do you know any places in Chelsea, Hoboken, Williamsburg, SoHo, Park Slope, Tribeca, Long Island City, DUMBO—you pick? Absentee or negligent landlords, overly picky co-op boards, possible evictions, rent strikes, what is above or below market value, rent increases, illegal occupancy—this is what consumes an artist's spare time in New York.

The high price of living and working space in Manhattan and the surrounding boroughs and cities creates tensions between landlords (who forever believe they deserve higher rents) and tenants (who believe they deserve more for the high rents they currently pay) and even makes friends wary of each other. "If you're looking for a place and find one, and you mention it to someone you know," said John Kramer, a painter in Brooklyn, "that person might try to steal it from under you." Every year, these tensions are expressed in a public hearing at One Police Plaza in Manhattan, when the Rent Guidelines Board—composed of nine members (renters, building owners, and others), who are appointed by the mayor—meets to discuss proposed increases for the city's rent-stabilized apartments, as well as to listen to those wishing to voice their own concerns.

HOW TO FIND AN APARTMENT

There are many ways in which artists and others find places to live and places to work in New York. Claudia Cron went door-to-door in Chelsea, "asking every doorman, every elevator operator, every rental office, asking everyone who came out of a building if there were any available studios. I was a pest." Eventually,

that paid off when one tenant was looking to sublet her space. While Cron was working there, the building owner opened up some upper floors for studios, and Cron rented a space there (where she also sleeps on a futon and cooks on a hot plate).

Sometimes, artists hear about available spaces through friends or see a notice on a bulletin board in a cafe, art supply store, community center, supermarket, or laundromat. A woman who runs a cooperative studio space in Brooklyn tacked up a few notices in the neighborhood, one of which was quickly snatched up by painter and freelance designer L.J. Lindhurst. "I had had my eye on that place for a while," she said, "so I'm glad I saw the notice so quickly."

The city's colleges and universities also have housing offices, where listings for available apartments and apartment shares may be perused. (Technically, these listings are for current students and alumni, but it is rare that anyone asks for someone's student I.D.) Current students and alumni of the School of the Art Institute of Chicago are permitted by a reciprocity agreement to use the employment and housing offices of Cooper Union, Fashion Institute of Technology, Parsons School of Design, Pratt Institute, and the School of Visual Arts. Other artists have found apartments and studios through classified advertisements in newspapers. The *Village Voice* and the *New York Times* have the largest number of listings, and one may also look in community newspapers available within the city (the *Westside Spirit* and *Our Town* in Manhattan; the *King's Courier* and the *Phoenix* in Brooklyn; the "Queens" section of *Newsday; Irish Echo* and *Riverdale Press* in the Bronx; and the *Staten Island Review,* as well as the *Jersey Journal* in Jersey City and the *Record* in Bergen County, New Jersey).

Many artists, John Kramer among them, located places to live and work in the *Village Voice* (the classifieds in the *Voice,* by the way, are listed online before the print edition appears), and yet others go through realtors or even the World Wide Web. There are many available Web sites for apartment-seekers, although being listed online does not make these spaces less expensive, and there is also the question of how frequently information is updated. Among the sources on the Internet are: Apartments.com, AtNewYork.com, citydigs.com, CitySublets, HousingNYC.com, LoftsOnline, Move.com, Newyorkcityhousing.com, NYHabitat.com, Realtor.com, Rent.net, RentHelpers.com, RoommateAccess.com, Roommateclick.com, RoommateFinders.com, RoommateLocator.com, and Roommates.com. A good source of information about one's rights as a tenant in New York City is

http://tenant.com. The Riley Guide (*www.dbm.com/jobguide/relocate.html*) offers useful online links to realty services and moving companies, as well as others that provide information about the average salaries, demographic makeup, and health care facilities for almost four hundred cities in the United States.

While artists live in apartments, co-ops, condos, homes, and lofts throughout the five boroughs, there are two districts of Manhattan officially designated for them, SoHo and NoHo, where those who are certified by the Artist Certification Committee (composed of artists, art educators, and arts administrators) of the New York City Department of Cultural Affairs [330 West 42nd Street, New York, NY 10036; (212) 643–7770] may live in commercial buildings officially designated as permitting artists-in-residence (or A.I.R.). There are 832 manufacturing buildings that have been fully or in part converted to residential use strictly for artists in SoHo and NoHo under the New York City Loft Law and administered by the New York City Loft Board [49–51 Chambers Street, Room 1006, New York, NY 10007; (212) 788–7610]. To be eligible to live in these buildings, one must be certified prior to occupancy, and the certification process involves submitting an application (there is no fee) that demonstrates the applicant is engaged in the fine arts, is currently working in a fine art medium, and needs a large loft space in which to create work. The applicant must be a "professional" artist, which refers to the nature of the commitment to art rather than the amount of money earned from the art. The Department of Cultural Affairs also maintains a small list of housing and studio spaces available exclusively to certified artists.

Of all ways of locating an apartment, realtors are probably the most expensive because, in addition to the one month's rent and one month's security that landlords usually require a tenant to pay at signing a lease, real estate agents charge renters a percentage of the first year's rent as a fee, ranging from 10 to 15 percent. A $1,000 per month apartment would thereby require a tenant to pay out $3,200 at the outset ($1,000 + $1,000 + $1,200) if the realtor only charges 10 percent. For an apartment with a rent of $2,000 and a realty fee of 15 percent, the initial outlay jumps to $7,600.

Prospective tenants usually find realtors through the apartment, co-op, condo, or home advertisements placed in the *New York Times* or other publications, although realtors are also listed in the yellow pages or through associations to which they belong. The Downtown Brokers Association (*www.dbanyc.com*), for instance, consists of sixty-eight realtors that handle rental and purchasable properties in Manhattan from 42nd Street on down. Other rel-

evant associations are the Brooklyn Board of Realtors [7403 Fifth Avenue, Brooklyn, NY 11204; (718) 238–0202, *www.brooklynrealtor.com*], Long Island Board of Realtors (includes Queens, 300 Sunrise Highway, West Babylon, NY 11704; *www.mlslirealtor.com*), and New Jersey Association of Realtors [295 Pierson Avenue, Edison, NJ 08818; (732) 494–5616; *http://njar.com*]. A reason for selecting a realtor through the classified advertisements in newspapers is that the listings indicate where, geographically, the real estate company specializes: A realtor with ads for co-op apartments around Central Park is unlikely to have lofts in Tribeca or Chelsea.

A regularly heard complaint against realtors is that they practice "bait-and-switch," holding out one property to lure in apartment hunters but actually showing others. "I'd seen ads for places that looked perfect, that were affordable," said Audrey Frank Anastasi, a painter in Brooklyn, "and when I called the realtors, they always said, 'Well, that's gone, but how about this . . . ?' and what they had was always more expensive and not as nice."

BEFORE YOU SIGN THE LEASE

Because of the high demand for available space, landlords are able to be very picky, which sometimes works against artists, according to Carol Quatrone, a realtor in lower Manhattan. Some landlords do not trust artists to be responsible in terms of paying rent on time or properly taking care of the space. There may be concerns about the use of toxic materials or, if the space is strictly for commercial use, that the artist may end up living there. "To many landlords, someone who leaves for work at 7:00 A.M. and comes back at midnight sounds better than an artist who will be in the apartment all day and actually use the space," she said. Quatrone advised apartment hunters to be "flexible in terms of location. The places everyone would love to be are where demand drives the prices up." She recommended that newcomers to New York who don't have a lot of money to devote to rent or buying an apartment look in New Jersey or Queens.

Because landlords are in a position to be choosy, prospective tenants should come prepared with the information that landlords will want, such as a completed rental application (if applicable), written references from previous landlords (especially useful if one hasn't rented in New York before) and employers, perhaps a credit report, and proof of current employment. Renters should know whether they will have a lease (a long-term contract with the landlord) or a rental agreement (generally, a month-to-month tenancy) and read all

of the conditions on the lease; there may be some provisions that are unacceptable, such as no pets, guests, or working at home. Everything between a landlord and tenant should be in writing, even if following up on a verbal agreement, in order to avoid later disputes and misunderstandings. How the security deposit will be refunded, and what deductions might be made from it, should be stated clearly in the lease.

Prospective tenants need to check that the door locks turn easily and, as a matter of safety, have been re-keyed or replaced since the last tenant. They should check under the kitchen sink and in the bathroom for leaks, inspect the pipes for rust and the tiles in the bathroom to make sure they are all securely in place and in good shape. Any cracks, dents, marks, or scratches in the doors or walls should be documented (preferably with photographs) before moving in, with this documentation signed and dated by the landlord. The ceilings should be examined for any signs of water damage, and any carpeting should be fastened securely (if there are stains, they also need to be documented). An apartment should have one or more smoke detectors working properly. Tenants are responsible for keeping the premises clean and paying for any damage caused by abuse or neglect. They also should not make any major alterations without receiving the landlord's permission and report immediately any defective or dangerous conditions in the property.

TENANT RIGHTS

Approximately one million apartments in the five boroughs of New York City are covered by the regularly-updated and renegotiated rent stabilization law, which determines rental increases. For currently occupied apartments (October 1, 2000 to September 30, 2001), the allowable increase is 4 percent for a one-year lease and 6 percent for two-year leases. For apartments that are currently vacant, an increase of 18 percent over what the previous tenant paid for a one-year lease, 20 percent for a two-year lease, plus one-fortieth of the cost of any improvements to the apartment by the building owner is allowed. Rents over $2,000 per month are not covered by the rent stabilization law for vacant apartments, and apartments of current residents with a household income more than $175,000 in two consecutive years are automatically decontrolled.

Complaints of overcharging are rife. Tenants may obtain a rental history of their apartment going back four years from the New York State Division of Housing and Community Renewal:

BRONX

One Fordham Plaza, 2nd floor
Bronx, NY 10458
(718) 563-5678

BROOKLYN

55 Hanson Place, Room 702
Brooklyn, NY 11217
(718) 722-4778

MANHATTAN

25 Beaver Street, 5th floor
New York, NY 10004
(212) 480-6238
or
163 West 125th Street, 5th floor
New York, NY 10027
(212) 961-8930

QUEENS

Gertz Plaza
92-31 Union Hall Street
Jamaica, NY 11433
(718) 739-6400

STATEN ISLAND

60 Bay Street, 7th floor
Staten Island, NY 10301
(718) 816-0278

It is through these offices that an official complaint may be filed. The tenant must file a complaint within four years from when the overcharge began. The length of time between when a complaint is made and judgment is handed down is between six months and one year on the average (a significant improvement over the early- and mid-1990s). In most cases, overcharged tenants are entitled to treble damages (a refund of three times the disputed amount), with interest dating back to the beginning of the overcharge from the building owner. Lofts—residential units in formerly commercial buildings— are not covered by the rent stabilization law, leaving individual tenants and building owners to work out their own rental agreements.

Not all disputes between landlords and tenants are over the permissible amount of rent to be charged. Nonpayment of rent, landlords who fail to make needed repairs, tenants who violate the lease or allow someone not named on the lease to live in the apartment, illegal occupancy, and other reasons for eviction are common areas of disagreement, which are generally brought to Housing Court, a part of the civil courts of the City of New York. Each borough has one court, located at:

BRONX

1118 Grand Concourse
Bronx, NY 10451
(718) 466–3021

BROOKLYN

141 Livingston Street
Brooklyn, NY 11201
(718) 643–3665

MANHATTAN

111 Centre Street
New York, NY 10007
(212) 374–8357

Harlem Community Court
170 East 121st Street
New York, NY 10025

QUEENS

89–17 Sutphin Boulevard
Jamaica, NY 11435
(718) 262–7100

STATEN ISLAND

927 Castleton Avenue
Staten Island, NY 10310
(718) 791–6000

In a typical case—for instance, nonpayment of rent—a tenant cannot be sued unless the landlord or someone working for the landlord makes a demand in writing or orally for the overdue rent, threatening eviction. If the tenant does not pay the rent after that demand is made, the landlord files a nonpayment petition with the Housing Court, and the tenant will be notified by postcard of the lawsuit and when to come to court (the address will be listed on the postcard). Within five days of receiving legal papers (either given personally or to someone other than a small child who lives or works at the tenant's home, or sent by certified mail to one's home), the tenant should go to the Landlord-Tenant Clerk's office to answer the petition orally or in writing. Each Housing Court has a resource center, with information on how to answer a petition and what happens in a nonpayment case. Tenants may request a jury trial, although almost all leases include a clause waiving the right to a jury trial, which most renters fail to notice when they sign.

After the petition has been answered, the clerk determines a date for both landlord and tenant to come to court. If the tenant does not answer the petition or come to court on the indicated day, the landlord may receive a final judgment and have a city marshal serve the tenant with a notice of eviction. All is not necessarily lost: Those receiving an eviction notice at this point should go to the Landlord-Tenant Clerk's office to ask for an "Order to Show Cause" if the post-

card or petition was not delivered properly or at all. If a judge signs the Order to Show Cause, this will stop the eviction until the tenant can come to court to explain what happened.

Most landlords in Housing Court are represented by lawyers, which puts tenants without legal representation at a disadvantage. Tenants who can afford a lawyer but do not have one might contact the Legal Referral Service at (212) 626–7373. These attorneys will charge a $25 consultation fee for the first half-hour; additional charges will have to be negotiated between the tenant and lawyer. Those who cannot afford a lawyer should call the Legal Aid Society at (212) 577–3300 or Legal Services at (212) 431–7200) for free legal counsel.

If the judge decides in favor of the landlord, the tenant may still be permitted to stay in the apartment if he or she corrects the problem (pays the overdue rent) within a certain period of time, usually ten days. After that, the judge may order the tenant to move out of the apartment, perhaps providing a few months in which to do so. Landlords cannot take the law into their own hands and physically evict a tenant—only the city marshal is legally empowered to carry out a court order for eviction—nor can they use threats of violence, remove a tenant's belongings, lock the tenant out, or discontinue essential services, such as heat and water. Landlords who do so are subject to civil and criminal penalties.

Although landlords may threaten it, the police cannot arrest anyone for failure to pay rent: The police only can physically remove a tenant for a crime that has been committed, or if a judge has ordered the tenant to leave. Not paying rent and not leaving when a landlord says to do so are not crimes. Not having money, having been robbed, or being pregnant or sick are not legal defenses for failure to pay rent. Tenants are obligated to pay rent for every day they spend in an apartment, even after they have received an eviction notice.

As important as it is to know how to fight an eviction, it is also useful to know when not to. A tenant in the wrong may end up with a large debt, consisting of money owed to the landlord and legal fees, and the possibility of a poor credit rating.

LOOKING FOR LOFTS IN ALL THE WRONG PLACES

One of the open secrets of New York is that many people—and not just artists—live illegally. Sometimes, too many people live in one apartment; at other times,

homeowners illegally rent out their basements or make their two-family homes into three- or four-family dwellings. The interest on the part of artists and others in living in unused commercial lofts, where they can have abundant spaces to live and work, has led to an explosion in illegal loft conversions over the past thirty years, first in Manhattan and increasingly in Brooklyn, Queens, and coastal New Jersey. There is a process by which building owners may apply to the New York City Department of Buildings to receive a residential Certificate of Occupancy, allowing them to legally rent out space to people who not only want to work but also live there; but converting a commercial space for residential use often requires considerable repairs and renovations in order to bring it up to code, and many building owners simply choose to skip the expense and take their chances on being caught: They will rent space to artists at rates somewhat below market value, letting the artists renovate the lofts in their own manner.

Jason Middlebrook, a sculptor, claimed that he spent approximately $20,000 to make his loft in a former factory building on Bedford Avenue in Williamsburg "a livable home" before an inspector from the buildings department padlocked the factory and forced the eviction of all the tenants, claiming the structure was "a firetrap." Paul Wein, a spokesman for the buildings department, noted that evicted tenants are offered alternative housing through the Red Cross or the city housing office, "but we can't allow people to live in buildings that are unsafe, regardless of how long they've lived there under those conditions." While the buildings department is aware of the large number of illegally converted factory buildings within the five boroughs, there is a limited number of inspectors who only know to go to buildings when there is a complaint. The buildings department had received word about hazardous conditions at the Bedford Avenue factory—including amateur electrical and plumbing work, an insufficient number of exits, and too-narrow hallways—from a fire chief who had been there to put out a fire on the floor below Middlebrook's loft. Prior to that, there had been some other minor occurrences that had brought the fire department to the site.

"It was incredibly disruptive, after five years that this had been my home, to be told to stop working, just leave, and don't come back," Middlebrook said. "I didn't want to leave. I had work to do, but they threatened to arrest me." After scrambling for a place to sleep and do work, during which time the building owner made improvements in the factory and received a Certificate of Occupancy, Middlebrook finally returned to the building, as did a number of the

other previous tenants. "The building's safer now, and the rents got doubled," he said. "I think the City fined the landlord a couple of hundred dollars for minor violations."

Living illegally often does mean lower rents, but it raises the anxiety level for artists who lose a sense of permanence. "I've met a lot of artists who have gone through what I did or are afraid they're going to go through what I did," Middlebrook said. "It's very hard to do your best work when you're under so much stress." John Kramer, who lives separately from where he works, noted that "it's smart not to combine both living and working, because it may not be viable in the long-term. Most landlords, if they're willing to break local zoning ordinances, are fairly desperate, and you find that the general repair of their buildings is lower. That leads to complaints, and then the buildings department comes in, and that leads to evictions."

Which loft buildings are legal for residences and which are not cannot easily be identified. The lack of an intercom system or no stove may or may not reveal anything. Factory buildings, even those that have been brought up to code for residential use, still look more like empty factories than apartment complexes. In addition, building owners and rental agents may not speak truthfully about the spaces they are renting. "I personally was looking for an apartment recently, and the realtor told me, 'I have three apartments to show you,'" Paul Wein said. "I told the realtor that I'm the press spokesman for the Department of Buildings of the City of New York, and the realtor then said to me, 'I have two apartments to show you.'"

Wein recommended that prospective tenants call the New York City Department of Buildings [60 Hudson Street, New York, NY 10013; (212) 312–8000] or the New York City Department of Housing and Preservation [100 Gold Street, New York, NY 10013; (212) 863–5000], both of which have information on all the buildings in the five boroughs that are approved for residential use.

THE ARTIST AS LANDLORD

The high cost of real estate in New York City is the cause of lots of grumbling and a source of long-term worry for the future of the arts in New York. Evicted artists and rents in the thousands of dollars can only spell disaster, but this crisis is already decades old, and the arts only flourish more. The death knell for art is regularly sounded, yet artists always seem to find a way to create, show,

and sell their work. Escalating rents have been especially hard on performing arts groups, many of which "operate on a month-to-month lease and are asked to leave when someone new has bought the building," said Amy Schwartz-Brightbill, executive director of Volunteer Lawyers for the Arts. "We've been involved in a number of cases of trying to get new owners to let a dance or theater company stay and not have to pay a lot more." It is considerably more difficult to relocate a performing arts troupe than an individual, she added.

This is a national problem, rather than a purely New York one. A study of arts organizations and institutions in San Francisco by CompassPoint Nonprofit Services, a consulting group to nonprofits, reported that of the organizations surveyed, "13 percent of their site leases cannot be renewed; 42 percent can be renewed, but at much higher, or market rate; 20 percent are unsure if they can renew." An organization based in San Francisco, The Partnership for Affordable Nonprofit Space (*www.OrgSpaces.org*), has created an opportunity for organizations and individual artists around the country to share ideas, pool information, and receive guidance on how to survive the real estate crisis.

High rents, however, also encourage artists to think entrepreneurially, leading many of them to create studio shares—dividing up one large loft into smaller spaces in order to split the rent—or renting large spaces and subletting them to other artists. Both Bill Jensen and Judy Pfaff, who are well-known artists, for instance, rent studio space to artists in Williamsburg. With two rental spaces, Jensen charges $1,400 per month for a 1,200-square-foot studio on Metropolitan Avenue—"I try to stay a little below the current market value." Jason Middlebrook rents a 7,300-square-foot space, for which he pays $1 per square foot, and has divided it into eight units, which he rents to seven artists (the eighth unit is his own live-work space) for $1.75 per square foot. Both Danny Simmons, a Brooklyn painter, and Scott Whittle, a Brooklyn photographer, credit their respective decisions to buy their own buildings and rent out spaces in them as the reason for their ability to remain artists. Whittle said that "the only way to get a space you can work and live in is to buy a place and rent it out. If you only buy a loft for yourself, it's very hard to afford." His building at Whitehall Place, which he bought for $300,000, costs him $1,900 per month in mortgage payments, but he earns $2,300 per month in rent from two tenants. Simmons also claimed that "the only way I could afford to live in a loft is by having someone else pay for it." The mortgage payments at his Grand Avenue building amount to $24,000 per year, but the yearly income from rentals is $38,000.

Co-op studio spaces or the more informal studio shares—both involving artists dividing up a work space and paying equal amounts in rent—have become popular ways to find affordable place in which to create art. John Kramer has split a 1,400-square-foot studio in a loft building on Water Street in the DUMBO section of Brooklyn with two other artists (the studio is sectioned off so that each person has a 450-square-foot work space), but, when the rent was increased 45 percent to $2,600 per month, he and the others decided to bring in a fourth person. "I hope it's someone who works only at night," he said. That type of arrangement has worked for Alex Stolyarov and Rob Davis, two painters who share the rent on a small (11-foot by 12-foot) studio in SoHo. Both artists work at the Metropolitan Museum of Art (Stolyarov is a guard in the galleries, Davis an art handler) but at different hours of the day. Working from 8:00 A.M. to 4:00 P.M., Davis noted that his job doesn't tax his mind or exhaust him physically or emotionally: "My mental space is free and clear at the end of the day, and, in fact, my head really gets going later in the day," which is when he goes to the studio. Stolyarov, on the other hand, works as a guard from 4:30 P.M. until midnight, "which lets me paint during the day—that's when I do my best work."

Stolyarov and Davis met and became friends before they chose to share a studio space, but many other artists find studio shares through word-of-mouth referrals or by seeing a flyer in the neighborhood or an advertisement in the *Village Voice* or other publication. "I prefer to get people from referrals by friends," Middlebrook said. "You put an ad in the *Village Voice,* and you'll get hundreds of people calling you at all hours of the day and night." He interviews prospective tenants, asking what they do for a living, what other money they may have, how long they have been married (if married), but mostly he chooses tenants "intuitively, what I instinctively feel about the person."

John Kramer was the tenth person to answer an ad in the *Village Voice* for a studio share in DUMBO—one doesn't have to be the first to respond to an ad in order to get something—and the process of being selected involved a visit by the leaseholder to the studio Kramer was leaving, three visits to the advertised studio by Kramer, and a lot of questions and answers before any money changed hands: What kind of work does he create? What kind of space requirements does he have? What is his job, and how long has he been there? What kind of music does he listen to? Is he taking any psychotropic medications? How often does he plan to come to the studio? How does he get along with people generally, and how has he dealt with people whom he dislikes in the past?

"The most essential elements are compatibility, having common tastes and being respectful of one another—which is a difficult dynamic to get right—and financial stability," Kramer said. "When you're asking someone to pay $500 a month for a studio, in addition to whatever they're paying in rent for a place to live, you have to have a reliable form of income. If you can't pay your share, there's a long line of people out there ready to replace you, no problem."

One of the reasons that artists' tenure in artists' neighborhoods is rarely permanent is that the expense of maintaining perhaps two spaces, or even one large place to live and work, is difficult for artists who are neither independently wealthy nor lucratively employed. Full-time guards and art handlers at the Metropolitan Museum of Art start at $24,000 per year, advancing to $30,000 after three years. Rob Davis noted that "guards and technicians do a lot of overtime," which helps them pay their rent but takes time away from the art they hoped their jobs would support. Scott Mischione, an architect and occasional gallery artist, who with his painter wife bought and converted four factory buildings in Brooklyn for residential conversion (charging $1.25 per square foot in rent) and another building for strictly studio space ($1 per square foot), said that "half of our tenants are lawyers, businessmen, and doctors—they think it's chic to live in an artists' building. We had originally planned to just rent to artists, but we were naive. Artists just can't afford to rent here."

STUDIO SPACE FOR ARTISTS

Many terms in the art world can be misleading: A studio apartment, for instance, does not refer to a large space in which an artist can live and work; just the opposite, it indicates cramped quarters in which kitchen and bedroom are all in one small room. The term artist-in-residence also does not mean that an artist actually resides in that place, but only works there. At colleges and universities, an artist-in-residence is a term that is synonymous with lower-paid adjunct faculty, and many adjuncts are not given a studio space in which to work, as full-time studio art faculty receive. At other times, an artist-in-residence receives a stipend, or the term may refer to the relationship of an artist to an artist community (where most artists have to pay to attend).

A number of arts organizations, recognizing the difficulty that artists have in finding affordable studio space, have made short- and long-term studios available in New York, sometimes for free (or with a stipend) and other times for low rents.

Two significant programs that help artists obtain real space in this are the Marie Walsh Sharpe Art Foundation [711 North Tijon Street, Colorado Springs, CO 80903; (719) 635–3220] and The Elizabeth Foundation for the Arts [451 Greenwich Street, New York, NY 10013–1757; (212) 431–0381]. Both offer studio space to fourteen artists for a period of twelve months in lower Manhattan. Although the two programs are separate, with their own applications and criteria for selection, their respective studios are located in adjoining buildings, and both programs are administered by the same person, Dennis Elliott.

The Marie Walsh Sharpe Art Foundation is primarily open to artists in the United States, while the Elizabeth Foundation's program has a greater emphasis on artists outside the United States. The Marie Walsh Sharpe Art Foundation offers studios to artists without cost, while those sponsored by the Elizabeth Foundation rent for between $13,000 and $16,000 annually. In some cases, the Elizabeth Foundation awards a grant to cover the cost of the studio, but most artists in its International Studio Program find corporate (for U.S. artists) or governmental (for foreign artists) sponsors to pick up the tab.

Both the Marie Walsh Sharpe Art Foundation and the Elizabeth Foundation's International Studio Program serve to place artists in New York City, making what they can of the opportunity. The underlying assumption of these respective programs is that, while art may be created anywhere, the art world of critics, art dealers, museums, and nonprofit exhibition spaces only exists in a relative handful of places, particularly New York.

"Artists feel a need for a studio in which they can work, or they need the location of our studios in order to show their work to other people," said Joyce Robinson, executive director of the Marie Walsh Sharpe Art Foundation, whose studio program began in 1991. In a recent year, 770 artists from thirty-six states as well as from abroad applied for the fourteen studios available, submitting their work to a blind jurying process whose jurors are all artists. The largest number of those applicants were residents of New York City (292) and elsewhere in New York State (63), reflecting the difficulty that even long-time Manhattan residents have in finding a studio they can afford (those artists who already have a studio of 440 square feet or larger are ineligible).

Studio space programs may not be for everyone, as out-of-towners still need to find a place to live and, quite possibly, a job to pay for one's rent and food. "I know that Dennis [Elliott] keeps his ear out for inexpensive sublets for artists," Robinson said. "The biggest problem is finding work in New York. Artists want to earn enough to pay for room and board, but they don't want a job that takes up so much time and energy that there is nothing left for making art."

While similar, the Elizabeth Foundation's intention is more focused on actively helping artists to develop their careers and visibility. "The premise of the International Studio Program is to help artists get shows and representation in New York," Elliott said. "I work with the artists to create a list of the critics, art dealers, officials from foundations, museum curators, and museum directors whom they would like to come see their work. At least twice a month, a prominent curator, writer, gallery owner, or even another artist meets privately with each artist for a forty-five-minute studio visit."

Although the International Studio Program was only created in 1994, it has already earned the respect of many of those critics, curators, dealers, and directors who respond to the artists' invitations. Among those who have made these visits are critics from the *Village Voice* and *Art in America,* curators from the Guggenheim Museum, Museum of Modern Art, Whitney Museum of American Art, and the New Museum of Contemporary Art, as well as major art dealers, independent curators and writers, and the directors of nonprofit art spaces, such as Dia Center for the Arts, Artists Space, and New York Kunsthalle.

In the who-you-know world of the arts, scheduled opportunities to display one's work to people of influence in a spacious studio is an ideal situation. "I've been actively seeking gallery representation in New York," said Clytie Alexander, a Santa Fe, New Mexico, painter whose corporate sponsor is an oil and gas company in Santa Fe. She noted that "there is a series of paintings I've been working on since 1991, which I wanted to show in New York," and her studio serves both as a place in which to complete that series and as a showroom for dealers, critics, and museum curators.

Similarly, painter Marjorie Welish saw the studio program as an opportunity to meet in "a dignified showroom" critics and dealers "who would have disdained coming to my very shabby studio in my apartment" in New York City's West Village. "The fact that the Elizabeth Foundation saw fit to support me puts a favorable imprimatur on my work."

The positive results of these studio visits are both tangible (an upcoming exhibition) and long-term for Welish. "I received a wide range of responses to my work; I may never again get such an encyclopedic group of interpretations of a given body of work," she said. "Some of it was helpful in terms of my artmaking, helping me follow through on certain ideas. Some of it was helpful in understanding how critics look at art."

Everyone in the Elizabeth Foundation's program is looking to break through to a higher level of success and gain exposure in New York City (with

both aims merging into one) through developing relationships with powerful art world figures. Those contacts are what is left after one's year in the program is over, helping an artist find more opportunities to show and sell work, either through those particular critics, curators, and dealers or by word-of-mouth to yet others. Sculptor Helen Ramsaran, who "found it hard to get people to come to my studio in Brooklyn," said that the main benefit of the program was getting her name passed from one person to another. Dealers and curators, for instance, began to suggest showing her work to others they knew. Tom Eccles, deputy director of the Public Art Fund, who was one of the people on her studio visit list, recommended Ramsaran's work to the Battery Park Redevelopment Authority in lower Manhattan, which provided a $7,500 grant to help pay for casting. Eccles "also got me to start thinking about temporary art," she said. "I might place a work somewhere for just a year, which may be an easier way to present a controversial piece. Up until then, I had only thought about permanent work. He also got me thinking about doing other works than in bronze—concrete and metal, or concrete and wood, for instance—and doing smaller casts."

Here is a list of other arts agencies, schools, and cultural centers with studio or live-work space programs. Note that five programs included at the very end of the New York listings are actually located quite far from the five boroughs, although they are within the state. They are included because they offer unique programming not available elsewhere.

CONNECTICUT

Arbor Street Studios
56 Arbor Street
Hartford, CT 06106–1201
(860) 222-4357

Artspace Hartford
555 Asylum Avenue
Hartford, CT 06105–3842
(860) 548–9975/9981

Live-work space with 48 units. Rents are based on household income: A family of two with a combined income of $25,000 would pay between $500 and $800 per month. Heat is included in the rent. Those with lower incomes pay less.

Artspace Norwich
Willow & Franklin Streets
Norwich, CT 06360
(860) 548–9981/9975

Live-work space with 58 units. Rents are based on household income: A family of two with a combined income of $25,000 would pay between $500 and $800 per month. Heat is included in the rent. Those with lower incomes pay less.

Artspace Connecticut
942 Main Street, Suite 300
Hartford, CT 06103
(860) 808–3000

Looking to develop other live-work sites in New Britain, New London, and Willimantic.

Connecticut Graphic Arts Center
299 West Avenue
Norwalk, CT 06850
(203) 899-7999
Studio rentals.

Griffis Art Center
605 Pequot Avenue
New London, CT 06320
(203) 439-0039
(203) 443-3431
Nine-month residency includes use of studio, furnished room, and three daily meals; participants donate an artwork completed during their residency to the center.

Old Library Art Center
7 Post Road East
Westport, CT 06889
(203) 226-9620
Studio space rentals.

Real Art Ways
Media Residency Program
56 Arbor Street
Hartford, CT 16106
(860) 232-1006
Residencies for media artists.

Weir Farm Heritage Trust
Department A.A.
735 Nod Hill Road
Wilton, CT 06897
(203) 761-9945
Up to one-year residency.

NEW JERSEY

Jersey City Arts Center
111 First Street
Jersey City, NJ 07302
(201) 792-2787
Studio space rentals.

Peter's Valley Craft Center
19 Kuhn Road
Layton, NJ 07851
(973) 948-5200
One- to four-year residencies, including living-studio space at modest cost.

NEW YORK

Asian-American Arts Centre
26 Bowery
New York, NY 10003
(212) 233-2154
(212) 766-1287
Eight-month residency, including studio and $1,200 per month stipend.

Bronx Council on the Arts
Scholarship Studio Program
1738 Hone Avenue
Bronx, NY 10461
(718) 931-9500
(718) 842-5659
Studio space at the council's Longwood Arts Project and a monthly materials stipend of up to $500.

Center for Book Arts
Sally R. Bishop Residency
28 West 27th Street
New York, NY 10001
(212) 481-0295
www.centerforbookarts.org/residence/
 index.html
Six-week residency between May and July, in which one is to create a limited edition book, providing living space, cash stipend, full use of the Center's facilities, materials budget, assistants, exhibition of the artist's work.

Charas
605 East Ninth Street
New York, NY 10009
(212) 533-6835
Short- and long-term studio rentals.

Creative Time
307 Seventh Avenue
New York, NY 10001
(212) 206–6674
www.creativetime.org
Cyberwide Project Series assists artists in developing projects that explore the public space of the Internet.

Dieu Donne Papermill, Inc.
Workspace Program
3 Crosby Street
New York, NY 10013
(212) 226–0573
Four artists, who have little to no experience in papermaking or in creating works on paper, are selected annually for five-day residencies (bunched together or spread out over a period of time), with a $500 honorarium.

Digital Clubhouse Network
55 Broad Street
New York, NY 10004
(212) 269–4284
www.digiclubny.org
Housing multimedia computers, the nonprofit organization assists organizations to develop communities.

Downtown Community Television Center
87 Lafayette Street
New York, NY 10013
(212) 966–4510
www.dctvny.org
Up to $500 worth of equipment use; also, low-cost equipment rental.

Electronic Arts Intermix
542 West 22nd Street
New York, NY 10011
(212) 966–4605
www.eai.org
Media services, including distribution of artists' videotapes, postproduction facilities, and artists' representation.

Electronic Cafe at the Kitchen
512 West 19th Street
New York, NY 10011
(212) 255–5793
www.panix.com/kitchen/Info/Cafe.html
Creates collaborative projects with performers around the world.

Elizabeth Foundation for the Arts
International Studio Program
451 Greenwich Street
New York, NY 10013–1757
(212) 431–0381
Residencies up to one year in the TriBeCa section of New York City.

Eyebeam Atelier—Digital Museum
115 Mercer Street
New York, NY 10012
(212) 431–7474
www.eyebeam.org
Online critical forums and exhibitions.

Franklin Furnace
112 Franklin Street
New York, NY 10013
(212) 925–4671
For performance artists.

GAle GAtes et al
37 Main Street
Brooklyn, NY 11201
(718) 522–4596
www.galegatesetal.org
For performing and visual artists.

Greenwich House Pottery
16 Jones Street
New York, NY 10014
(212) 242–4106
Residencies for professional ceramic artists.

Harlem School for the Arts
645 St. Nicholas Avenue
New York, NY 10031
(212) 926–4100
Studio space; exhibition space for rent.

Harvestworks, Inc.
596 Broadway, Suite 602
New York, NY 10012
(212) 431–1130
www.harvestworks.org
Production grants, including studio time, a tape supply allowance, and the services of a professional engineer, to twenty audio artists per year.

Henry Street Settlement
466 Grand Street
New York, NY 10002
(212) 598–0400
Van Lier Fellowships of $5,000 available to minority artists under thirty-five.

Jamaica Center for Arts and Learning
Workspace
161–04 Jamaica Avenue
Jamaica, NY 11432
(718) 658–7400
One-year residency plus an $8,000 stipend for Brooklyn or Queens residents.

LIC Artlofts
37–06 36th Street
Long Island City, NY 11101
(718) 784–9624
Studios available on a long- and short-term basis.

Lower East Side Printshop
59–61 East Fourth Street
New York, NY 10003
(212) 673–5390
Thirty artists selected to use printmaking facilities every three months.

Kenkeleba House
214 East Second Street
New York, NY 10009
(212) 674–3939
Studio rentals.

Lower Manhattan Cultural Council
5 World Trade Center, Suite 9235
New York, NY 10048
www.lmcc.net
Five-month-long residencies at the World Trade Center.

Manhattan Graphics Center
481 Washington Street
New York, NY 10013
(212) 219–8783
Printmaking facilities available on a rental basis.

Manhattan Plaza
400 West 43rd Street
New York, NY 10036
(212) 971–0660
Apartments for theater artists.

New York Experimental Glass Workshop
647 Fulton Street
Brooklyn, NY 11217
(718) 625–3685
Supplies materials.

Painting Space 122
P.S. 122
150 First Avenue
New York, NY 10009
(212) 533–4624
Project studios of 200 to 350 square feet are offered.

Printmaking Workshop

19 West 24th Street

New York, NY 10011

(212) 989–6125

Residency program; rental facilities on a daily, weekly, or monthly basis; artist-in-residence program for minority artists, including classes, supplies, and a stipend.

P.S. 1

Institute of Art and Urban Resources

46–01 21st Street

Long Island City, NY 11101

(718) 784–2084

Year-long studio program for twenty-eight artists.

The Studio Museum in Harlem

Artist-in-Residence Program

144 West 125th Street

New York, NY 10027

(212) 864–4500

One-year residency plus a $13,000 stipend; artists must spend at least twenty hours per week in their studios and conduct two public workshops.

Taller Boricua

1685 Lexington Avenue

New York, NY 10029

(212) 831–4333

Studio rentals.

Westbeth Corporation

463 West Street

New York, NY 10014

(212) 691–1500

Studio and living space rentals.

CEPA/Center for Exploratory & Perceptual Art

700 Main Street, Fourth Floor

Buffalo, NY 14202

(716) 856–2717

Use of computers, darkroom, studios, exhibition space, housing, and an honorarium.

Experimental Television Center

RD2, Box 235

Newark Valley, NY 13811

(607) 687–4341

Five-day intensive-study residencies.

Stone Quarry Hill Art Park

P.O. Box 251

3883 Stone Quarry Road

Cazenovia, NY 13035

(315) 655–3196

Workplace, stipend, and lodging are provided.

Visual Studies Workshop

31 Prince Street

Rochester, NY 14604

(716) 442–8676

Supplies all materials.

Women's Studio Workshop

P.O. Box 489

Rosendale, NY 12472

(914) 658–9133

On-site housing and unlimited access to the studios.

Chapter 4.
FINDING A JOB

New York is a city of working artists, yet their work and their art are frequently two separate and unrelated activities; the plan is always to get more time to create art. (Actually, the plan is to sell more artwork and give up the day job.) According to an estimate by the New York Coalition for Artist Housing, there are roughly 250,000 fine and performing artists in the five boroughs of New York, and, for most of them, art is a secondary source of employment. Artists must compete against each other for many art-related job categories and against everybody else for other types of jobs.

The history of art over the past century is filled with white- and blue-collar jobs that artists held until they could afford to do without them: Yves Tanguy sold wine, Arnold Friedman was a letter carrier, and Henri Rousseau a customs agent. The jobs don't assume a large space in the biographies of these artists— they are not seen as meaningful parts of their true life stories, even when the artists held these jobs for many years. Like the clothes they wore, the jobs offered protection from the world and some comfort but otherwise were of no consequence in their artistic and intellectual development; as the artists' stars rose in the art world, their salaried jobs gracefully receded into the background. To these artists and others, however, the day jobs probably consumed a lot of their thoughts and energies. Picking a job that is appropriate to an artist's interests and talents is vital to the continuation of his or her art—who wants to wait tables for decades, looking forward to the day that a big break comes about? And there is no guarantee that the job will cease to be necessary one day.

Few artists are so successful that they needn't do some type of job. Graphic design and computer programming are the ways that Dread Scott Tyler supplements his income. The Brooklyn artist, who sells his work at gallery exhibitions and privately, and who also has received fellowships from the Ford Foundation

and the Mid-Atlantic Arts Foundation, among others, is successful as an artist to the degree that "I haven't had to work full-time anywhere. But just because you have a certain visibility in the art world, New York is a city of 100,000 fine artists, and everybody's trying to make a living. I'm just one more."

ART-RELATED JOBS

Artists may choose to work in fields related to their art training that require additional degrees and schooling—such as art conservation, art therapy, arts management, graphic design, digital imaging, and interior design—or that may or may not demand other credentials (jobs in art schools, galleries, or museums). They may decide to separate what they do as artists from what they do for a living and work in a completely different field.

Balancing a demanding job and artmaking may prove too difficult, leading to a painful choice. More often than not, the art loses, but not always. Kathleen Hayek, who received first a B.F.A. from Louisiana State University and later a master's degree in educational administration from the Bank Street College of Education in Manhattan, left Pratt Institute in 1992, where she was the dean of professional studies, in order to paint. "Pratt was a good job, but a high-pressure job, and there was no time to paint," she said. "After ten years here, I realized I was helping everyone else to paint, but not myself." Some artists opt to work only part-time or as freelancers in order to make more time available for their artmaking. "Freelance is the only way I ever want to work," said L.J. Lindhurst, a Brooklyn painter who supports herself through largely Web-based design working out of her apartment. "I made a choice not to take a salaried job, giving up a steady income and benefits, because there would be no way I would have time to paint."

She has worked in office jobs, doing graphic design for a television station in Indiana and, after she moved to New York from St. Louis in 1993, doing more graphic design, first for the no-longer-extant *Brooklyn Bridge Magazine* and later for an advertising information service. However, Lindhurst wanted a way to balance a job with her artwork. She learned Web design on her own and, like many other freelancers in this field, subscribed to the WorldWideWeb Artist Consortium (*www.wwwac.org*), where many employers bring jobs in Web and more traditional print design. "Since I was getting a lot of freelance offers, it wasn't a scary leap into the unknown when I left my job," she said. Some weeks, Lindhurst works just ten hours, other weeks sixty, but she believes that

the average is thirty to forty hours per week, "just like anybody else at a job. The difference for me is, I'm not commuting to work, and I can take time off to do errands or walk down the street to my studio and start painting. It's up to me."

Some fields are particularly amenable and welcoming to artists, few more so than museums, where many of the guards, technicians, education department staff, conservators, and even some curators are artists with fine art backgrounds or active exhibition records. Robert Kuszek, whose paintings are represented by the Rosenberg and Kaufman gallery in Manhattan, works in the registrar's office of the Metropolitan Museum of Art, although he started in shipping. While shipping was physically tiring, working at the registrar's is often more stressful, he noted, because "things must be sent precisely in a precise way, and there are times when you worry about things at the end of the day. I'll lay in bed wondering, 'Did I remember to send that piece . . . um, um, um?'" He added that "some people can't handle all that stress and make their art at the same time."

Because art tends to be a hands-on profession, many artists have an aptitude for carpentry and the building trades; a large percentage of those who work in building sets for theater and dance groups have backgrounds in the fine arts. But there are other uses of these talents as well. For example, Fred Tomaselli, who "eked out a living" in Los Angeles and Brooklyn as a "sheetrocker and general handyman," worked for five years in a frame shop as a woodworker.

One's studio training is viewed as qualification for working at particular jobs in a museum—a senior thesis show at art school requires art students to learn something about transporting, installing, perhaps framing, exhibition design, and talking about art—whereas nonartists may have to show prior experience or an additional degree. Rob Davis, who received a B.F.A. from the School of the Art Institute of Chicago, worked as an intern at the Field Museum in Chicago, installing exhibitions, before moving to New York (Brooklyn), where he quickly was hired by the Metropolitan Museum as an art handler (framing, crating, and shipping) in the American Wing. There is little mental stress connected to the job, he said, "mostly I try not to get a hernia." His schoolmate from the School of the Art Institute, the Russian-born painter Alex Stolyarov, also works at the Met as a guard. "I don't have any real skills, such as carpentry and computers," Stolyarov said, "but I was in the army in Russia, so they hired me for a security job."

More in the curatorial end, both Karen Shaw, a painter and curator at the Islip Art Museum in Long Island, and Karina Skvirsky, a painter and exhibi-

tions manager at the Jamaica Center for the Arts and Learning in Queens, became curators more by doing than by years of study. Shaw began to put together exhibitions of her work and that of other artists she knew, and the site of one of these artist-curated shows was the Islip Art Museum. While there, she met the director, who hired her for the part-time job of curator. Skvirsky had learned about curating at Indiana University, where she received an M.F.A. in 1995. "The other students in the program wanted to get teaching experience, so they were given classes," she said. "I never was interested in teaching, so I asked if I could work in the gallery," where she eventually began to curate exhibitions. After graduating, she was hired to be the first director of a gallery at one of the university's branch campuses, where she stayed for two years before moving to New York. Skvirsky was soon hired as the exhibitions manager at the Queens Library Gallery in Jamaica and later took the job at the Jamaica Center for Arts and Learning. The job is thirty hours per week, "part-time enough so I can paint, full-time enough so I can pay my rent."

Arts organizations often serve artists and frequently are staffed by them. In many cases, arts organizations—clubs, societies, and artist membership groups—are run by volunteers and have no paid employees. Photographer Andrew McConnell, for example, is the administrator of Brooklyn Working Artists Coalition, duties he attends on the weekends and after work (he is the manager of a day treatment program for retarded people). Similarly, Lower Manhattan Loft Tenants, a coalition of loft dwellers in SoHo, Tribeca, Chelsea, and Brooklyn, has no office or staff, only a post office box, a Web site, and a telephone answering machine that announces when the next meeting will take place.

Nicholas Costantakis and Bryony Romer, on the other hand, came to New York from small, rural towns specifically to work in the arts administration field. Both, however, work only part-time in order to have time for their art. A 1990 graduate of Yale with a B.A. in fine art, Romer worked for several years as a grant writer for the Jacob's Pillow Dance Festival in Lenox, Massachusetts, largely developing this skill on the job. "Lenox is a beautiful place to live, and it's full of activity during the summer when the festival takes place and so many people come," she said. "It was a little too quiet for me the rest of the year. I think I needed the energy of the city." It may also have hindered her ability to paint, because there were so few other fine artists around. During those years, she largely gave up painting. "Artists can get into a place where they're doing arts administration and use that as an outlet for their creative energy."

Through the nonprofit jobs publication *Artsearch,* she found a listing for the Brooklyn-based arts service organization, Elders Share the Arts, which was looking for a grant writer, and moved to New York in 1995. "I had always thought about moving to New York—meaning Manhattan—in order to be an artist, but the idea was always too scary, too epic," she said. "Moving to Brooklyn didn't seem as terrifying." Soon after arriving in New York, she began to paint again. "Working for a small organization really opened my eyes to how the arts worked. Everything is so precarious; you're always this close to running out of money. I started to see that, if I could manage this level of risk for an arts organization, I could stand to do that for the benefit of my own art." After a year, she went part-time at Elders Share the Arts, eventually leaving to work at David Bury & Associates, a Manhattan consulting firm that provides fundraising services for large and small arts organizations, also on a part-time basis (twenty-five hours per week). "It's been helpful to me that I'm doing work for arts organizations that are not in my field," noting that some of her clients are Chamber Music America and Meet the Composer. "Classical music people know me as a fundraising person and not as a creative artist. It's easier for me to put that work behind me and get on with my painting."

Costantakis's road to art took more turns. He received a masters in business administration in 1989 and went to work immediately at Arthur Anderson, a national accounting firm, first in its office in Hartford and later in Philadelphia. "I made a lot of money, but I didn't really enjoy my work or even the money I was making," he said. "I decided to go back and redo my life." In 1997, he earned a studio degree in fine arts from the Corcoran College of Art and Design, pursuing both painting and sculpture.

While a student at Corcoran College, Costantakis had a residency at the Vermont Studio Center, liking it so much that he later wrote a letter to the operations director there, asking if there was any job for him. "I told him I would clean up, answer the phones, anything," he said. "As an afterthought, I mentioned that I had a business degree. A week later, I got a phone call, asking me to be their finance director." Costantakis stayed there for a year-and-a-half, finally tiring of living in Johnson, Vermont, a town of one thousand people. "Moving to New York seemed like the appropriate thing. A lot of people working in residence at the Vermont Studio Center had come up from New York, and they would tell me what they did there. I began to think that, if I was to take my art career seriously, I had to move to New York."

Writing more letters, Costantakis asked about jobs at arts organizations in New York City. He was hired as finance director at the Lower Manhattan Cultural Council, and he also does financial advising for the Brooklyn Arts Council, both on a part-time basis, which allows him to create his sculpture and find sites in which to exhibit the work.

More on the entrepreneurial side, both David Judelson and Joy Glidden founded arts organizations and raised money to support them (and them-selves). Judelson, a sculptor who moved to New York from Boston in 1993, got caught up in the real estate talk that is so much a part of New York City living and saw that "there was a limited amount of time that artists would be able to live in Manhattan. It was clear that, eventually, most or all would be priced out, which is just what happened." Based on similar experience as the Artists Living and Working Space Project director at the Artists Foundation in Boston, where he was instrumental in establishing the Brickbottom Building as an artists-only live-work enclave, he founded the New York Coalition for Artist Housing, which has been in the process of raising money to renovate buildings in Brooklyn and Jersey City for live-work artists space.

Glidden, a painter who moved to New York City from Nova Scotia in 1987, worked for a time as an assistant to painter Richard Haas, as well as at several art galleries, but her cause became the waterfront area in Brooklyn later called DUMBO (Down Under the Manhattan Bridge Overpass), where she moved in 1989. "I liked the atmosphere here, and the mood, but it was pretty lonely for a time," she said. "When artists began moving in, in the 1990s, I started organizing people." The result of that organizing is the DUMBO Arts Center, which sponsors an annual open-studio event in October and maintains a slide registry of the work of area artists for dealers and collectors, and of which she is the full-time director.

WORKING AS AN ARTIST'S ASSISTANT

With great hopes of finding an entree into the art world, Gina Campanella grad-uated Skidmore College in 1989 and set to work as an artist's assistant, first for Michael David, later for Joyce Kozloff and Barbara Zucker. "I had a naive expec-tation," she said, "that I would work for an established artist who is part of a gallery, and that person would help me get into a gallery." Naive, perhaps, but many young artists have the same expectation, or they believe that through the collectors, dealers, and critics who walk into the established artist's studio, they will meet someone who becomes a buyer, seller, or champion of their artwork.

Campanella even approached this plan with a strategy. She wanted to work for a woman artist, because "I thought a woman artist would be more of a mentor to me," taking interest in her work and helping launch her career.

In fact, some of her hopes were realized. A print publisher who visited Michael David's studio, when she was still working for him, struck up a conversation with her, took her out to lunch, and introduced her to Joyce Kozloff. Kozloff, for whom she soon went to work as an assistant, introduced Campanella to Barbara Zucker, and it was Zucker who recommended her to fill a short-term teaching spot (a sabbatical replacement) at the University of Vermont, where Zucker herself worked. Both Kozloff and Zucker also chipped in $250 apiece to pay for Campanella to attend the Vermont Studio Center as an artist-in-residence. Campanella became part of a network of artists ("Joyce has never missed a show I've had") and, through working for some artists who are more established, learned something about what it is to be an artist. "I saw how they found materials and how they researched their subjects," she said. Through conversations in the studio, she understood "how their personal and professional lives intertwined."

Few job descriptions are as nebulous as that of artist's assistant, because each job reflects the personality, temperament, and work style of the artist involved. Assistants may be asked to work alongside the artist on a new piece or sweep up after the work is done. "I made coffee, answered the telephone, took instructions," Campanella said. "There was a lot of that." Julia Jacquette, who worked for painter Richard Haas off and on for ten years, stretched canvas, mixed colors, handled bookkeeping, organized slides, worked on his maquettes, and painted sections of his murals. "Working for him kept up my drawing skills." Haas, who has had "a hundred or more" artist-assistants work for him over the years, was himself an assistant early in his career to printmaker Malcolm Myers and to painter Peter Busa. Myers was "both casual and demanding," Haas said. "He knew what he wanted all the time," while Busa "needed a lot of attention and a lot of help keeping his life in order. His car broke down; I had to get it towed. He had a lot of girlfriends, and I had to schedule his dates."

The art world's lightning strikes from time to time: A dealer visiting Peter Halley's studio struck up a conversation with one of his assistants, George Rush, and began to talk about Rush's own work. Later, that dealer made a studio visit and eventually gave a show of Rush's work at his gallery. A similar circumstance occurred with Carroll Dunham in Dorothea Rockburne's studio. However, most artists receive less tangible benefits from working as assistants. Certainly, one

doesn't take this job for the pay, which can be as low as $10 per hour (Haas goes up to $15 per hour for assistants with experience and whom he trusts) with no benefits. "Once, one of my assistants had a minor injury here," said painter Mimi Gross. "I took care of it."

Perhaps what an artist-assistant gains from working in an established artist's studio is an understanding that it is truly possible to make a go of a life in art. Working with Red Grooms and his then-wife Mimi Gross on their celebrated installation, "Ruckus Manhattan," Andrew Ginzel saw this sprawling artwork "evolve slowly over time, as new ideas led to new problems that needed to be resolved, and the process of finding solutions led to yet other ideas." Ginzel, who himself now employs assistants and creates both gallery pieces and complicated public works of art, noted that "probably, the biggest thing I learned from Red and Mimi is that there are a lot of unknowns in any large project I undertake, and I know that I will be able to figure it out. I might not have known that if I had taken another path to becoming an artist."

David Saunders, another artist who worked for Red Grooms and Mimi Gross and has assistants in his own studio, learned some practical lessons about how to run his own studio, learning how to hire assistants and organize their activities, as well as gaining a balanced view of artist-dealer relationships. "While I was there, dealers came in and out, saying things that were very flattering, so flattering that it was annoying sometimes," he said. "Red and Mimi took it in stride, not bringing out the champagne and saying 'Hurray, they love us,' but rolling up their sleeves and going back to work." He also came into contact with dealers who said one thing and did another, who didn't pay their artists, and who were insulting to artists. From that, he learned to proceed cautiously when looking for gallery representation.

There are many ways that artists find established artists to work for. Dealers often know if the artists they represent need assistants, and many artists are called up directly by those wishing to work for them (all but the most famous artists are listed in the white pages of the telephone directory). Some artists who teach or give a talk are approached then and there; otherwise, artists learn of opportunities to work in an artist's studio through word-of-mouth. George Rush, who had worked in the studios of a couple of artists after he had received his B.F.A. and before he entered an M.F.A. program, was recommended for the job in Peter Halley's studio by a college friend who was already working there. Ginzel's parents, both artists, were friends of Red Grooms and Mimi Gross and helped line up a job there. Saunders was preparing to go to

graduate school when Grooms wrote to him, asking him to come work with them on "Ruckus Manhattan." He had made a few short art films, which were shown at film festivals. Grooms, himself a part-time filmmaker, enjoyed one of Saunders' films enough to purchase one, and the two met.

Saunders never got to graduate school, which he doesn't regret, considering that he learned more as an assistant to established artists. (He also worked for Cynthia Carlson, Donna Dennis, and Alex Katz, landing those jobs with recommendations from another assistant with whom he had worked on "Ruckus Manhattan.") "As a young artist right out of school, I felt that I'd have to spend twenty years honing my skills until I was ready to show my work," he said. "Over the years, I've met a lot of artists, who all tell me, when I ask if they're showing, 'Oh, I'm not ready yet, maybe in a year or two.' I've offered to take one artist's slides and show them to my dealer, but this guy said, 'No, but I'll keep it in mind when I'm ready.' Even some guy I worked with on 'Ruckus Manhattan,' I just ran into him after twenty years, and he told me he isn't ready right now—maybe in a year or so. At that rate, you'll never be ready. If I had just gone to grad school instead of working for Red and Mimi, I might have had the same idea, that everything has to be stone perfect before I can show it. But, having worked for some artists, I found they all were doing the best they could in a compromised situation. I know that I can do my best, and that will be good enough."

Working as an artist's assistant requires one to be versatile and open to learning how to do whatever needs to be done. Both Ginzel and Saunders became adept at carpentry and electrical wiring as a result of working on "Ruckus Manhattan," and George Rush became more "personally organized" because of his work as a project coordinator in Halley's studio. Another requirement of the job is having good social skills and knowing how to keep one's ego in check, which may run contrary to the way young artists view themselves. "You have to sublimate your own selfishness and put it into someone else's work," Haas said. "Those who can't don't last here too long."

Perhaps male assistants find the "maid" jobs (answer the telephone, fetch lunch, make coffee, clean up) that they are asked to do galling and, therefore, more difficult to perform properly than female assistants, causing friction in the studio. Practically every artist who has ever hired assistants has had to fire some, frequently because of a contest of egos and sometimes because assistants believe they have been hired to be artists and not gofers. "In my studio, no one person has to take out the garbage," Vito Acconci said. "We all take out the garbage. I take out the garbage, but probably other people take it out more

often. If you won't take out the garbage, you're not much help to me." Mimi Gross said that she has a much easier time with female assistants, because they are more willing to do the housekeeping and office management tasks than males. "When I had a small child, I'd ask a female assistant to baby-sit while she was in the studio," she said. "I wouldn't ever think of asking a male assistant to watch my child. They're more into their attitude, and, if you ask them to do something they don't want to do, they won't focus on it and do it badly."

Perhaps baby-sitting, answering the telephone, and taking out the garbage are actually easier jobs for an artist's assistant to perform than working directly on an established artist's work. It is certainly more glamorous to envision and describe one's work as being involved in the process of making art, but the emotional toll may be higher on the assistants who are essentially giving away their talents and ideas for very little money, especially since someone else is taking all the credit. There is a long tradition of artists working as assistants and apprentices to more-established artists, dating back to the guild system of the Middle Ages and the workshops of the Renaissance, extending into the early nineteenth century and later reappearing in the 1930s, when artists such as Jackson Pollock and Philip Guston worked on the murals of Mexican Revolutionary artists Diego Rivera and Jose Clemente Orozco, respectively. However, artists today see themselves quite differently from their counterparts of five, six, seven hundred or more years ago, and they are less willing to work anonymously. "It's hard to find someone who'll do hands-on work without making aesthetic decisions," Gross said. Maybe that is asking too much of an artist.

Young artists may approach established artists' studios with expectations about the type of relationship they will have—the artist will reveal artistic secrets, the artist will allow assistants to use materials and tools for their own work, the artist will engage assistants in lofty conversations, the artist will discuss his or her personal life and be equally interested in that of the assistants—which are not borne out in practice. Joyce Kozloff noted that she has become "good friends" with some of her assistants, whereas Alex Katz is described by some of the people who worked for him (sometimes for years) as never asking a personal question. "Alex is not very emotional," Saunders said. "He doesn't wear his heart on his sleeve. He is a very cool character and expects people around him to just tend to their work." Other artists' assistants recall having weighty conversations about art, life, and personal matters with the artists they worked for. "Tim and I talked about art a lot," said Jilaine Jones, a sculptor who worked one summer as an assistant to British sculptor Tim Scott. "We talked

constantly. We had a running dialogue on sculptural issues." Her relationship with James Wolf, another sculptor for whom she was an assistant, on the other hand, was far less heady: "We didn't talk about much. Sometimes, he'd ask me to get him a soda, and otherwise, we'd just go about our work."

As the years go by, the willingness of established artists to try to engage their assistants on a personal, individual level seems to lessen. Assistants are always about the same age—in their early twenties, replaced by others of that same age group—while the artist simply gets older. Assistants have more in common with each other than with their employers (Haas mentioned that he tried to understand "grunge" music when one of his assistants was into that, "but I never really could get it") and make social connections with them rather than through the network of the established artist.

Noting that his "best, brightest, sharpest helpers" are not necessarily artists themselves, Ginzel found a "slight but real conflict of interest" between artists and the artists working for them: "Artists are best doing their own work, and they're not necessarily doing their best work if it is someone else's." Hands-on work makes an assistant a collaborator in the creation of art, but it doesn't equalize the relationship between artists and their assistants, which can prove very frustrating when assistants disagree with their instructions or have their own ideas of what should be done. Richard Haas and his assistants had "battles of egos from time to time," Jacquette recalled, when assistants "felt they knew the right way to paint or to do something else, but their job was to make something on a large scale exactly as Richard instructed. I learned, don't fight it, just do it. The battle is not worth the time, and you don't win anyway."

There may be no way to get this relationship exactly right, regardless of how willing the artist is to listen to assistants. "A while ago, I stopped calling my work 'by Vito Acconci' and started using 'Acconci Studio,' and I make sure that everyone's name is listed," Acconci said. "Everyone gets credit. Still, when my work is written about, it's always mentioned as a Vito Acconci project, and that bothers some people. We try to work collaboratively here, more like an architect's office rather than a place where there is one artist and bunch of assistants. But, of course, I pay them, they don't pay me." He added that "the older a person gets, the less he wants to be subsumed into someone else's work. He wants to receive attention for his own work."

It may be difficult for artists who are surrounded by another artist's work, especially artwork they are actually helping to create, to go home and produce their own. The influence of their employer's work may be difficult to eliminate

at the end of the day, which assistants can feel strongly if their own creations seem to have no ready audience. While artists generally look to hire artists as their assistants, the effect of the job may be to lessen the assistants' commitment to their own art.

There may be a certain lifespan to the job of being an artist's assistant: The artistic ego can only be repressed so long if one's ambitions are to be an artist. As much as they see artists working with others (sometimes whole crews) around them, artists need to be self-reliant, believing in what they are doing artistically and proactive about their own careers. Burn-out exists in the world of being an assistant, especially when the hoped-for introduction to a willing dealer or collector never takes place. Campanella said that working for other artists was "fine when I was twenty-two or twenty-three and right out of school. By the time I was thirty, though, I wanted something more. I didn't want to still be making $10 an hour and living like this." The break may come about when another opportunity arises (Campanella found a job at Tommy Hilfiger) or when an assistant's own career begins to take off (by 1978, Saunders claimed, "My work was starting to sell, and I didn't need to work for someone else"). Sometimes, assistants just quit and try to assess what they want to do next. After ten years, Jacquette stated that she "grew out of" being an assistant. "I realized that I needed to not be working for another artist if I was to show my work and to have my own sense of self." She "segued into teaching and occasionally selling my work. Teaching is not as hard on your self-esteem."

FINDING A TEACHING JOB

For many artists, teaching is the traditional fallback position—what you do to make money until the artwork begins to sell—but what is the fallback after that? Every year, thousands of artists pursue masters of fine arts degrees, which are the union card for full-time art teaching on the college level, and then discover upon graduation that there are between one hundred and two hundred (and, sometimes, quite a few more) applicants for every advertised studio art job, according to the College Art Association. It is commonly said that artists who want to teach at the college level may have to set their sights outside of the major cities, sometimes in the hinterlands—Nebraska or Idaho, maybe—but studio art teaching jobs there are just as difficult to get. "I've sent out hundreds of applications to schools for teaching positions," said Roger Sayre, a painter who lives in Jersey City, New Jersey. "I've got a two-inch stack of rejection notices."

Not every letter was a rejection, though. He was hired as a sabbatical replacement for one year at Longwood College in Farmville, Virginia (recommended by the person taking the sabbatical, a friend with whom he had attended college) and stayed on for another two years as an adjunct. In 1995, ten years after receiving his art degree, Sayre was hired by Pace University as a full-time, benefitted studio art teacher.

TEACHING ON THE COLLEGE LEVEL

Sayre's experience is par for the course. Most new, full-time hires in New York City and elsewhere are in their thirties or forties and are paid in the $30,000 to $40,000 range, depending upon their years of teaching experience. Artists in their twenties are more likely hired as adjuncts, and Pace University pays them between $600 and $800 per credit—if they teach three classes a semester, a full-time course load at most schools, the maximum they will earn is $7,200 with no benefits. Half of the new hires in the arts division at Fordham University are full-time assistant professors (teaching three days per week, another day for advising, and paid $45,000 to $50,000), while the others are adjuncts, called artists-in-residence (teaching two days per week and paid $35,000 to $40,000). Adjuncts will not earn a full-time position through adjuncting for the same university for many years. Schools generally don't hire another full-time faculty until one retires, and then they conduct a national search. John Monti, a sculptor in Brooklyn, has been an adjunct at Pratt Institute since 1988, although his teaching load is full-time. "The full-time sculpture faculty members are not that much older than I am, which can be somewhat discouraging when I wonder if I'm ever going to have a regular job." Adjuncts generally have to paste together a living from various sources, and their job security is low (when there is a drop in enrollment, they are the ones let go).

As with much else in the art world, recommendations and who you know greatly help an otherwise-qualified applicant land a teaching job. Monti had earned his M.F.A. from Pratt in 1983 and maintained contact with the department chairman after that, occasionally "bumping into each other at art openings," he said. One day, when they bumped into each other on the street in SoHo, the chairman mentioned that "there's a class opening up in the Spring" at Pratt, and Monti was hired on the spot. Art schools and universities generally advertise for full-time positions (placing notices in the *Chronicle of Higher Education,* the newsletter of the College Art Association, perhaps an art magazine, and one or more local newspapers), but not for temporary and adjunct

slots. William Conlon, chairman of the arts division at Fordham, noted that he will "put out feelers" to other schools, or to design firms "if it's for a graphic design job," for recommendations. Besides extensive teaching experience, Fordham's requirements for full-time hires include gallery representation and an active exhibition record. "We received 110 applications for the last photography job we advertised," he said. "The person we hired received a Guggenheim and had a retrospective at the Museum of Modern Art."

At the New York Academy of Art, hiring takes place not so much from receiving résumés but by "word of mouth and recommendations from the faculty," said Michael Gormley, director of academic affairs. "Faculties are self-selecting. They bring in people they know, who come from the same school of thought." Most art schools and university art departments, however, strive for greater diversity in artistic styles, ideas, and media, in order that students receive a wider exposure to methods of artmaking. As a result, they do look beyond the names supplied by their current faculty, soliciting résumés for jobs and attending the annual College Art Association conference to meet with job seekers. Sayre was interviewed by the chairman of Pace's art department at the College Art Association two years before he was eventually hired. "You hear people say, 'We'll keep your résumé on file,' but in this case, they really did," he said.

Teaching appeals to artists for a number of reasons. As art-related careers go, teaching is as close as artists can come to being paid to do their own artwork without having an actual collector. Other art-related professions—for example, art therapy, arts administration, studio foundry technician, Web designer, art appraiser, or other, similar fields—make use of artistic talents, but with the end of providing a service rather than an artistic product. With only two or three courses to teach per term, the work itself is not overly demanding, and many schools provide free studio space for art faculty; they encourage their teachers to be practicing, exhibiting artists.

There also may be a hazard or two for artists looking to teach. Teaching is a day job that affords artists the resources—if somewhat abridging the time— to create the work that (they hope) leads to shows, sales, and (God willing) the ability to leave their job and pursue art full-time. Like the clothes the artists wear, teaching offers protection from the world and some comfort. Well, not all the time. A livelihood predicated on low-paying, frequently unbenefited, temporary employment hardly affords much comfort. Many students are not strongly motivated to develop their skills and their ideas, and many instructors find that they need to delude themselves into thinking that their students are

more talented than they in fact are in order to maintain their own interest in teaching. In addition, art schools and university art departments can be hot-houses of intrigue and backstabbing. Artists have occasionally found that schools are not altogether accommodating to their faculties' careers, a result of jealousy and a belief that artists cannot (or should not) both draw a salary and win acclaim in the art world.

"To begin with, I was the only woman in the entire sculpture department, and some of the older faculty didn't feel at all comfortable with my presence," said Elyn Zimmerman, who lasted three years at the State University of New York at Purchase. "When I started to get commissions to do public works, they were even more unhappy." That unhappiness manifested itself by assigning Zimmerman unpopular evening hours in which to teach and not affording her time in which to visit the sites of her installations.

The competition between artists for scarce full-time teaching jobs may also create tensions, leading to "a lot of backbiting" within a department, according to Sam Gilliam, a painter in Washington, D.C., who has taught at a number of schools, including the University of Maryland, the Corcoran College of Art and Design, and Carnegie-Mellon. "If someone thought that you were getting more praise than they got, that person would try to make life hard for you." He noted that one faculty member at Carnegie-Mellon "searched art mag-azines to see if I got a bad review. If there were any, he would read it aloud to his classes." Another time, Gilliam was walking past an office where he heard one instructor telling another that "'[Gilliam] doesn't know color at all.' I stuck my head in the door and said, 'Hey, I thought we were buddies,' but there you are." Gilliam added that he had also taught art in high schools, which he found in some respects preferable: "I was the only professional artist there, and the students and teachers all had a lot of respect for what I was doing."

In order to advance at a school—obtain a raise and a choice of classes, become tenured and promoted—faculty must demonstrate a primary commit-ment to the institution, which may conflict with the needs of being an active artist. "When artists teach in an institution, it is very easy to get swallowed up by that system," said painter and photographer William Christenberry. "A lot of my artist friends who started teaching at the same time I did are no longer prac-ticing artists."

Christenberry credited art schools in general with providing greater lati-tude to art faculty than the majority of college and university art departments. There is no hard-and-fast rule about which types of institutions of higher edu-

cation hire art teachers who also happen to be artists and which look for artists who also teach. "If one of my faculty—say, Elizabeth Murray—has an important show, I'll tell her, 'Go,' and I'll find some way to cover her class," said Judy Pfaff, a sculptor and cochair of the art department at Bard College in New York State. That type of flexibility and willingness to acknowledge that a faculty member's career interests are on a par with, or take precedence over, school-related responsibilities is found only rarely. As much as many schools are happy to boast that their faculties consist of artists with established careers, these institutions may express displeasure when these same faculty members see their careers as primarily outside of the academies.

Christenberry noted that colleges benefit from the nonteaching work of their art faculty, adding "that when I go somewhere, I'm representing [the college] and not just myself. I think of myself as an effective teacher, but I've never put as much into my teaching as into my art." Christenberry added that almost every university art department he has seen has been rife with "petty jealousies" and "fiefdoms." "I spent a week at one university as a visiting artist. It was during a faculty evaluation period. One poor soul was reprimanded for exhibiting too much; another was criticized for not exhibiting enough. I was happy to get out of there."

Artists resolve the problem of balancing a rising art career and their day job in different ways. Christenberry left one school, taking a pay cut to come to another, because the working environment was more suitable to him. Zimmerman just left a position, shortly after having put up a successful battle to reverse a decision that denied her tenure. "I recognized that I wanted to pursue my own art more, and the rewards of teaching lessened, especially as I felt all these hassles." For her part, Pfaff tries to schedule her shows during spring break or other times when Bard is not in session, "so it causes the least amount of interference."

Throughout his years teaching at the college level, Gilliam kept reminding himself that "my future lies outside of this." Certainly, Gilliam's future increasingly rests with art collectors, curators, and historians who periodically will make determinations on his place in art history. Perhaps that kind of reminder is also useful for all artists who look to keep in perspective the turmoil and jealousies around them while they set their sights on a higher prize.

It is not infrequent that artists do consciously or unconsciously make choices about whether they are artists first who teach or vice versa. Balancing

the two professions occurs, but only in a minority of cases. Many artists produce work steadily, but others create artwork off and on, moving into high gear when an exhibition looms. If they do not actually pursue opportunities to show their work, artists may become less productive. "I'll show my work in group shows, an occasional one-person show," Sayre said. "If I weren't teaching, I'd be spending more time trying to get into galleries, but because I have a job and an income, I have less motivation to try to do that."

The itinerant nature of teaching, in which so few full-time salaried positions are available, requiring artists to work as adjuncts or in-residence at a variety of schools, also takes away from an artist's ability to concentrate on producing work. Between 1986 and 1994, mixed media artist Karen Shaw not only worked at Queensborough Community College in Queens, Southampton College in Long Island, Hofstra University in Long Island, Princeton University in New Jersey, Silvermine Art Guild in Connecticut, and several Long Island high schools, she also taught at a variety of schools in the South and the Midwest. "I was always applying to other schools, moving, and then teaching," she said. "I got my school work done, but I didn't have a lot of time to do my art. It's hard to keep an art career going in earnest if you teach." Another teaching artist, Melvin Pekarski, who works at the State University of New York at Stony Brook (Long Island), noted that he made "the choice of being an educator. I choose to focus my energies on students, rather than hustling dealers. Making that choice allowed me to relax and be more honest in my work, but it also made me less plugged into the art scene."

Teaching artists may also be taken away from their work if they have to travel extensively to get to their jobs. Howardina Pindell, a Manhattan artist who teaches at SUNY-Stony Brook, claimed that the daily commute takes three hours door-to-door each way, a trip she makes twice a week, sometimes three times if there are meetings she must attend. On the days she teaches, Pindell wakes up at 5:00 A.M. in order to leave home at 6:00 A.M., not returning until 10:00 P.M. that night. The fatigue from the commute affects her not only on the days she teaches but "half a day the next day, too." On certain days, when she feels "absolutely wrecked," she refrains from artmaking and concentrates on "detail work, sending out announcements, labeling my slides." She added that "Stony Brook was the closest place that I could find a good teaching job. It's very hard to find a tenure-tracked job at schools in the city." Half of the art studio faculty at SUNY-Stony Brook commute, making the trip a "frequent subject of conversation among artists. We're all hostage to the train schedule."

The alternative, of course, is to move to Long Island, which some full-time tenured faculty have done. Pekarski used to commute from Manhattan by car two or three times per week, "and I'd get tired at the wheel." Commuting, he said, "had an adverse effect on my painting" in terms of making him less able to work on his days off. "I'd have Monday and Wednesday classes, getting home at ten at night and then trying to work, staying up until two or three in the morning. Tuesdays and Thursdays just became a lost cause—I just spent the days recuperating." Finding the traffic increasingly bumper-to-bumper and the expense of living in Manhattan escalating (he had young children, too, which meant expensive private schools), he decided in the 1970s to move to Long Island. "I can use the time I used to spend driving to read and write, do some sketches. It's pretty hard to sketch while you're driving or even riding on the train, especially if it's the Long Island Rail Road."

If the challenge of balancing college-level teaching with making your art is one that interests you, New York has many potential employers. Many colleges and universities have art departments and studio art departments, even if they do not grant bachelor's or master of fine arts degrees.

One way to acquaint yourself with the many schools of higher education in the Metropolitan area is through the standard collegiate guides, usually found in the reference sections of libraries and bookstores, such as *Barron's Profiles of American Colleges in the U.S., The Fiske Guide to Colleges, Kaplan Guide to the Best Colleges in the U.S., Lovejoy's College Guide,* and *Peterson's 4 Year Colleges.*

OTHER TEACHING OPPORTUNITIES

There are a variety of opportunities for artists to teach, of which art schools and colleges (including community colleges) are but one type. Many of these same schools have adult or continuing education courses, which pay considerably less but require less time and have fewer pressures associated with them. Artists may take private students or offer workshops (daylong, weekend, week-long) for groups or work at summer camps that specialize in the arts (such as the New Jersey Summer Arts Institute in New Brunswick or the Ramapo Anchorage Camp in Rhinebeck, New York); they may work at day care facilities, after-school programs, and YM or YWCAs, and they may stage demonstrations at schools or museums. Many museums also have Saturday or after-school programs for children, creating employment for artists.

Some programs also hire artists to provide arts access to target audiences, such as children in schools or the disabled. Among the most prominent of these are Young Audiences and Very Special Arts:

Young Audiences, Inc.
115 East 92nd Street
New York, NY 10128
(212) 831–8110

Very Special Arts Connecticut
56 Arbor Street, Hartford, CT 06106
(203) 236–3812

Very Special Arts New Jersey
841 Georges Road
North Brunswick, NJ 08902
(908) 745–3885

Very Special Arts New York
Margaret Chapman School
5 Bradhurst Avenue
Hawthorne, NY 10532
(914) 592–8526

Very Special Arts New York City
18-05 215th Street
Bayside, NY 11360
(718) 225–6305

These teaching opportunities allow artists to add extra income, to get a foot in the door at institutions where they would like to work, or to learn how to teach in a low-pressure environment. Michael Peery, a painter in Manhattan who briefly taught on the high school level, teaches continuing education classes at the New York Academy of Art, "gathering experience for jobs that may open up somewhere in the country," he said.

TEACHING IN THE PUBLIC SCHOOLS

Nationally, there has been a growth in the number of people hired to teach in the public schools over the past two decades. In the early 1980s, a study conducted by the state directors of art education found that only 33 percent of all elementary schools in the United States had art teachers. By the early 1990s, a study by the University of Illinois found, that number had risen to 58 percent, and 33 states had established as a requirement for high school graduation the completion of at least one class in visual arts. That does not mean that 58 percent of all elementary schools and two-thirds of all high schools have full-time art teachers. Many schools, especially in rural areas, may claim to have an art curriculum when there is an art teacher in the building one day per week or per month; many art teachers travel from one school to the next (referred to as Art-

on-the-Cart). Still, the numbers are improving, which benefits artists. "Virtually all National Art Education Association teachers have art degrees," said Thomas Hatfield, executive director of the association.

Approximately 7,200 licensed art teachers work in the public schools in New York State. The five boroughs of New York City employ close to 1,400 art teachers in the public schools; Long Island has another 1,300 art teachers (700 in Nassau County, 600 in Suffolk). In order to be hired for a permanent, full-time position, prospective art teachers in New York State must obtain certification from the New York State Education Department (89 Washington Avenue, Albany, New York 12234, *www.nysed.gov/*). They will need to fill out and submit a formal application (with a check for $100) and include a transcript from an approved and accredited institution of higher learning (the Office of Teaching of the state Education Department has a list of approved and accredited schools) from which an applicant received a bachelor's or master's degree. The transcript must show that the applicant has at least thirty-six credits in art and twelve education credits, as well as at least one year of student teaching (New York State will accept two semesters of student teaching). Applicants must also be United States citizens or in the process of applying for citizenship. Those meeting these standards are given two exams, the first on liberal arts and science that tests an applicant's general knowledge and the other an assessment of teaching skills that evaluates professional knowledge and the ability to communicate clearly. Those who pass these tests are required by state law to take a two-hour child abuse prevention workshop. They then receive "provisional certification" and have five years to make that full certification (to obtain that, applicants must show two years of teaching, complete any missing education credits, and file another application with the state Education Department, along with another check for $100).

In New York City and Buffalo, all teachers must also be licensed, for which one applies (in the five boroughs) to the New York City Board of Education (110 Livingston Street, Brooklyn, New York 11201); the application fee is $40. To be licensed, applicants must obtain six credits of special education and human relations within two years of receiving provisional certification. To teach in elementary schools (prekindergarten to sixth grade), they also must show twenty-four education credits, plus six credits in reading and six credits in math, science, and a foreign language (a master's degree in education fulfills all of the requirements for both certification and licensing). Unlicensed teachers must work as substitutes, either on an occasional basis (filling in for an absent

teacher) and earning $100 per day with no health benefits or on a full-time basis (with an annual salary plus benefits and vacations) in hard-to-staff schools. The starting salary for full-time teachers in New York City public schools is currently $31,910, topping out at $70,000 for those with a master's degree and twenty-two years or more of teaching. Unlicensed full-time teachers start at $31,910, but their raises will only climb to the mid-thirty thousand dollar range.

A number of colleges in New York offer degree programs in fine art education, enabling graduates to be immediately employable in the city's public schools. These include:

City College of New York
138th Street and Convent Avenue
New York, NY 10031
(212) 650–7000

Columbia University Teachers College
Program in Art and Art Education
Department of Arts and Humanities
525 West 120th Street
New York, NY 10027
(212) 678–3270

Marymount Manhattan College
Fine and Performing Arts Department
221 East 71st Street
New York, NY 10021
(212) 517–0400

New York Academy of Art
111 Franklin Street
New York, NY 10013
(212) 966–0300

New York University
22 Washington Square North
New York, NY 10012–1019
(212) 998–4500

Parsons School of Design
66 Fifth Avenue
New York, NY 10011
(212) 229–8910

Pratt Institute
200 Willoughby Avenue
Brooklyn, NY 11205
(718) 636–3669
(800) 331–0834

School of Visual Arts
209 East 23rd Street
New York, NY 10010
(212) 592–2000

There are several sources of information about teaching jobs in New York's public schools. The New York City Board of Education has a toll-free hotline at (800) TEACHNY, and one may send a résumé to the Art Education Office of the Board of Education (same Brooklyn address). The New York State

Art Teachers Association (*www.nysata.org*) and the New York City Art Teachers Association (*www.nycata.org*) also offer information on job availabilities to members.

Teaching in the public schools is different from teaching at a college. One significant reason is the issue of discipline—settling down students, resolving disputes between them, and keeping the noise level down while herding them from one element of a project to another in an orderly manner—which is a regular feature of public school life and far less evident in art schools and universities, where students are there by choice. "High school students can be pretty rowdy. Discipline was always a problem," said Alexis Vasilos, a Brooklyn painter who briefly taught at the High School of Fashion Industries in Manhattan and someday hopes "to teach on the college level." Classes are also frequently crowded, with between thirty and forty students, and it is difficult to work with individuals who would welcome and benefit from extra attention in such a crowd, especially when there are disruptive children. She also complained of the school "lacking in supplies and materials that the students needed" and that she could not use "live models, which we would ordinarily have in [art] school."

Whereas studio art classes in art schools and universities vary from one institution to the next and from one instructor to the next, public school art instructors are expected to teach a basic, uniform set of skills. Guidelines for this teaching is set down in a publication of the New York State Education Department, *Learning Standards for the Arts,* which describes goals for students and projects that should be undertaken in class.

As opposed to art schools and universities, where instructors are described as artists who also teach, public school art teachers are teachers first and foremost—their work as artists is not only separate from their salaried duties, their artwork might not even be allowed in the school if it is provocative in some way. Art teachers in public schools may be constantly on their feet, talking to as many as 150 students per day (if they have five classes). They are also responsible for preparing and cleaning up their classrooms, setting up exhibitions, and even locating supplies for student projects. Many art teachers claim that they are not able to do much of their own artmaking during the school year, because of the long, exhausting days. "It's not nine to three, it's not even nine to five most days, because you work at home and during the summer, developing projects for children to work on and collecting materials," said Sharon Dunn, head of the art education office of the New York City Board of Education. Joan Davidson, president of the New York Art Teachers Association and a jun-

ior and senior high school art teacher for almost thirty years, said that she created ten paintings per year as a teacher, eight of them during the summer. She noted that some ideas for her own work came from her students—"They don't have preconceptions about how things are supposed to be done, so they just try things with a spontaneity I admire"—but most of those ideas have to be saved for the summer.

Davidson didn't see teaching as only taking away from her own art, but as a significant challenge in itself. "The aim is to help children find their own personal voices," she said. "You energize the kids, and that energy comes back and excites you. I don't think you find that same type of excitement in colleges, because the students there are already more sophisticated about art. There aren't as many surprises." That judgement was confirmed by Joseph Hijuelos, an art teacher who teaches painting, drawing, and illustration at the Fashion Institute High School in Manhattan and has also taught for four years at Brooklyn College, as well as at the Brooklyn Museum. "College students may appreciate what you're telling them," he said, "but you're really opening up a whole new world for high school kids, and they get turned on in a way no one else does."

There are other differences between teaching high school and college, of course. Public school art projects are generally product-oriented—creating something that doesn't take long to make, that students may feel good about, and that they can take home to show their families—while college teaching focuses on the process of artmaking, which is a more conceptual and analytical approach. College art faculty are expected to exhibit their work, and their counterparts in public schools somehow have to maintain their desire to make art on their own time. Public school art teachers may easily become frustrated and give up. Hijuelos took a sabbatical from teaching in the 1999–2000 school year in order to rededicate himself to his painting. When he returned to school, Hijuelos instituted a routine in which he would cordon off several hours every evening for himself simply to paint. Both the New York City Art Teachers Association and the National Art Education Association have begun to sponsor art exhibitions of the work of their members in order to encourage and provide a practical goal for artists working in the public schools.

PART-TIME PUBLIC SCHOOL TEACHING

There are many ways for artists to work in the public schools, of which becoming a certified, licensed New York City public school art teacher is but one. Some

artists work as consultants to schools, helping them develop a curriculum that makes use of artworks, music, literature, or dance. "My work is teaching teachers," said Barbara Ellman, a painter who works with public schools through the education department of the Museum of Modern Art. "I'll show them how you can take a work of art and make it a subject of study. That involves finding something that is critical to understanding the piece—maybe the materials or the colors or the content or when it was created—and then develop classroom activities around the piece."

A number of institutions work with schools in this way, regularly or exclusively using artists, including:

ArtsConnection
120 West 46th Street
New York, NY 10036
(212) 302–7433
www.artsconnection.org

Artsgenesis
310 East 46th Street
New York, NY 10017
(212) 696–2787
www.artsgenesis.org

Arts Horizons
One Grand Avenue
Englewood, NJ 07631
(212) 268–7219
www.artshorizon.org

AV-Tech
223–11 103rd Avenue
Queens, NY 11429
(718) 740–9043

Brooklyn Center for the Urban Environment
The Tennis House
Prospect Park
Brooklyn, NY 11215
(718) 788–8500
www.bcue.org

Brooklyn Museum
200 Eastern Parkway
Brooklyn, NY 11238
(718) 638–5000
www.brooklynart.org

Carnegie Hall
881 Seventh Avenue
New York, NY 10019
(212) 903–9600
www.carnegiehall.org

Center for Arts Education
225 West 34th Street
New York, NY 10122
(800) 721–9199
www.cae-nyc.org

Creative Arts Laboratory
Teachers College
Columbia University
525 West 120th Street
New York, NY 10027
(212) 678–3715

Creative Educational Systems
P.O. Box 6659
East Brunswick, NJ 08816
(732) 698–9885

Dia Center for the Arts
548 West 22nd Street
New York, NY 10011
(212) 989–5566
www.diacenter.org

Doing Art Together
P.O. Box 32, Gracie Station
New York, NY 10028
(212) 650–2779

Educational Video Center
55 East 55th Street
New York, NY 10010
(212) 725–3534
www.evc.org

Harlem School of the Arts
645 St. Nicholas Avenue
New York, NY 10030
(212) 926–4100
www.erols.com/hsoa

Henry Street Settlement
466 Grand Street
New York, NY 10002
(212) 598–0400
www.hentrystreetarts.org

LaGuardia Performing Arts
31–10 Thomson Avenue
Long Island City, NY 11101
(718) 482–5151

Learning through an Expanded Arts Program
(LEAP)
441 West End Avenue
New York, NY 10024
(212) 769–4160
www.leapnyc.org

Learning through Art
Solomon R. Guggenheim Museum
1071 Fifth Avenue
New York, NY 10128
(212) 423–3510

Lincoln Center Institute for the Arts
in Education
70 Lincoln Center Plaza
New York, NY 10023
(212) 875–5535

Metropolitan Museum of Art
Fifth Avenue at 82nd Street
New York, NY 10028
(212) 879–5500
www.metmuseum.org

Museum of Modern Art
11 West 53rd Street
New York, NY 10019
(212) 708–9480
www.moma.org

New Museum of Contemporary Art
583 Broadway
New York, NY 10012
(212) 219–1222
www.newmuseum.org

New York Foundation for the Arts
155 Avenue of the Americas
New York, NY 10013
(212) 366–6900
www.nyfa.org

Program in Art and Art Education
Department of Arts and Humanities
Columbia University Teachers College
525 West 120th Street
New York, NY 10027
(212) 678–3270

Queens Museum of Art
New York City Building
Flushing Meadows—Corona Park
Flushing, NY 11368
(718) 592-9700
www.queensmuse.org

Studio in a School Association, Inc.
410 West 59th Street
New York, NY 10019
(212) 765-5900
(212) 459-1455
www.studioinaschool.org

Lincoln Center Institute is one of the oldest of these programs, having been created in 1975, and works with approximately 125 performing and visual artists, who take part in the Institute's Teaching Artist Training Program before going into schools for curriculum development. This is all part-time work, and the actual amount of teaching these artists do in the school varies widely—it may be once or twice a week or a cluster of days. Artists are paid between $250 and $300 per day, although some schools may consider them employees and take out withholding taxes; some schools reimburse artists for transportation costs, others do not. One need not have education credits or previous public school teaching experience in order to participate in this program, according to Catherine Williams, deputy director of the Lincoln Center Institute. "They should be working artists, which would be established through their résumés," she said. "They should be interested in working with school-age children and be able to articulate their reasons for wanting to work with children. Being able to present ideas clearly goes a long way."

Ideally, all public schools should have full-time art teachers. For budgetary and space reasons, that is not the case, and many schools contract out art instruction to private, nonprofit organizations, which provide teaching artists on a nonbenefitted, part-time basis. ArtsConnection, for example, pays artists between $50 and $75 per class, teaching no fewer than two classes and no more than five per day; artists work between five and twenty-five days per year. Studio in a School Association works with over one hundred artists, who are placed in-residence at public schools, day care, and community centers; these jobs last between a few months and a few years, and payment for artists ranges from $28.50 to $36.50 (hourly) and from $170 to $220 (daily). The 92nd Street Y's Schools Partnership Program hires artists for year-long residencies in public schools, paying them $52.50 per class, and there may be as many as six classes per day (artists will only work one or two days per week). Brooklyn Arts Exchange pays artists $300 per day (8:30 A.M. to 2:30 P.M.), working five days per week for the entire school year (there is no summer pay, which regular teachers receive).

These organizations place artists in schools for short-term demonstrations or longer artist-in-residencies:

ArtsConnection
(same contact information as above.)

Artsgenesis
(same contact information as above.)

Arts Horizons
(same contact information as above.)

Asian American Arts Centre
26 The Bowery
New York, NY 10013
(212) 233–2154
www.aaartsalliance.org

Bronx Museum of the Arts
Collaborative Art Project
1040 Grand Concourse
Bronx, NY 10456
(718) 681–6000
www.fieldtrip.com/ny86816000.htm

Brooklyn Arts Council
195 Cadman Plaza West
Brooklyn, NY 11201
(718) 625–0080
www.artswire.org//baca

Brooklyn Arts Exchange
421 Fifth Avenue
Brooklyn, NY 11215
(718) 832–0018
www.bax.org

Caribbean Cultural Center
408 West 58th Street
New York, NY 10019
(212) 307–7420
www.caribectr.org

Center for Book Arts
28 West 27th Street
New York, NY 10001
(212) 481–0295
www.centerforbookarts.org

Aaron Davis Hall for the Performing Arts
City College of New York
135th Street and Convent Avenue
New York, NY 10031
(212) 650–6900
www.ccny.cuny.edu/campus/tour/davis.html

Dia Center for the Arts
(same contact information as above.)

Henry Street Settlement
(same contact information as above.)

Hospital Audiences, Inc.
220 West 42nd Street
New York, NY 10036
(212) 575–7676
www.hospitalaudiences.org

Interactive Drama for Education and
Awareness in the Schools (IDEAS)
57 Front Street
Brooklyn, NY 11201
(718) 834–1033
www.handson.org/ideas.html

Kaleidoscope: Teaching Math through Art
54 Sterling Place
Brooklyn, NY 11217
(718) 399–9233

Learning by Design
New York Foundation for Architecture
200 Lexington Avenue
New York, NY 10016
(718) 768–3365

Learning through an Expanded Arts Program
(LEAP)
(same contact information as above.)

Lindamichellebaron
c/o Harlin-Jacque Publications
P.O. Box 336
Garden City, NY 11530
(516) 489–8564
www.lindamichellebaron.com

Mind Builders Creative Arts Center
3415 Olinville Avenue
Bronx, NY 10467
(718) 652–6256

92nd Street YM-YWHA
1395 Lexington Avenue
New York, NY 10128
(212) 415–5744
www.92ndsty.org

Isamu Noguchi Garden Museum
32–37 Vernon Boulevard
Long Island City, NY 11106
(718) 721–1932
www.noguchi.org

Queens Council on the Arts
One Forest Park
Woodhaven, NY 11421
(718) 647–3377
www.queenscouncilarts.org

Rockaway Artist's Alliance
260 Beach 116th Street
Rockaway Park, NY 11694
(718) 474–0861

Snug Harbor Cultural Center
1000 Richmond Terrace
Staten Island, NY 10301
(718) 448–2500

Sociedad Educativa de las Artes, Inc.
107 Suffolk Street
New York, NY 10002
(212) 529–1545
www.sea-ny.org

Young Audiences
One East 53rd Street
New York, NY 10022
(212) 319–9269
www.yany.org

In addition, there are also opportunities for artists in after-school art programs for pre-school, elementary, middle and high school children at a number of institutions, including:

BRONX

Bronx River Art Center and Gallery
1087 East Tremont Avenue
Bronx, NY 10460
(718) 589–5819
www.bronxriverart.org

Lehman Center for the Performing Arts
250 Bedford Park Boulevard West
Bronx, NY 10468
(718) 960–8731
www.lehman.cuny.edu

Longwood Arts Project
965 Longwood Avenue
Bronx, NY 10459
(718) 931–9500
www.longwoodcyber.org

Mocholu Montefiore Community Center
3450 DeKalb Avenue
Bronx, NY 10467
(718) 882–4000

Riverdale Community Center
660 West 237th Street
Bronx, NY 10463
(718) 796–4724

BROOKLYN

Brooklyn Museum of Art
200 Eastern Parkway
Brooklyn, NY 11238
(718) 638–5000, ext. 238
www.brooklynart.org

Center for Art and Culture of
Bedford-Stuyvesant
1368 Fulton Street
Brooklyn, NY 11216
(718) 636–6976

Kingsborough Community College
2001 Oriental Boulevard
Brooklyn, NY 11235
(718) 368–5184

El Puente
211 South Fourth Street
Brooklyn, NY 11211
(718) 387–0404

The Rotunda Gallery
33 Clinton Street
Brooklyn, NY 11201
(718) 875–4047
www.brooklynx.org/rotunda

Manhattan
92nd Street YM/YWHA
1395 Lexington Avenue
New York, NY 10128
(212) 996–1100
www.92ndsty.org

American Craft Museum
40 West 53rd Street
New York, NY 10019
(212) 956–3535

American Museum of Natural History
Central Park at 79th Street
New York, NY 10024
(212) 769–5100
www.amnh.org

Art Students League of New York
215 West 57th Street
New York, NY 10019
(212) 247–4510

ArtsConnection
120 West 46th Street
New York, NY 10036
(212) 302–7433
www.artsconnection.org

Asian American Arts Center
26 Bowery
New York, NY 10013
(212) 233–2154

Center for Book Arts
28 West 27th Street
New York, NY 10001
(212) 481–0295
www.centerforbookarts.org

Children's Museum of the Arts
72 Spring Street
New York, NY 10012
(212) 274–0986

Cooper-Hewitt National Design Museum
2 East 91st Street
New York, NY 10128
(212) 849–8390
www.si.edu

The Door
55 Broome Street
New York, NY 10013
(212) 941–9090
www.door.org

Educational Alliance Art School
197 East Broadway
New York, NY 10002
(212) 780–2300
www.edalliance.org

Harlem School of the Arts
645 St. Nicholas Avenue
New York, NY 10030
(212) 926–4100
www.harlemschoolofthearts.org

Henry Street Settlement
466 Grand Street
New York, NY 10002–4804
(212) 598–0400
www.henrystreetarts.org

Lenox Hill Neighborhood House
331 East 70th Street
New York, NY 10021
(212) 744–5022

Metropolitan Museum of Art
1000 Fifth Avenue
New York, NY 10028–0198
(212) 570–3828
www.metmuseum.org

El Museo del Barrio
1230 Fifth Avenue
New York, NY 10029
(212) 831–7272
www.elmuseo.org

Museum for African Art
593 Broadway
New York, NY 10012
(212) 966–1313
www.africanart.org

Studio in a School
410 West 59th Street
New York, NY 10019
(212) 705–5900
www.studioinaschool

QUEENS

Jamaica Center for Arts and Learning
161–04 Jamaica Avenue
Jamaica, NY 11432
(718) 658–7400

P.S. 1 Contemporary Art Center
22–25 Jackson Avenue at 46th Avenue
Long Island City, NY 11101
(718) 784–2084
www.ps1.org

Queens Museum of the Arts
Flushing Meadows—Corona Park
Corona, NY 10368
(718) 592–9700
www.queensmuse.org

STATEN ISLAND

Snug Harbor Cultural Center
1000 Richmond Terrace
Staten Island, NY 10301
(718) 448–2500
www.snug-harbor.org

Staten Island Children's Museum
1000 Richmond Terrace
Staten Island, NY 10301
(718) 273–2060, ext. 237
www.kidsmuseum.org

OPPORTUNITIES FOR EMPLOYMENT IN THE ARTS

Supporting oneself while pursuing one's art—or just supporting oneself—is no easy matter in the art world, especially in such an expensive city as New York. Job listings are posted and updated at the state arts and humanities agencies of the following states.

CONNECTICUT

Connecticut Commission on the Arts
755 Main Street
Hartford, CT 06103
(860) 566–4770
www.cslnet.ctstateu.edu/cca

Connecticut Humanities Council
955 South Main Street
Middletown, CT 06457
(203) 685–2260
www.cthum.org

NEW JERSEY

New Jersey State Council on the Arts
20 West State Street, CN 306
Trenton, NJ 08625–0306
(609) 292–6130
www.njsca.org
e-mail: njscaaah@tmn.com

New Jersey Committee for the Humanities
28 West State Street
Trenton, NJ 08608
(609) 695–4838
www.njch.org

NEW YORK

New York State Council on the Arts
915 Broadway
New York, NY 10010
(212) 387-7000
www.nysca.org
e-mail: nysca@tmn.com

New York Council for the Humanities
150 Broadway, Suite 1700
New York, NY 10038
(212) 233-1131
www.culturefront.org

One should also examine the classified sections of service organizations' newsletters, which may list job openings; and some of these organizations also maintain a job file, within their offices, of currently available positions. A number of employment agencies and recruiters, some nonprofit and some for-profit organizations, as well as groups that largely exist as a Web site, list available jobs and opportunities online. At times, one Web site may be of limited value, but they have links to other sites that have far more offerings. A good, all-purpose cyberspace-only company, Blink.com (*www.blink.com*), offers a vast array of links to those in search of jobs, housing, public art sponsors, artists organizations, and lots more. Below is a listing of organizations and publications that list available jobs through a newsletter or online:

Academic360.com
www.academic360.com
Jobs in higher education.

The National Network for Artist Placement
935 West Avenue 37
Los Angeles, CA 90065
(213) 222-4035
Publishes a *National Directory of Arts Internships* ($35) that lists internship opportunities at small and large arts organizations around the country.

American Philanthropy Review
www.charitychannel.com/career_search/

American Symphony Orchestra League
Bulletin
777 14th Street NW
Washington, DC 20005

(202) 628-0099
$25 for monthly listing of conducting positions; $25 for monthly listing of performing positions; $30 bimonthly listing of administrative positions.

Art Call
P.O. Box 4468
South Colby, WA 98384-0468
(360) 871-5371
www.artistcall.com
$36 per year for twelve monthly issues (or for twelve monthly disks; $24 per month for e-mail) containing information on competitions, internships, teaching positions, and job opportunities.

Artswire
Artswire.org/current/jobs.html
Free listing, updated weekly, of employment and internship opportunities for artists, administrators, and teachers.

Art Deadlines List
Resources
Box 381067
Cambridge, MA 02238
www.artdeadline.com
$30 per year for twelve monthly lists of competitions, jobs, fellowships, internships, and scholarships.

Artists
Plymouth Publishing
P.O. Box 40550
Washington, DC 20016
(703) 506–4400
$25 for twelve monthly issues, listing jobs for artists, arts administrators, and arts educators.

Artjob
WESTAF
236 Montezuma Avenue
Santa Fe, NM 87501
(505) 986–8939
www.webart.com/artjob
$30 for six monthly issues; $45 for one year.

Artsearch
355 Lexington Avenue
New York, NY 10017
(212) 697–5230
www.tcg.org
$40 for twenty-three issues.

Aviso
American Association of Museums
1225 Eye Street NW, Suite 200
Washington, DC 20005
(202) 289–1818
$33 for AAM nonmembers.

Charity Channel's Career Search Online
www.charitychannel.com/careersearch
Jobs in the nonprofit sector.

Chronicle of Philanthropy
www.philanthropy.com/jobs.dir/jobsmain.htm
Jobs in the nonprofit sector.

College Art Association of America
Placement Service
275 Seventh Avenue
New York, NY 10001
(212) 691–1051
$23 subscription for a full year.

Community Career Center
www.nonprofitjobs.org
Jobs in the nonprofit sector.

Corporation for National Services
www.cns.gov/jobs/jobs/
Jobs in public agencies.

Council on Foundations
www.cof.org/jobbank

Creative Artists Network
P.O. Box 30027
Philadelphia, PA 19103
(215) 546–7775

Current Jobs in the Arts
P.O. Box 40550
Washington, DC 20016
(703) 506–4400
$19 for three monthly issues.

Idealist
www.idealist.org
Index of, and links to, nonprofit organizations.

JOBline News
The Graphic Artists Guild of New York
90 John Street
New York, NY 10038
$75 per year for forty-eight issues for Guild members, $100 for nonmembers.

Jobs in Government
www.jobsingovernment.com/seekers/
 seekers.htm

Job Source Network
www.jobsourcenetwork.com/employ.html
Employment agencies.
wwwjobsourcenetwork.com/popula.html
A large group of online job search sites.

National Arts Placement
National Art Education Association
1916 Association Drive
Reston, VA 22091
(703) 860-8000
$45 for nonmembers.

Nonprofit Career Network
www.nonprofitcareer.com

Nonprofit Career Quest
www.nonprofitcareerquest.com
Jobs in the nonprofit section in Canada.

Nonprofit Times
www.nptimes.com/classified.html
Jobs in the nonprofit sector.

OpportunityNocs
www.opportunitynocs.com
Listing jobs in the nonprofit sector.

Opportunity Resources, Inc.
500 Fifth Avenue
New York, NY 10017
(212) 575-1688
Executive search firm for mid- and upper-
management positions for cultural institutions
across the United States.

Philanthropy News Digest
http://fdncenter.org/pnd/jobs/index.html
Job listings from the Foundation Center.

Philanthropy News Network
http://pnnonline.org/jobs/

Professionals for Nonprofits
http://www.nonprofit-staffing.com

Resources and Counseling for the Arts
429 Landmark Center
75 West Fifth Street
St. Paul, MN 55102
(612) 292-3206

VisualsOnline
Visualsonline.com/jobpostings.html
Free listing of employment and show opportu-
nities for artists and craftspeople.

WorldWide Art Resources
www.wwar.com
Employment opportunities.

For jobs in the design field:

Art Directors Club
www.adcny.org/job/job2.html

Communication Arts
www.commarts.com/career/index.html

Find Creative Jobs
www.findcreative.com

Interior Design Jobs
www.interiordesignjobs.com

Jobs in Fashion
www.jobsinfashion.com

Jobs in New Media
www.newmedia.computerjobs.com

Philadelphia Academy of Fine Arts Job Bank
www.pafa.org/school/alumni/jobs.shtml

School Jobs (public schools)
www.schooljobs.com

U.S. Creative
www.uscreative.com/members/jobs/
 jobseekers.cfm

For general employment job
search sites:

America's Job Bank
www.ajb.dni.us/

Career Mosaic
www.careermosaic.com

Career Path
www.careerpath.com

Job Sleuth
www.jobsleuth.com

Job Options
www.joboptions.com

Jobtrak
www.jobtrak.com

The Monster Board
www.monsterboard.com

Wall Street Journal's Careers
http://careers.wsj.com

Chronicle of Higher Education
http://chronicle.com/jobs

Government Jobs
www.govtjobs.com

Playbill Jobs Search
www.playbill.com

Techies.com
www.techies.com

One of the more innovative ideas in helping artists find jobs, a two-year professional development fellowship sponsored by the College Art Association (address and contact information listed above), assists artists of color and other diverse backgrounds (ethnicity, race, and sexual orientation) who are in financial need and in the process of earning an M.A., M.F.A., or Ph.D. During the first year, the artist receives $5,000; in the second year, the artist will be assisted in finding a job, for which the College Art Association provides a subsidy to the employer.

RÉSUMÉ OR C.V.?

Artists may apply for many things over the course of their careers—it may be a salaried job or a public art commission, a fellowship, entry into a juried art competition or a gallery. In all these opportunities, artists need a way to document their careers in a professional manner, but no one document may suffice for every situation. A gallery owner or a foundation, for instance, would want to know where an artist has exhibited, who has commissioned the artist previously, in what public or private collections are the artist's work, in what publications has the artist's work been reviewed, where the artist has taught or lectured, and where the artist received his or her training. However, a gallery owner or foundation administrator would have less interest in knowing how many years the artist worked as a museum guard or waited tables in restaurants: Although knowing how the artist actually makes a living makes for an interesting anecdote, the information may work against the artist, raising questions about how serious the person is about his or her art. Similarly, an employer looks for relevant work experience—how long and how recently the applicant has been employed in the field, what skills the individual has acquired that can be brought to the currently available job, how long the applicant has stayed in any particular job, whether or not the individual has received promotions at a previous company, the specific salaries that the applicant has received in the past, academic degrees earned, and any additional courses or training relevant to the type of work. A document that describes an individual's one-person and group art exhibition record, grants and awards received, and who has purchased the applicant's work might turn off a potential employer: Clearly, this individual is more devoted to an art career than to the job at hand.

A résumé is a history of employment experience, listing (usually in reverse chronological order) the relevant jobs one has had, naming the employers and dates of employment. One should use active verbs in the descriptions of the tasks performed in previous jobs (directed, managed, coordinated, supervised), rather than weaker, passive language (involved with, was responsible for, on the staff of), because this demonstrates the applicant was an active role-player rather than merely filling a position. It also gives greater authority to what otherwise may be low-level positions. Career counselors also regularly advise job seekers to include a "Profile" or "Summary" section near the top of their résumés, which reveals quickly to someone scanning the document—and they

are more scanned than read—the skills and most relevant experience that the applicant brings. This shorthand approach allows applicants to describe themselves rather than hoping that the reader will carefully examine everything written to figure out what the job seeker knows and can do. A sample résumé may look like this:

ELIZABETH SCULPTOR
40 Seventh Avenue
Brooklyn, New York 11211
(718) 555–5555
E-mail: *esculptor@aol.com*

PROFILE
Managed the branch of a print shop chain.
Adept in Excel, Quark, PhotoShop and several database programs.

EMPLOYMENT HISTORY

1998–2001: *Manager,* Alley Cat Print Shop, 252 Grand Avenue, Brooklyn, New York.
Directed the day-to-day operations of a print shop, hiring and supervising personnel, preparing weekly reports of revenues, and maintaining a customer database.

1996–1998: *Gallery Assistant,* Brooklyn Public Library Gallery, Flatbush Avenue and Eastern Parkway, Brooklyn, New York.
Coordinated the exhibitions, corresponded with exhibitors, built display cases, installed objects, and built shipping crates.

1995–1996: *Intern,* Brooklyn Museum of Art, 200 Eastern Parkway, Brooklyn, New York.
Designed and directed the printing of brochures and other promotional materials for both the office of development and the education department.

ADDITIONAL EXPERIENCE

1997–2001: *Art Instructor,* Continuing Education Program, Pratt Institute, 200 Willoughby Avenue, Brooklyn, New York.

EDUCATION

1996: Bachelor of Arts, Brooklyn College, Brooklyn, New York.

A bio or C.V. (curriculum vitae), on the other hand, describes an artist's exhibition record and any other professional achievements as an artist. Most artists need to be able to describe themselves in two separate documents, both of which are factually true, but reveal aspects that are pertinent to the specific situation. The C.V. of the same individual may look like this.

ELIZABETH SCULPTOR
40 Seventh Avenue
Brooklyn, New York 11211
(718) 555–5555
E-mail: *esculptor@aol.com*

SELECTED ONE-PERSON EXHIBITIONS

2001: DUMBO Arts Center, Brooklyn, New York.
1997: Rotunda Gallery, Brooklyn, New York.

SELECTED GROUP EXHIBITIONS

2001: "10 Artists Downtown," Smack Mellon, Brooklyn, New York.
2001: "Art Under the Bridge," DUMBO Arts Center, Brooklyn, New York.
1999: "A Metal Block," Islip Art Museum, Islip, New York.
1996: "Between a Rock and a Hard Place," Brooklyn College Art Gallery, Brooklyn, New York.

REVIEWS

"'10 Artists Downtown' Moving Up" by Robert Hurley, *Village Voice,* August 27, 2001.
"Sculpture at Islip" by Karen Moody, *Newsday,* February 13, 1999.

TEACHING EXPERIENCE

1997–2001: *Art Instructor,* Continuing Education Program, Pratt Institute,
200 Willoughby Avenue, Brooklyn, New York.

EDUCATION

1996: Bachelor of Arts, Brooklyn College, Brooklyn, New York.

COLLECTIONS

Brooklyn College Art Gallery
Brooklyn Public Library Gallery
Mr. and Mrs. Theodore Steinway
Esther Levitt

Chapter 5.
PUTTING WORK UP FOR DISPLAY

Coming to New York and "being" a New York artist is about as far in their think-ing as many artists go. What happens next? Well, many assume something magical must happen, because, of course, it is always New York artists that one hears or reads about. However, as New York artists can attest, simple residency in the Big Apple only puts one physically closer to the action; it doesn't lead to exhibitions, commissions, or sales. That takes some career planning.

FINDING A DEALER IN NEW YORK CITY

In early 1957, Leo Castelli was looking for up-and-coming American artists for the New York City gallery he had recently opened. One of the artists whose works he was currently showing, Paul Brach, gave a strong recommendation for his friend Robert Rauschenberg and arranged a studio visit. While there, Rauschenberg happened to mention his friend and fellow artist Jasper Johns, whose painting "Green Target" Castelli had seen at an exhibition at the Jewish Museum and whose studio was one floor below. Within a matter of days, both artists were slated for one-person shows at the Castelli Gallery, which made both the artists and the dealer major stars of the art world.

Fame and prestige are difficult to predict; easier to chart is the power of a word of recommendation to lead to major events—if not in the history of art, then at least in the life of an artist. The New York gallery world strains to accom-modate the tens of thousands of artists who live and work within a few miles of the galleries, not to mention the scores of thousands who live elsewhere in the country and around the world, and gallery owners rely on the word of the artists they already represent, as well as that of collectors, critics, curators, and other dealers, to alert them to new artists. Such was the case of Jilaine Jones, a sculp-

tor in New Haven, Connecticut, who was brought to the attention of Larry Salander, owner of New York's Salander-O'Reilly Galleries, by *Partisan Review* art critic Karen Wilkin. Wilkin had first seen Jones's student work in 1979 at the School of the Museum of Fine Arts in Boston when the critic was invited to make a critique. Four years later, the two met again at the no-longer-extant Triangle Workshop artist community in Pine Plains, New York, where they were both in residence. After that, Wilkin made a point "to see Jones's work every other year," although the two were in periodic contact because of having artist friends in common.

By the late 1990s, Jones had received a fellowship from the Connecticut Commission on the Arts, and her work had been exhibited at a variety of galleries and museums in Connecticut and New York—including Artspace in New Haven, the Stamford Museum, Silvermine Guild Gallery in New Canaan, and the New York Studio School Gallery in Manhattan—but she did not have a dealer representing her. Unbeknownst to her, however, Wilkin's years of interest in her sculpture was about to pay off. "I rarely pass on recommendations to dealers, although I'm asked to do so all the time," Wilkin said. "But, when there are artists I'm very excited about, who I know don't have a gallery, I have asked dealers to look at their work, to their get ideas about which galleries the artists should contact. I remember showing Larry Salander some slides of Jilaine's work, and he was so bowled over by what he saw that he took her on then and there."

Salander stated that most of the artists he shows at his gallery came to him "through some trusted person's recommendation," but not every one. In 1991, George Fitzpatrick, a self-taught, largely unknown painter in Cleveland Heights, Ohio, simply sent Salander a portfolio containing photographs of his work with a note that read, "Dear Mr. Salander: I would like to exhibit my drawings at your gallery. To that end I have prepared this book illustrating a portion of my work over the past sixteen years. I would be pleased to hear from you and, if you wish, to show you my drawings either in Cleveland or in New York." Again, Salander was taken with the work and telephoned Fitzpatrick immediately, telling him to send some of his works to the gallery. "I told him I'd rather bring them in person," the artist said. "Larry told me that once he sees the actual work, he might decide he doesn't like it, but I decided to bring it to him in person anyway. When I came in, he looked at my drawings, and in five minutes he told me it would be an honor to represent me."

This sequence of events is rare enough that one could hardly recommend to artists that they just send slides to dealers they don't know and with

whom they have no art world friends or acquaintances in common to make a recommendation on their behalf. "I don't go to artists' studios indiscriminately," said New York City dealer Stephen Rosenberg. "I'm too busy, and I'm too tired. Things develop through relationships, not by some artist just showing up or sending me a packet of slides and saying, 'Look at me.'" Fitzpatrick had actually sent portfolios to four dealers in New York back in 1991. Two of the dealers never acknowledged having received them, and one—to Larry Gagosian—was returned unopened. Only Larry Salander took the time to open the box, look at the portfolio, and make contact with the artist. Salander noted that he or someone in the gallery looks at all the artists' packets that come in, and everyone's is returned, sometimes with a note that suggests an interest in seeing more work in the future. "At the beginning of my career as a dealer, an old guy I know—he was also a dealer—called me up and told me to come over to look at some photographs of work by a painter," Salander said. "The implication was that I should take this artist on. I said to him, 'Oh, God, don't do this to me. I don't want to look at any more artists' work, my plate is already full.' But then I went down and looked at those photographs. They were amazing works; I couldn't believe it. I asked, 'Who is this person?' and this dealer told me the photographs were details of paintings by Piero della Francesca. The point is, the next Piero della Francesca will walk through a door one time, and I hope it will be mine. I hope I will be smart enough to appreciate an artist like that."

The value of recommendations for art dealers is that they can rely on something other than just their own eye to evaluate an artist's work. Sometimes, a gallery owner may be enthusiastic about an artist's work but wants to know personal qualities about the artist before taking him or her on: Is the artist productive (creating enough work for exhibitions every two or three years)? Is the artist mature and reliable (understanding a business relationship without whining and causing disruptions)? Is the artist personable (able and willing to converse with collectors)? Has the artist worked with galleries in the past? The people from whom a dealer takes recommendations seriously also know whether or not the new artist fits into the gallery's aesthetic and might be temperamentally compatible with the gallery director.

"I know Stephen [Rosenberg] socially, and I know what kind of work he shows," painter Janet Fish said. "I thought Lex Braes's work was at a high level and well suited to Stephen's gallery. I also liked Lex a lot and wanted to help him if I could." She telephoned Rosenberg, advising him to look at Braes's work: "It

was all pretty direct. I told him, 'In my opinion, this guy's a really good painter, and I think you should look at his work.'" Fish and Braes had met at an artists community in the 1980s, "and we had a rapport," Braes noted.

Braes was not otherwise unknown to Rosenberg, since the artist had been visiting the gallery for three years before he was invited to show his work there in 1991. After making visits to the gallery, he eventually struck up conversations with the dealer, and when Braes showed his work elsewhere, Rosenberg regularly received invitations and notices. Dealers like to be courted and to see that an artist has a commitment to their galleries. "An artist should want a working relationship with a gallery, not just a show," Rosenberg said. "The business of instant stardom is overdone." Rosenberg had begun to take notice of Braes's regular appearances at the gallery and of the invitations to shows, but it was Janet Fish's call that led him to make a studio visit. During the conversation, Braes dropped the fact that a rival dealer—Nancy Hoffman—was also looking at his work, and Rosenberg soon asked to represent him.

Better-known artists are often asked to make introductions on behalf of some new, young artist to gallery owners, which puts them in a bind sometimes. These more-established artists can remember wanting and needing the very same recommendations themselves earlier in their careers, and they frequently see it as their "role to be helpful to younger artists," according to painter Marthe Keller. Still, they may not feel an artist's work is ready to be brought before a serious dealer, and if they find themselves making too many recommendations, the value of their introductions will be discounted. Introductions in themselves may be overrated as a means of attaining success in the gallery world. Certainly, a recommendation may convince a busy gallery owner to take time out to actually look at an artist's work—an experience artists who simply send in materials to dealers cold cannot often claim—but other factors need to be in place before a relationship between an artist and a dealer will begin to form. The artist's work needs to be appropriate for the gallery (same style, size, medium, and price range), and the gallery owner has to personally like the work ("my work came to him when Larry was exactly ready for it," George Fitzpatrick said); the artist should have some exhibition history, as well as a track record of sales, and the artist and gallery owner need to be able to get along.

Sometimes (probably more than half of the time), absolutely nothing comes of an introduction. Janet Fish noted that painters Chuck Close and Alex Katz made recommendations to dealers on her behalf. She even called one of

her collectors to ask that person to contact a particular gallery about her work. "It was encouraging to me that people were trying to help me, but that didn't mean I got anything from it. It's not the ticket." Calling the process of going round to galleries "a crap shoot," she said that "some people come off the street and show work that the dealer likes right away. On the other hand, someone may say he'll make a recommendation for an artist, but then this so-called friend ends up bad-mouthing the artist to the dealer. You never know." Once, she made a recommendation for an artist to her own dealer, and when the artist came into the gallery to show the dealer his work, "the artist was treated horribly. I thought that was discourteous to the artist and to me. I was later to find out that this dealer was mean to a lot of people, and that was a contributing factor to my leaving that gallery for another dealer."

A recommendation is made as a token of friendship and respect, which takes time to develop. Artists expecting to rush into making quick acquaintances with critics or notable artists who will just as quickly turn around and make a recommendation are likely to be disappointed. Relationships develop organically—based on shared interests, ideas, mutual friends, values, and a compatibility of personalities—over a period of years. During that time, artists must remain devoted to their artwork, allowing the power of connections to grow slowly, without staring at the clock. Marthe Keller first came into contact with painter Alex Stolyarov at the School of the Art Institute of Chicago in the early 1990s, when he was a student and she a visiting artist. She also taught one term at the Oxbow Summer Institute, which is run by the school and which Stolyarov attended. "Alex struck me as unusually intelligent and very astute in observing art," she said. "I didn't get to know many students there. They were mostly sweet and unambitious. Most people who study art don't go on to become artists, and the fact that here was someone who was really dedicated to his art was surprising." Keller added that she has also kept in touch with a couple of students from a graduate seminar at the Hartford Art School in Connecticut (where she was a visiting artist), and she "might write a reference some day" for one student from Ohio State University.

When Stolyarov moved to New York City in 1992, he got in touch with Keller—"she is very part of the art community," he said. Within a year or two, Keller was periodically visiting Stolyarov's studio, talking with him about his work and offering general encouragement. "When she felt that my paintings were ready to be shown, she asked Stephen Rosenberg to come over and see them." Rosenberg did so, spending over an hour, and asked Stolyarov to contact

him again when his work had developed further. Eight months after that first visit, Rosenberg and his partner, Fran Kaufman, both went to his studio and offered to put a couple of his works in a group show that summer (1996). One of the two works sold—his first art sale ever, earning him $1,000 before the commission—and Stolyarov was invited to participate in the following summer's exhibit at the gallery as well.

Nothing of his sold from that second show, but it was seen by Elizabeth Harris, who owned a gallery in Chelsea, and Bill Carroll, who was the director of her gallery. "I went there initially to look at someone else's work, but it was Alex's work that was really captivating," Harris said. She asked Rosenberg for Stolyarov's telephone number and called him to arrange a studio visit, where they found a piece they wanted to put in a group show that autumn. That work sold almost immediately to yet another dealer for $1,200, and Stolyarov was invited to have his first one-person exhibition at the Elizabeth Harris Gallery the following year, in which two small works were sold. At that point, he was officially represented by the gallery. "It's the domino principle," he said, describing the gallery world. "Marthe Keller asked someone I would hesitate to ask to see my paintings, which led to a group show, which led to another group show, which led to other dealers seeing my work, and one of them made me a part of her gallery."

Sometimes, dealers don't need the say-so of someone else and simply bring in an artist whose work they admire. Dealers regularly look at shows at other galleries or attend invitational art exhibits or look through art publications in search of work that pleases them. Galleries can only represent so many artists at one time—twenty is a standard number—and dealers speak truthfully when they tell hopeful artists that they are "not looking for artists at this time." That doesn't mean they are not looking at artists or that they don't want to establish a relationship with additional artists. Galleries often have a range of relationships with artists, from acting as their agents to including them in group shows (which is a type of tryout for the gallery) and keeping their slides on file for corporate or other clients who might hire the dealers as art consultants (another type of tryout).

Next to selling art, a dealer's principal job is to find art to sell, and all but the laziest ones continuously keep their eyes and ears open, looking everywhere. Stephen Rosenberg discovered the work of Dennis Pinnett in a juried show of painting at the Silvermine Guild in Connecticut in 1986. "I didn't really like the show, but I liked Dennis's work," he said. Elizabeth Harris had seen

Peter Atchison's work at a cooperative gallery on Greene Street in SoHo called The Painting Center in the fall of 1997 and then called him to arrange a studio visit. Within a few weeks of that visit, Harris telephoned Atchison to say, "I have an open slot in January. Could you put together a show of work that hasn't been shown before?"

THE ARTIST-DEALER RELATIONSHIP

One of the chief benefits of artists looking to show their work in New York actually being in New York is that they can easily visit the galleries in which they are interested. There are more than four hundred commercial galleries, in addition to cooperatives, nonprofit alternative spaces, and other exhibition sites (corporate lobbies, community centers, libraries, schools, hospitals, cafés, and restaurants). Since the gallery world is spread out geographically, it is useful to have a sense in advance of which galleries are more likely to be a good fit with one's art. *Art in America*'s annual *Sourcebook to the U.S. Art World* alphabetically lists hundreds of commercial galleries, museums, and alternative spaces in Manhattan and the other boroughs, providing the address, telephone number, and Web site address of the gallery, the name of the gallery director, the media shown, and the names of most or all of the artists represented. Another valuable source of information is *Art Now Gallery Guide,* found in many galleries, which lists current shows by neighborhood (SoHo, NoHo, Chelsea, and 57th Street, for example) and includes photographs of some of the works on view. *Gallery Guide* also has a Web site (*www.galleryguide.org*), by which one may also tour the gallery sites electronically and view the art on display. Another online source of information is Art in Context (*www.artincontext.com*), which offers a listing of galleries that can be categorized by discipline, genre, and geographical area; there are also links to many of these galleries, where works by gallery artists may be seen. A Williamsburg, Brooklyn version of this is Billburg (*www.billburg.com/arts/galleries.cfm*).

A gallery would be appropriate for an artist if the work represented is similar stylistically and in the same medium. The artists should be of the same relative level of experience, and the work should be in the same price range—just because your work looks like Frank Stella's doesn't mean that Stella's dealer should take you on. Physically, the gallery itself should be suitable for one's art, with adequate wall space for tall paintings or high enough ceilings for large sculpture. The installation of shows would also be of interest to artists, who

would want to see that work is properly hung, not crowded together or stuck in corners that are not sufficiently illuminated. Information about the artist and the artwork on display should be readily available to visitors, and staff need to be welcoming. Artists should visit galleries repeatedly to be confident that any worries could be dispelled.

Finding a gallery becomes an obsession for many artists who assume that once they land a dealer, the hard work of getting shows, promotional efforts, and sales will be taken over by the dealer. In reality, galleries charge higher commissions (50 or 60 percent or more) and do far less for the artists they represent than thirty or forty years ago: Few galleries take out newspaper or magazine advertisements for artists' shows, unless the artists pay at least half of the cost; publishing even small catalogues is a rarity for all but the most prestigious artists; dealers almost never pay for the framing of paintings and prints, only doing so when they will deduct those costs from the sale of works.

Even after becoming represented by a gallery, artists may still have to do all of the same audience development and sales work (better known as "marketing") as before. However, the artist acquires a permanent space, rather than showing work in his or her studio or hunting around continually for exhibition venues. Artists also gain the endorsement of a third party (the dealer) rather than themselves having to tell collectors, critics, and curators how good they are.

Establishing a solid business relationship at the beginning, in which both artist and gallery owner understand what is expected of them, removes a number of tensions that frequently plague this association. Some artists and their dealers have written legal contracts, but not that many. Artists are frequently hesitant to present dealers with such a document for fear of turning off the agents they have been trying to win over for so long, and dealers use that fear to look askance at artists who want to insure their legal rights. As much as artists want to be represented in a gallery, they must be certain that they can have a satisfactory relationship with the gallery owner. Before making any agreements, the artist and dealer should meet on several occasions—once, perhaps, at the artist's studio, another time at the gallery, and yet another time at a neutral location, such as a restaurant, museum, or café—in order to determine: Do they get along? Can the artist speak frankly with the dealer? Does the dealer seem to get what the artist is doing in his or her work? Does the artist feel listened to? Will this relationship wear well over time?

A few meetings may not answer all the questions, and artists may want to talk with other artists that the gallery currently represents or represented in the past. (To find out whom the gallery showed in the past but doesn't now, look at a copy of *Art in America's Sourcebook to the U.S. Art World,* which is published every summer, from a few years back and compare the names to those currently listed.)

During the meetings with the dealer, business issues should come up, and these include: Is this an exclusive relationship (the gallery handles all sales for all works the artist produces throughout the world) or may the artist show work (perhaps work in another medium) in other galleries in the same city, region, or country and even sell from his or her studio? What is the commission for sales? What are the prices for the works (set for each individual piece or for a group of artworks), and can discounts be offered (5 or 10 percent is common)? When will the artist's work be shown (every year, every two or three years), and what is the nature of the exhibition (one-person, group shows)? When will the artist be paid after a sale takes place (within thirty days is optimal, no more than sixty or ninety days)? May the work be sent out on loan (and, if so, who pays for any damage to, or theft of, the work)? Will the artist be notified of who purchased the work (and receive a sales receipt)? Who will cover the costs of advertising, framing, shipping, crating, and insurance? If there is a dispute, will it go to mediation? How long shall this agreement be in effect (one or two years, perhaps more) and how will the relationship be terminated? These issues should then be written down informally as a letter from the artist to the dealer—Dear Bob, I enjoyed our lunch the other day. As we discussed . . . —and lay out the terms of the agreement. That letter should be signed by the artist and also by the dealer, which forms a legally binding contract. An oral agreement is also a binding contract, but it is more expensive to enforce, because of the need for depositions to determine who said what when; memories fade and change, and lawyers charge by the hour.

Every time the artist sends any work to the gallery, it should be accompanied by a consignment form, listing what the work is (medium), its title, size, and price, which should be signed or initialed by the dealer. A paper trail insures that any lost or stolen works are the responsibility of the gallery. In addition, New York State has an artist consignment law protecting artworks from being seized by creditors if the gallery goes bankrupt.

WHAT PRICE TO SHOW IN NEW YORK?

In order to succeed in one's career, we are often told, one needs to invest in it. That may mean additional schooling—would-be lawyers and doctors, for instance, have rigorous academic programs and sizeable tuition bills ahead of them—or taking out advertisements or purchasing a new wardrobe or simply buying business cards. Money needs to be spent, but it must be spent for the most appropriate things: Should the musical group invest first in new outfits, in producing a demo CD, or in new equipment? That may depend on whether or not they have a bunch of performances planned, if they are looking for a recording contract or if their instruments are adequate. On the other hand, it might seem odd for a would-be novelist to "invest" in an expensive pen with which to do book signings before the first page of a manuscript has been written.

Fine artists also have investment decisions to make: Art supplies can be quite expensive; paintings may need to be framed, sculptures placed on pedestals; works may have to be crated, shipped, and insured. There are outlays for postcards, postage, brochures, slides, and even (perhaps) a Web site. Still more possible expenditures loom ahead.

Should artists buy an ad in a who's who type of directory or rent a booth space at an art fair? New York City offers another opportunity for spending: renting a gallery for an exhibition. There are a number of exhibition spaces—most of them called galleries—that charge artists between $1,000 and $4,000 for the opportunity to display their work for a two- to four-week period. Monserrat Gallery, for instance, which is located at 584 Broadway, has three rooms that are rented for two-week shows. The room with a twenty foot-long wall costs $1,900; the gallery with a thirty-foot wall is $2,300; and the forty-foot-long space rents for $3,900. Jadite Gallery, at 413 West 50th Street, charges $1,200 for its small room and $3,500 for the larger space for shows lasting four weeks. "We love artists, and we try to treat them well," Katalina Petrova, assistant director of Jadite, said.

Similar fee structures are also found at Agora Gallery (560 Broadway), Art Alliance (98 Greene Street), Artsforum Gallery (24 West 57th Street), Broome Street Gallery (498 Broome Street), Caelum Gallery (526 West 26th Street), Cast Iron Gallery (159 Mercer Street), E3 Gallery (47 East Third Street), Emerging Collector (62 Second Avenue), Jain Marunouchi (24 West 57th Street), New Century Artists (168 Mercer Street), Nexus Gallery (345 East 12th Street), Slowinski Gallery (215 Mulberry Street), Subculture (376 Broome

Street), and World Fine Art (443 Broadway). Most of these gallery spaces are located in major gallery districts—57th Street, SoHo, Chelsea, and the East Village—which might suggest to artists that even if the gallery itself is not prestigious, walk-in traffic may well include real collectors. Manhattan Fine Art Storage, which has two gallery spaces that rent for $75 and $125 per day, regularly advertises in art magazines: "Have a show in SoHo."

Rental costs may or may not include the expense of someone actually hanging the show or sitting in the gallery—the artists or their friends and families often assume those jobs—and promotional efforts are limited at best. New Century Artists will place a listing in *Art Now Gallery Guide,* but Feroline Pavone, owner of Agora Gallery, stated that artists may have a catalogue for their shows "if they pay for that."

The likelihood that shows at these "vanity galleries" (as they are sometimes called) will be reviewed is almost nonexistent. Sales are also iffy at best. Meyer Tannenbaum, a painter in New York City who has paid to have his work exhibited at New Century Artists three times, noted that during his best show he sold two small paintings for $200 apiece—"I've never sold enough to make the rent." Naomi Campisi, president of the Artists League of Brooklyn, which has shown its work at Broome Street Gallery, said that "if we sell two pieces, that's good. Usually, it's more like one piece, or maybe nothing at all." However, sales and write-ups may not be the point to at least some of the artists. "A lot of out-of-towners and people from other countries want a New York credential on their résumés," said Caroll Michels, an artists' career advisor in East Hampton, New York. "They assume that saying their work was exhibited in SoHo will impress people back home. Maybe it will."

She noted, however, that there may be a valid reason to rent a gallery space to show one's work: "You may have some people who want very much to see your work, but you don't have a place suitable to show it. In that case, renting a gallery simply solves a problem, and the costs are likely to be offset by sales or whatever you're expecting from the people you're showing the work to."

A number of artists and gallery owners have taken a different tack on the concept of artists paying to have their work shown, not only in the vanity spaces but also in galleries that otherwise represent artists in the traditional way. Artists may be asked to pay one-third or one-half or even more of the costs of the gallery in putting on the exhibit—payment to the gallery owner may reach $3,000 or $4,000 in order to have a three- or four-week show. Sometimes,

these pay-your-own-way shows are tryouts for artists who want to be represented by the gallery. "I usually go 50–50 with the artists," said Deborah Davis, director of El-Baz Gallery in SoHo. "Artists may not want to think about how salable their work is, but I have to. Artists may think that their work should be shown in museums, but I have to know if it will appeal to people who walk in off the street. You take a flying leap into the unknown with many artists, and you know that sales will be less than the costs of putting up the show."

Another SoHo dealer, who asked not to be named, asked, "How can you invest in someone whose return on your investment is likely to be zero? We're not a communist country; everything isn't free. Artists have to be willing to help out in the costs, or else they're living in some fairy tale." With escalating rents, dealers claim, many galleries are not in a position to give young artists a show without the financial assistance of the artists. "The reality," according to Katharine T. Carter, an artists' advisor, is that artists and dealers "need to be in a shared business relationship" in which both parties decide what they want and how they are going to pay for it.

She noted that artists should approach "emerging talent galleries" with a budget, "equal to what you would pay a part-time secretary, say $8,000 to $10,000." That money would be used in part to publish postcards, a full-color catalogue with an essay, press mailings for the show, and mailings (of the catalogue) afterwards to museum curators and dealers around the country. For Carter, as well as many artists and dealers, this is what it means for artists to invest in their careers.

PAY TO PLAY?

Pay in order to play is certainly a well-known theme in artists' lives. Most juried competitions, for instance, require an entry fee. Co-op galleries entail the payment of an annual membership, plus monthly dues, plus all the costs of organizing and promoting an artist's show. Many mall sites for artists on the World Wide Web require artists to pay sometimes sizeable amounts of money with the hope that an Internet user finds them and wants to buy something. For example, ArtistsOnline, which is based in Santa Barbara, California, calls itself a "free" Web site, but it charges a one-time fee of up to $150 to create a one-page portfolio (artists with their own Web site must still pay for a one-page "personal profile"); additional pages are $50 per page plus a fee of $1.95 per month, and any changes made to the Web site—such as changing the images periodically—are

billed at $40 per hour. Gallery Art Garden, which comes out of the city of Alkmaar in The Netherlands, costs a monthly fee of $25, affording an artist four images and a description of his or her work; there are also costs for changes and additional pages.

The New York City–based ArtistRegister charges $450 for a one-year "membership" that includes one color illustration and text (up to ten lines); additional illustrations are $60 each. The Web site itself is not actively promoted—either by direct mailings or advertising—by its operators, but Marie Fischer, who designed ArtistRegister, claimed that there are an average of 12,000 hits every week from all over the world. "I tell artists to support their Web site with direct mailings; that's the best way to let people know where they can find the artists' work," she said. ArtistRegister will also create an artist's direct mailing ("We'll write a nice letter, putting the artist's Web site on it") and provide a stamp and an envelope at the price of $1 per name.

A spokesman for World Wide Arts Resources (located in Columbus, Ohio) claimed that the site receives 100,000 visitors per month, but there are no figures for the number of sales actually made on- or offline from the artists and galleries that have Web pages linked. ArtistRegister also only has anecdotal information about works sold, commissions, and artists taken on by dealers or hired to lecture, teach, or give demonstrations. They only count the number of overall hits, not the quality or the result of browsing, and they do not actively survey their artists. Unlike ArtNet.com, PaintingsDirect.com, NextMonet.com, and some others, these gallery sites remain in business because artists pay them for services and the rental of cyberspace.

The art world has a lot of what could be called victimless crimes. Critics, for instance, are often hired to write privately published catalogue essays for artists they never heard of before and to whom they may never ever pay attention to again. One editor at *Art in America* has written a number of these essays for artists whose work would never appear in that magazine, although the artists who pay for the editor's implicit endorsement ("a dollar a word is the going rate," the editor said) will proudly proclaim that their work was the subject of an essay by an editor at *Art in America*. The artist is happy, the editor is happy, but it is a fool's bargain into which the artist has entered, because it is cynical about rather than beneficial to the artist's career: Critics and editors will associate their names with these artists precisely because they expect the artists will never be heard of again. They wouldn't want their words thrown back at them years later.

Calling an expenditure of money an investment may make people feel as though they are taking charge of their lives or careers, when in fact they are only gambling. All investments, of course, are a form of risk taking, although the better risks tend to be researched and evaluated. The art world offers many opportunities for one's money to flow freely. Artists would be wise to invest a little time to understanding how the art market works.

THE ARTIST AS CURATOR

"If an artist can't show his work to the public, then he doesn't exist. How long can you go without existing?" said Phillip Sherrod, a New York painter who has actually shown and sold his work quite a lot. Still, a lot is not quite enough, since he annually organizes—or curates—an exhibition of what he calls "street painters" at one or another alternative art space that includes his own work and that of a dozen or so other artists. "We're artists who went to the street and try to match the energy and sense of time in the city with technique. When the mainstream refuses to acknowledge your effort, then you can act collectively to present your ideas."

And so, to present and promote a shared interest of a certain group of artists, Sherrod became a curator. He's not the first artist to come up with the concept of staging a show rather than waiting for a gallery or museum curator to put together a display—the French Impressionists, the Ashcan School, the Blue Rider group, the Surrealists, and even some Pop artists all staged their own exhibitions and events, bringing attention to otherwise ignored developments in the arts—but part of a growing trend. "Too many artists just wait for some-one to discover them, leaving their careers in other people's hands, instead of taking control of how and when their work is seen," said Devorah Sperber, a Manhattan artist who has curated exhibitions of her work and that of others at the Snug Harbor Cultural Center in Staten Island and elsewhere. "It's very empowering to be the selector, not just the selectee."

There are a number of benefits and a few drawbacks to being an artist-cura-tor. Putting together an exhibition allows artists to create a context for their own artwork—such as the use of similar materials or the pursuit of similar themes, which a gallery owner may not choose to see—and to install the show in a way that more clearly suits the artists themselves. Even some artists represented in commercial galleries find that they become restless to show their work more fre-quently than the once every two or three years that is common gallery practice.

Sherrod is far better known than the other artists in his "street painters" group, a reason his dealer, Allan Stone, is not likely to show their work in his gallery. Sperber noted that "when I've been in group shows in the past, I've been let down by the quality of other people's work. People have a general feeling about a show, and the better they feel about a show, the more they like individual works. When I curate a show, I try to find artists who are at my level or better."

Of course, a primary reason that artists take a hand in creating shows is the opportunity for more people to see their work, perhaps to have the show written up in some publication and to be invited into other exhibitions. Catya Plate, a mixed media artist living in Manhattan, first curated a show at the Kenkeleba Gallery, a nonprofit space on the Lower East Side, displaying her work and the work of artists whom she met through a seminar series at the Bronx Museum. That exhibition was seen by curators at the Longwood Arts Gallery in the Bronx and the Kingsborough Community College Art Gallery in Brooklyn, who invited her to curate another show of the same artists at their facilities. Following that, a Web site asked her to curate an online exhibition, which she did. In four different venues, Plate's work was seen.

Sperber also stated that her work as an artist-curator has led to her being invited by three different sites (a commercial gallery, an alternative space, and a museum) to jury shows, allowing her to meet critics and museum curators with whom she might not have otherwise crossed paths. "I'm meeting curators on common ground—I'm not just a lowly artist with my hand out," she said.

Curating an exhibition is a lot of work, and that effort helps to build an artist's skills in a number of areas. Artist-curators need to be able to find appropriate artists and to work with them. The curator must develop an idea for the show—something that links the artists—and present that idea in a proposal to the director of the gallery space (research may be required to determine how to write a proposal). The curator must research which art spaces welcome proposals of artist-curated shows and which types of works or artists they favor. The Skylight Gallery of the Center for Art and Culture of Bedford Stuyvesant in Brooklyn, for instance, works primarily with African-American artists, while the Cork Gallery of Avery Fisher Hall at Lincoln Center focuses on groups of artists involved in community service. The selected artists may need to be prodded to submit their slides, résumés or curricula vitae, and artists' statements by a certain date. "There are a lot of egos," Plate said. "Everyone wants the best site in the gallery to put their work, and it takes a lot of diplomacy to resolve problems and satisfy everyone."

There are a number of alternative, nonprofit spaces in New Jersey and in the five boroughs of New York City that welcome proposals for artist-curated exhibitions, including:

NEW JERSEY

Aljira
100 Washington Street
Newark, NJ 07102
(973) 643-6877

City Without Walls
One Gateway Center
Newark, NJ 07102
(973) 622-1188

Sumey
19 Liberty Street
Newark, NJ 07102
(973) 643-7883

BROOKLYN

Arena@Feed
173A North Third Street
Brooklyn, NY 11211
(718) 624-1307

BACA Downtown
111 Willoughby Street
Brooklyn, NY 11201
(718) 522-4322

Bellwether
150 Franklin Street
Brooklyn, NY 11222
(718) 389-3213

Brooklyn Brewery
79 North 11th Street
Brooklyn, NY 11211

Brooklyn Fire Proof
99 Richardson Street
Brooklyn, NY 11211
(718) 302-4702

Brooklyn Public Library
Grand Army Plaza
Brooklyn, NY 11238
(718) 230-2100
http://www.brooklynpubliclibrary.org

Cave
58 Grand Street
Brooklyn, NY 11211
(718) 388-6780

The Center for Art and Culture of Bedford
Stuyvesant, Inc.
1368 Fulton Street
Brooklyn, NY 11216
(718) 636-6976

Chi Meat
152 Broadway
Brooklyn, NY 11211
(718) 486-8553

Corridor Gallery
334 Grand Avenue
Brooklyn, NY 11238
(718) 638-8416

Everything is Everything
245 South Third Street
Brooklyn, NY 11211
(718) 388-3947

Eyewash
143 North Seventh Street
Brooklyn, NY 11211
(718) 387–2714
www.warnernyc.com/eyewash.html

57 Hope
57 Hope Street
Brooklyn, NY 11211
(718) 782–5740

Figureworks
168 North Sixth Street
Brooklyn, NY 11211
(718) 486–7021

Fish Tank
93 North Sixth Street
Brooklyn, NY 11211
(718) 387–4320

Five Myles
558 St. Johns Place
Brooklyn, NY 11238
(718) 783–4438
www.offoff.com/fivemyles.html

Flame
93 North Seventh Street
Brooklyn, NY 11211
(917) 971–8411

Flipside
84 Withers Street
Brooklyn, NY 11211
(718) 389–7108

Four Walls
138 Bayard Street
Brooklyn, NY 11222
(718) 388–3169

4 1/2 Projects
218 Bedford Avenue
Brooklyn, NY 11211
(718) 781–0216

Front Room
147 Roebling Street
Brooklyn, NY 11211
(718) 782–2556

FUNY and Video Soapbox
65 Hope Street
Brooklyn, NY 11211
(718) 599–9411

Galapagos
70 North Sixth Street
Brooklyn, NY 11211
(718) 782–5188

GAle GAtes et al
37 Main Street
Brooklyn, NY 11209
(718) 522–4596
www.galegatesetal.org

Gallery Boricua
Boricua College
186 North Sixth Street
Brooklyn, NY 10032
(718) 388–9549

Goliath
117 Dobbin Street
Brooklyn, NY 11222
(718) 599–1263
(718) 389–0369

Holland Tunnel Art Projects
61 South Third Street
Brooklyn, NY 11211
(718) 384–5738

IM N IL
213 Franklin Street
Brooklyn, NY 11222
(718) 349–6510

Jean Deaux
143 North 7th Street
Brooklyn, NY 11222
(718) 782–8298

Kentler International Drawing Space
353 Van Brunt Street
Brooklyn, NY 11231
(718) 875–2098

Lazy J
199 North Seventh Street
Brooklyn, NY 11211
(718) 302–1634

Magnifik
191 Grand Street
Brooklyn, NY 11211
(718) 384–1304

Momenta Art
72 Berry Street
Brooklyn, NY 11211
(718) 218–8058

Smack Mellon Studios
70 Washington Street
Brooklyn, NY 11201
(718) 834–8761
http://smackmellon.org

Parker's Box
193 Grand Street
Brooklyn, NY 11211
(718) 219–7873

Parlour Projects
214 Devoe Street
Brooklyn, NY 11211
(917) 723–8626

Pierogi
177 North Ninth Street
Brooklyn, NY 11211
(718) 599–2144
www.pierogi2000.com/

R&B
68 Jay Street
Brooklyn, NY 11201
(718) 388-3929

Right Bank
409 Kent Avenue
Brooklyn, NY 11211
(718) 383–2024/2045

Roebling Hall
390 Wythe Avenue at South Fourth Street
Brooklyn, NY 11211
(718) 599–5352
www.brooklynart.com/

Rome Arts
103 Havemeyer Street
Brooklyn, NY 11211
(718) 388–2009

Rotunda Gallery
33 Clinton Street
Brooklyn, NY 11201
(718) 875–4047
www.brooklynx.org/rotunda

Salon 75
75 Roebling Street
Brooklyn, NY 11211
(718) 390–3516

Sideshow
195 Bedford Avenue
Brooklyn, NY 11211
(718) 486–8180
(718) 302–1577

Soapbox
65 Hope Street
Brooklyn, NY 11211
(718) 599–9411

Stamp
51 North Sixth Street
Brooklyn, NY 11211
(718) 963–1225

Star *67
67 Metropolitan Avenue
Brooklyn, NY 11211
(718) 599–7339

The State of Art
113 Franklin Street
Brooklyn, NY 11222
(718) 349–7250
www.thestateofart.com/

Studio Facchetti
193 Grand Street
Brooklyn, NY 11211
(718) 486–9331

31 Grand
31 Grand Street
Brooklyn, NY 11211
(718) 388–2858
www.31grand.com

Unfinished
239 Banker Street
Brooklyn, NY 11211
(718) 389–0209

V Gallery
301 Bedford Avenue
Brooklyn, NY 11211
(718) 782–2458

Williamsburg Art & Historical Center
135 Broadway
Brooklyn, NY 11211
(718) 486–7372/6012
www.wahcenter.org

BRONX

Bronx Museum of the Arts Satellite
Gallery Program
1040 Grand Concourse
Bronx, NY 10456
(718) 681–6000

MANHATTAN

AC Project Room
453 West 17th Street
New York, NY 10011
(212) 645–4970

Alternative Museum
594 Broadway
New York, NY 10012
(212) 966–4444

American Indian Cultural House Gallery
708 Broadway
New York, NY 10003
(212) 598–0010

Arsenal Gallery
New York City Department of Parks &
Recreation
Arsenal Building, Central Park
830 Fifth Avenue
New York, NY 10021
(212) 360–8163

Artists Space
38 Grand Street
New York, NY 10013
(212) 226–3970
www.artistsspace.org

Broadway Windows
80 Washington Square East
New York, NY 10003
(212) 988–5751

CityArts, Inc.
225 Lafayette Street
New York, NY 10012
(212) 966–0377

City University Graduate Center
33 West 42nd Street
New York, NY 10036
(212) 642–2127

Cork Gallery at Lincoln Center
70 Lincoln Center Plaza
New York, NY 10023
(212) 875–5151

Craft Students League
610 Lexington Avenue
New York, NY 10022
(212) 755–4500

Downtown Community Television Center
87 Lafayette Street
New York, NY 10013
(212) 941–1298

Drawing Center
35 Wooster Street
New York, NY 10013
(212) 219–2166

Ernest Rubertstein Gallery
Education Alliance, Inc.
197 East Broadway
New York, NY 10002
(212) 475–6200

Eighty Washington Square East Galleries
New York University
80 Washington Square East
New York, NY 10003–6697
(212) 998–5747

Franklin Furnace
112 Franklin Street
New York, NY 10013
(212) 766–2606

Henry Street Settlement
Abrons Arts Center
466 Grand Street
New York, NY 10002
(212) 598–0400

The Clocktower
Institute for Contemporary Art
108 Leonard Street
New York, NY 10013
(212) 233–1096

Jacob K. Javits Federal Building
26 Federal Plaza
New York, NY 10278
(212) 264–9290

Kenkeleba Gallery
214 East Second Street
New York, NY 10009
(212) 674–3939

La Mama's La Galleria Second Classe
6 East First Street
New York, NY 10003
(212) 260–4019

Loft Lawyers
145 Hudson Street
New York, NY 10013
(212) 431–7267

Paine Webber Gallery
1285 Avenue of the Americas
New York, NY 10019
(212) 713–2162/2885

Painting Space 122 Association
150 First Avenue
New York, NY 10009
(212) 228–4249/4150

Port Authority of New York and New Jersey
One World Trade Center
New York, NY 10048
(212) 435–8344

Rush Arts Gallery
526 West 26th Street
New York, NY 10011
(212) 691–9552

St. John the Divine Cathedral Church
1047 Amsterdam Avenue
New York, NY 10025
(212) 316–7493

St. Peter's Living Room Gallery
619 Lexington Avenue
New York, NY 10022
(212) 935–2200

Spanish Institute Gallery
684 Park Avenue
New York, NY 10021
(212) 628–0420

Tompkins Square Gallery
New York Public Library
331 East 10th Street
New York, NY 10009
(212) 228–4747

Vis-a-Vis Gallery
St. Clement's Church
423 West 46th Street
New York, NY 10036
(212) 246–7277

Washington Square Windows
82 Washington Square East
New York, NY 10003
(212) 998–5748

White Columns
320 West 13th Street
New York, NY 10014
(212) 924–4212
www.whitecolumns.org
Artists who show in the gallery receive fees.

QUEENS

Astoria Dance Center
25–95 Steinway Street
Astoria, NY 11103
(718) 278–1567

Citibank
Art Room 501
One Court Square
Long Island City, NY 11201
(718) 248–8530

Flushing Council on Culture & The Arts
137–35 Northern Boulevard
Flushing, NY 11354
(718) 463–7700

Greek Cultural Center
27–18 Hoyt Avenue South
Astoria, NY 11102
(718) 726–7329

Jamaica Center for Arts and Learning
161–04 Jamaica Avenue
Jamaica, NY 11432
(718) 658–7400

LaGuardia Performing Arts Center
Van Dam Street at 47th Avenue
Long Island City, NY 11101
(718) 482–5151

Langston Hughes Cultural Center
100–01 Northern Boulevard
Corona, NY 11368
(718) 651–1100

Long Island City YMCA
32–23 Queens Boulevard
Long Island City, NY 11101
(718) 392–7932

Maspeth Town Hall
53–37 72nd Street
Maspeth, NY 11378
(718) 335–6049

New York Hall of Science
47–01 111th Street
Flushing, NY 11368
(718) 699–0005

P.S. 1 Contemporary Art Center
22–25 Jackson Avenue at 46th Avenue
Long Island City, NY 11101
(718) 784–2084

Poppenhusen Institute
114–04 14th Road
College Point, NY 11356
(718) 358–0067

Queens Museum of Art
Flushing Meadows—Corona Park
Flushing, NY 11368
(718) 592–9700

Queensborough Community College
22–05 56th Avenue
Bayside, NY 11364
(718) 631–6311

Queensborough Public Library
89–11 Merrick Boulevard
Jamaica, NY 11432
(718) 990–0700

STATEN ISLAND

Snug Harbor Cultural Center
1000 Richmond Terrace
Staten Island, NY 10301
(718) 448–2500

Not all alternative spaces welcome artist-curated shows, and some that accept proposals for artist-curated shows do not permit the inclusion of the curator's own artwork, believing that this raises a conflict of interest. Joy Glidden, executive director of the DUMBO Arts Center in Brooklyn, said that "artist-curating disrespects the idea of what curating really is. Curators spend a lot of time studying art, and they try to put together shows that reflect a larger idea of what is happening. Shows put together by artists seem more like vanity, flavored by what their personal interests are, without any attempt at objectivity."

The directors of alternative art sites may claim the right to reject any work they feel is inappropriate or not at a sufficiently high level ("I don't pick the art, although I may veto something's that really awful," said Jenneth Webster, who runs the Cork Gallery at Avery Fisher Hall), and they frequently take partial or full control of the show's installation. "With one show, I ran into problems," said Olivia Georgia, director of Snug Harbor Cultural Center's gallery. "During the installation of the show, one of the two curating artists gave herself one of the most central locations, and she was particularly unfair with some of the other artists' work. I made her change the installation, and she was very upset about it. It was very awkward. Fortunately, the other curator was very accommodating, and she was able to overcome the difficulties of her cocurator."

Georgia noted that some artist-curated exhibitions have been "uneven in terms of quality," requiring "mediation to resolve problems." A possible reason for the conflicts is "cronyism—the curators want their friends in the show," which makes artist-curated events "a mixed situation for us." As a result, the gallery's emphasis has shifted to shows—they still may be curated by artists— that are more "purely educational and interpretive." Because of conflicts, Corinne Jennings, director of Kenkeleba Gallery, established rules for artist-curated shows: "First, each person in the show must be adequately represented," she said. "I don't want one artist to have ten large pieces, and another only one small piece. Second, there needs to be a mix of wall and floor pieces. Third, we have final word on installation."

Many alternative spaces provide an honorarium to the curator—even if that person's work is included in the show—that ranges widely. The Skylight Gallery in Bedford Stuyvesant pays between $300 and $3,000, depending upon how much work the curator has had to do. Henry Street Settlement pays between $200 and $500, and Snug Harbor's fee is between $1,000 and $5,000. Some pay nothing to the curator, but none of them require artists to contribute to the costs of mounting the exhibition. What the alternative spaces provide to

artist groups also varies. The Center for Art and Culture of Bedford Stuyvesant has a full-time publicist who sends out press notices, following up with telephone calls to media outlets, and the result has been some reviews of shows there. "We publish foldout brochures and, sometimes, a small catalogue for each show," said Eric Pryor, the Skylight Gallery's director. "That gives the show a life after the show is over." Snug Harbor also publishes a catalogue, if funding can be arranged (who is in charge of arranging that funding is not wholly clear). Other spaces may or may not publicize an event or sponsor an opening (providing refreshments or covering the costs of insurance for works in transit or on view). The Cork Gallery at Avery Fisher Hall requires any artist group to provide a sitter in the gallery when the space is open.

While curating a show in which one's work is included may solve some problems for artists, others may arise. Plate spent so much money on telephone calls, printing brochures, mailings, and visiting prospective exhibition sites that she asked the artists for whom she had done all this work to chip in money to reimburse her—"some did." Mary Ting, a New York City artist who has curated shows at Henry Street Settlement, the Craft Students League, and The Castellani Museum in Niagara Falls, New York, said she had "mixed feelings" about her experience. Curating an exhibition is "a labor of love," she stated, "not just another show to be in. It takes between three hundred and five hundred hours of work, and I wasn't paid in every case." She added that it can be "dangerous" for an artist to be known as a curator, "because all the artists in town contact you and want you to include them in your show. You're viewed as a vehicle for their careers. You're not thought of as an artist anymore, but only as a curator."

THE ARTIST AS ENTREPRENEUR

"One of the things you have to know about New York," said Brooklyn painter Kathleen Hayek, "is that there are hundreds of artists on every block"—or so it seems, anyway. Gallery owners' eyes glaze over when someone announces to them that he or she is an artist; nonprofit art spaces are besieged by artists (individuals and groups) who want to have their work shown there; just about every restaurant, café, building lobby, and otherwise blank space in the city contains art of some type. Graffiti art, which has worked its way into commercial galleries and museums, started out as an effort on the part of certain artists to appropriate space (on buildings, subways, and buses) that would offer them and

their art visibility. Forget the rhetoric of disdain for the commercial art world and the aim of violating private property: First and foremost, artists in New York have to be resourceful and entrepreneurial if they hope to get ahead.

Hayek, who has "never shown at a gallery, but I've done pretty well for myself," has tried to solve the how-do-I-get-people-to-look-at-my-art problem in four different ways. The first is putting her work on the World Wide Web, at Artichoke.com, an Internet site that specializes in paintings, as well as giclee or Iris prints created from paintings, charging a 30 percent commission for the sale of paintings and 50 percent for giclees (Artichoke handles the actual sale and transfer of property). There is an ever-increasing number of mall sites on the Web where art is for sale, featuring dozens or sometimes hundreds of artists, who are categorized and cross-categorized alphabetically or by medium, style, and subject matter. Almost all scan an artist's images (from slides) onto their Web sites, while a few permit artists to link their home pages to the sites. Some of these sites charge artists fees for scanning their images and creating pages (a yearly or monthly charge per page, with additional costs for changing the images on display, and even those artists who already have a home page are assessed a linkage fee), and prospective buyers would contact the artists directly about making purchases, eliminating the middleman commission. Other sites, such as ArtNet.com, NextMonet.com, and PaintingsDirect.com, charge no up-front fees of artists but rely solely on commissions. Artichoke.com has elements of both types, charging artists either $100 as a set-up fee or requiring artists to give the company the rights to create giclees of one of their artworks.

Hayek's second solution is opening a gallery on the second floor of her brownstone home, Parlor Gallery (named after the living room that the gallery displaced), in which she shows her own work and that of another artist or two from the neighborhood. As a business, she is able to claim a home-office deduction on her income tax returns, and "because I don't have to pay a commission to a gallery owner, I can price my work affordably and keep all the money from a sale."

She is not alone in her thinking. Danny Simmons, also a Brooklyn painter, owns and operates the Corridor Gallery on the street level loft space of the building he owns on Grand Avenue. (There are three other lofts in this building—he lives in one and rents the other two.) Simmons exhibits his work there from time to time and also shows the art of other emerging African-American artists in Brooklyn. "There just aren't enough exhibition spaces for emerging artists and artists of color," he said. "You can either accept that or do something on your own, which is what I did."

Hayek also heads two organizations, Brooklyn Watercolor Society and SONYA (acronym for South of the Navy Yard Association—New York artists love to give their neighborhoods pet names), in order to generate more opportunities to exhibit work. Like many artist clubs and societies, the Brooklyn Watercolor Society (www.bws.org) is a dues-paying organization with rules on how artists may become members; it exists in order for artists to share information and to put up an exhibition. The Society, which has been in existence since 1972, has held annual shows at the Brooklyn Museum, the National Arts Club, the community galleries of the Metropolitan Museum of Art, various college galleries, and at various minor venues.

Many artists clubs, societies, and organizations have no central office or their own listing in the telephone directory; rather, they tend to be headquartered in the home of the current president. As a result, the group's address and telephone number may change every year or two. The Artists League of Brooklyn (www.a-l-b.org), which puts on one or two shows per year and provides two scholarships annually for promising high school art students, "has been in existence since 1969," said its current president Naomi Campisi, "but if we didn't have a Web site, I don't know how anyone would find us." The Brooklyn Working Artists Coalition, another organization with an administrator, a president, a secretary, and a Web site (www.bwac.org), but no actual office, sponsors three exhibitions for Brooklyn artists every year. Two of them—the "Pier Show," during the spring and summer, and the "Small Works Show"—involve approximately 180 and 120 artists, respectively, and take place in a warehouse in the Red Hook section. The third show, "Between the Bridges," is sited in the Empire Fulton Ferry State Park and has displayed the work of as many as twenty-five sculptors. In existence since the 1980s, "the Coalition was formed to show artists who've been working for a long time but never publicly exhibited their work in the past, and emerging artists," said Andrew McConnell, the group's administrator. "It also offers a conduit to the art world for some of them."

For some exhibitors, these shows are a conduit to buyers as well. Artists at the 2000 "Pier Show" sold $17,500 in work (paying a 20 percent commission to the Coalition), and a curator at the Brooklyn Museum made an informal best-of-show selection at the 2000 "Small Works Show," offering not a prize but appreciative commentaries.

OPEN STUDIOS

Hayek's fourth plan is a twice-yearly open-studio tour of the neighborhood, which is the reason Hayek founded SONYA (www.sonya.org). Any organization

of artists brings them together physically, as well as through newsletters, telephone calls, and e-mails, defeating the isolation that art sometimes imposes on creators. "It's not just social, although it's very nice to meet other artists, especially when they're your neighbors," Hayek said. "There is strength in numbers; we get more attention as a group than we might singly. We also share and trade information." Part of that sharing and trading are mailing lists, the costs of publishing a brochure, and other forms of promoting the open studio tours (approximately $45 per person).

Open studio events have been around for decades, taking place all over the United States, and artists see them as an opportunity to show and sell their work, while the public enjoys the opportunity to tour spaces to which they otherwise might have no access, possibly picking up a piece of art at a very discounted price in the process. For artists, the goal must be to insure that the experience has positive, tangible results: Everyone seems to be doing it, but is anyone doing it right?

The term "open studios" has itself become all-purpose, referring to a variety of activities. Artists' Web sites now frequently go by that term, and the Benton Foundation in Washington, D.C., has established a program called Open Studio: The Arts Online, which provides financial support for artists and arts organizations to use the Internet. Two municipally owned artist studio space facilities in Virginia, the Torpedo Factory in Alexandria and Columbia Pike Artist Studios in Arlington, both have "open studios," but these are open to visitors year-round. In essence, they are tourist attractions where artists may also work.

For most artists, open studios are a once- or twice-a-year event, in which the public is invited into the creative workplace to meet the artist, look at artwork that is completed or in progress, and perhaps buy something. Some artists simply pick a day to allow visitors into their studios, inviting only a select group of past buyers and those who have shown an interest in their work. At other times, groups of artists, such as the members of SONYA or those organized by the DUMBO Arts Center, band together to open their studios on the same day during the same hours, encouraging the public to visit some or all of the others.

There are many reasons that artists want to create these events. One is to obtain a response to their work (do people get what they are trying to say, is the artist communicating effectively, which people seem to like the work and which do not). For China Marks, a Hoboken artist who works in a variety of two- and three-dimensional media, the annual "Artists' Studio Tour" of Hoboken and

Jersey City is "as educational for me as for the visitors. There may be something in a work that upsets people that I thought was funny, and it makes me realize that I have to make my intentions clearer. Someone may point out something in a drawing, for instance, that I hadn't seen before, and that adds to the resonance of my work."

Joy Glidden of the DUMBO Arts Center noted that the annual "Under the Bridge Festival," which drew between 40,000 and 50,000 people in 2000 (twice as many as in 1999), empowers artists by letting them be the exhibitors rather than relying on dealers ("dealers come to see them, not the other way around") and acts to build a community of the resident artists. "It forces artists to look around at other people's work," she said. "They become less isolated in their art and in their working habits."

Another appealing feature of an open studio event is the possibility that some of the people who walk through the door may become buyers at some point in the future. Gary Jacobs, a painter in Hartford who has participated in the open studio days at Artspace Hartford, noted that he could "credit some sales to people who first saw my work at the open studio." Even better, one visitor to his studio was a corporate art consultant who eventually sold several of his pictures to a large company. Marks stated that, during the Hoboken Artist Studio Tour, "on a bad day, I'll have 250 people come through my studio." She added, "A lot of them ask to be put on my mailing list. I've had people come to my studio on that day and buy my work when it's in a gallery or museum show. Someone who visited my studio later opened a gallery and wanted to give me a solo show. I look at studio tours like billiard balls striking, and you don't know what kinds of collisions will take place in the future."

Tallying up how many sales artists chalked up and how much money they earned during these open studio events is never easy, because the event organizers do not charge a commission for sales. For community artist studio tours, some artists may do very well, while others sell nothing at all. With such a heterogeneous group of people visiting open studios, actual sales may or may not take place, but they cannot be predicted. Mark Burns, a sculptor who has taken part in open studio events both in Hartford and New Haven, has never sold any of his work to people passing through. "People get in a daze, because they're seeing so much stuff," he said. "They get overwhelmed. Your work has to be very straightforward and obvious for people to really notice; if there is anything subtle going on, they just can't see it." Experienced art buyers are not the primary visitors, and those who will purchase some-

thing often want pieces at a souvenir price range, under $100 and frequently in the $25 to $75 area. On the other hand, painter Melanie Kozol, a participant in SONYA, said that she sold $3,000 worth of work at her first open studio and $8,000 at the next. "A number of my long-term collectors came by and bought things," she said. "When people start buying my work, they tend to buy more than once piece, and some of those people used the open studio as an opportunity to pick. One person brought her whole family—they all wanted to pick."

Some open studio visitors are not there to buy but just want to poke their heads in a studio to see what's happening. Many visitors on the SONYA studio tour want "to see the really cool loft spaces and maybe get a sense of a different lifestyle," Hayek said. "One person actually asked me how much I paid for my house. I told him, 'I got it just before the prices started to go up.'"

That kind of voyeurism may vex some artists, who are primarily looking for serious collectors and sales. Devora Singletary, a painter and a participating artist in the SONYA tour, noted that "I didn't take part in the first SONYA show. I live in a studio, as in a studio apartment, and I didn't want people to see how small my apartment is. I didn't want them to look at my bed and the small amount of furniture I own, but after a while, I realized that I shouldn't be ashamed. People should see that I live in a studio apartment and still make art." Still, artists don't want their homes—when their studios are in their homes— and their privacy invaded. Some artists blockade the bedroom but still find people trying to get around the barricades. "We encourage SONYA members to have someone at the door, to direct visitors and keep an eye out that nothing is taken," Hayek said.

Studio tours are not solely the domain of artists. Art dealers, for instance, regularly set up dates to bring potential buyers to the studios of the artists they represent, recognizing that a personal connection between artist and collector may advance a sale. Whereas in the past, artists were often thought of as slightly disreputable characters, more and more, moneyed collectors want to have artists as part of their circle of acquaintances. For many, there is a romance about buying from the artist. "A lot of collectors want to know the artist behind the art," said Arthur Dion, director of Gallery NAGA in Boston, "and we may arrange to bring the collector to the artist's studio." Janelle Reiring, director of New York's Metro Pictures, also occasionally arranges studio visits in order to satisfy curious buyers, since "collectors generally know that artists are somewhat colorful personalities." Christopher Watson, one of

the directors of New York's Nancy Hoffman Gallery, said that "some collectors boast that they get their paintings directly from the artist. They feel like they have some inside scoop."

At times, Watson added, "a visit to the studio tends to bolster enthusiasm for buying the artist's work." However, that is not always the case. According to Christopher Addison, director of the Addison/Ripley Gallery in Washington, D.C., some collectors "get turned off buying the artist's work after meeting the artist. We represent some fairly abrasive artists, and some of our collectors have a particularly imperious manner. The chemistry is all wrong, and it is a great embarrassment to bring together people who obviously won't get along."

Some artists also don't want to be bothered in their studios by collectors, especially ones with whom they do not have a long and personal relationship. "For me, it depends upon who the people are and why they've come," painter Pat Steir said. "Some people just want to look at my work and see my studio. Someone thinks it sounds fun to meet the artist. I don't let people I don't know come into my studio and see unfinished work."

The ability of artists in group open studio events to generate sales and potential buyers depends on a number of factors. The first is how large a mailing list they have and how diligently they have notified their friends, family members, collectors, and acquaintances about the open studio, rather than relying on an organization to spread the word effectively. A second factor is how well artists are able to talk about their artwork and listen to what other people have to say. The value of opening up one's studio to the public is the ability of artists and the public to meet—"bringing a lot of people into the community who wouldn't otherwise see art," said Danny Simmons—which may not lead to immediate sales but improves the general atmosphere in which artists try to show and sell their work. There may be throngs of people in the studio at any one time, and many have little or no experience talking about art. Some artists invite visitors to ask them questions, treating all questions seriously. "There are no such things as stupid questions," Hayek said, adding that artists should not take offense at non-art comments ("Why did you make that so big?") but should instead help visitors find a way to discuss the work—that's the artist's public service role in this event.

Kozol noted that she talks "a lot about the process I use in making my work. People assume that I use oil stick. In fact, I use oil paint with a palette knife, creating a textured surface. The surface quality of my work is unique, so I talk about it." She also asks visitors what they like about her work, in order to

"get a reading on my work from visitors. One woman said that one of my paintings reminded her of the dunes where she got married. After she talked about the painting for a while, she decided that she had to have it and bought it."

Artists should also try to discern through the crowds who seems most serious. Visitors who spend longer looking at works might be approached with general comments about how the pieces were made, sources of inspiration or influence, or the subject of them. Conversations that ensue may be followed by giving the visitors a brochure, postcard, business card, or other information about the artist, and the artist should also take down the visitors' names, addresses, and telephone numbers. One's studio should be visitor-friendly. No one should feel ignored, and biographical material about the artist (perhaps a portfolio, statement, and price list) should be easily accessible.

The open studio event itself should have a range of media and styles. A gallery generally has a certain unity, in terms of style, medium, and pricing, but visitors expect to be surprised when they move from one studio to the next. In addition, the work on view may be good, bad, or indifferent. "There is no curating of the open studios," Glidden said. "I don't like the idea of censoring artists. I like the idea that someone who's growing gets a chance to put a foot in the door. It is an important step for each artist, and it is also important that dealers and art lovers also see what artists are doing." Since there rarely is jurying in open studios, it is difficult to control who will take part, but the organizers generally try to be sensitive to the need of keeping the offerings diverse.

Perhaps group open studio events are more suitable for artists at the outset of their careers or who are not pursuing the marketing of their artwork steadily. The sometimes circus atmosphere and the uneven quality and content of the work in these open studios may begin to work to the disadvantage of artists whose work has reached a higher level of esteem. For them, selling $25 knickknacks would be a humiliating step down. These artists may continue to hold open studio events, but just for their own studio and by invitation only. Their focus primarily will be on sales, commissions, and establishing relationships with serious collectors.

An open studio tour needs to be planned well in advance, in order that invitations and other publicity material reach people in time so that they may plan for it. One should also check for competing events, such as the World Series or the NCAA Final Four basketball tournament ("someone once asked us if we had a television," one artist mentioned). SONYA's two open studio dates are in May and October, months in which the weather tends to be predictable

and good. "April and November are risky, because of rain," Hayek said. However, she is aware that the second weekend of May is Mother's Day, when people are less likely to visit studios, and the last weekend is Memorial Day, when many New Yorkers leave town. As a result, the studio tour is held on the first weekend of May. Similarly, in early October, many New Yorkers leave town to look at the leaves in New England; the studio tour takes place in the latter part of the month, when people are also starting to think about Christmas.

Another consideration is how long the event is to be. SONYA's studio tour takes place over two days (11 A.M. to 5 P.M. on Saturday and Sunday), while others may be just one long day (11 A.M. to 7 P.M., for instance). "A problem with the second day," one artist noted, is that collectors believe that "if they didn't come the first day, everything will be gone, so they didn't come the next day."

There are differing schools of thought on the subject of food and drink. Hayek provides bread and cheese, crudités, and dessert items to visitors— "nothing super elaborate, but enough to keep them there a little while." The longer they stay, the more likely they will purchase something. However, she serves "no wine. I don't want people to be affected by alcohol." Other SONYA artists offer just water. Kozol put out Halloween candy and seltzer at the October open studio, "also some cheese and fruit, but I really don't want food in my studio. I don't want dirty hands to touch things. I wear gloves when I show some of my work on paper, so that the paper doesn't get damaged."

THE ART WORLD'S CUTTHROAT COMPETITION

One evening in June at the Cedar Tavern in 1956, a drunken Jackson Pollock pulled Franz Kline by the hair off his bar stool, and Kline responded by punching Pollock in the stomach, doubling him over. Just another night in the art world. The history of the New York School of abstract expressionists is replete with physical and verbal assaults and counterattacks. The first group of American artists to ever know critical and financial success (even in a limited form) in the lifetime of its members was broken up into warring factions by that very success. Mark Rothko criticized sculptor Tony Smith for praising a work by Pollock, saying "I thought you were committed to me." And Reinhardt publicly referred to Barnett Newman as "the avant-garde-huckster-handicraftsman and educational shopkeeper" and castigated his "transcendental nonsense." (Newman sued for slander but lost.) Clyfford Still wrote a letter to Pollock, claiming that Pollock was probably "ashamed" of his work. (Still also described

the work of fellow abstract expressionists as "exercises in degradation.") Pollock, Newman, Rothko, and Still teamed up to pressure their dealer, Betty Parsons, to get rid of her other artists and only show them.

Having grown up in a world in which almost no artists were able to make a living except illustrators and teachers, this group of artists suddenly found itself besieged by competing dealers and critics, as well as younger artists who looked to them for inspiration, magic, and, perhaps, an entree into a gallery. The pressures they felt were intense, but probably no more than artists feel today. The main advantage of the artists succeeding the abstract expressionists has been that younger artists have seen what happened to the earlier generation—the move from obscurity to celebrity, then back to obscurity when a new artistic style takes over the spotlight. In the media age, the vicissitudes of fame seem less of a shock: Like rock stars, many artists see themselves as having a short run.

Today's artists generally have college degrees, sometimes postgraduate degrees, and understand that financial as well as critical success is possible for a wide range of artists. However, those degrees and that understanding raise the stakes for them. Regardless of what anyone says about creating art even if nobody ever buys it, no one gets a baccalaureate or a masters degree in studio arts in order to accumulate canvases, sculptures, videos of performances, or other works, whatever the medium. Unlike the abstract expressionists of an earlier time in New York, today's artists have expectations of successful careers, and, consequently, they may see themselves as failures if there is no attendant reward (money, popularity, status) for their work, no matter how good that work actually is.

Fisticuffs is rare in the art world, but the pressures on artists to succeed—to have something to show for all the years of study and sacrifice, making the rounds, and maintaining an image of themselves as artists (a highly value-laden term in our culture)—frequently leads to bitterness and backbiting. For example, painter Howardina Pindell once was given an award from the Studio Museum of Harlem, and, shortly after that, the museum received a letter from another black artist claiming that "everything I ever learned as an artist I learned from him," Howardina said, noting that a copy of the letter was sent to her by that artist. "I hardly knew this man, but I guess he was upset that I got this award and he didn't."

There are various forms in which backbiting takes place. Sometimes, it is a public forum, such as a letter. Pindell said that another artist has shown up at

conferences where she has been a panelist, challenging whatever she says, "trying to make me look dumb or foolish. I see it as a personal attack from someone who felt I was getting too much attention." Gossip and spreading rumors is quite common and is especially damaging in the art world, where who you know counts for a lot and information is regularly passed through tips and asides. "Artists who show and sell a lot always seem to be coming in for complaints from other artists," painter Will Barnet said. "They get called 'commercial artists.' People say, 'Their work has really declined a lot' or 'Keep away from that guy.' There's nothing like a little success to make all these people you thought were your friends want to cut you off at the knees."

The pecking order "was very important to Ken [Noland]," said Jules Olitski, also a color field artist. "With Ken, it was always who's on top, who's getting more money, more press, more shows. There was always a competition between us to be the best, to excel, but sometimes we came close to blows. I certainly did not have a placid relationship with Ken. We're good friends now, because we don't see each other very much."

Competition may be an inherent problem for fine artists, since they work alone and are unused to collaborating with others. The drive to create artwork that is new and unique and to have that work reach people in a crowded art environment may engender a war room mentality. As the experience of the abstract expressionists showed, critical and financial success does not make artists less competitive with one another and, in fact, increases the tensions. Keeping oneself in the public eye, which helps maintain at least the financial aspect of the success going, is vital in the media age, where memory is so short, inverting the old Roman adage, *"ars longa, vita brevis."*

Juried competitions often bring out anxiety in artists, because they open themselves up for a possible rejection, which may bring on a sense that everything is decidedly political in the art world. Who the jurors are and discerning their preferences and prejudices become burning issues, fueling resentment. Marilyn Derwenskus, a regional representative for the National Watercolor Society, noted that she prefers "a juror who is an artist rather than a museum person," because "museum people look for something different. They are trained as art historians and look for images that will endure. They are less interested in the craft of the piece." On the other hand, Warren Taylor, a painting instructor at Midland College in Texas, complained that "some shows value craft or tradition over originality." Yet other artists claimed that they are more or less likely to be accepted into a show based on whether a juror is male or

female. Conversations at get-togethers of artists, especially those who are members of various societies, often veer onto the subject of who is judging what competition.

Another form of artworld backbiting is simply to never offer praise for or speak about a particular artist. Lack of positive reinforcement may be just as damaging, or more so, than something said out of jealousy. An influential teacher, for instance, may go unmentioned in an artist's biography out of fear that unflattering comparisons will be made or that an artist's apparent originality is actually less than it might seem. Barbara Nechis, who regularly teaches workshops to serious amateurs and occasionally hears from them what other workshop instructors have said about her (often positive, sometimes not), said that she won't complain about that artist or even mention that person's name to her students, but "I'll spend a lot of time promoting my approach to painting, which may be the opposite of what the other artist taught. And if the person who says something negative about me has a book, I will never mention the book and never recommend it."

Faith Ringgold, a painter and sculptor, noted that she didn't show in New York between 1969 and 1984, because "there was a concerted effort to ignore me and keep me out of things." That silence, she believed, is the result of envy ("you're doing something that they might be doing but aren't") or fear ("your work makes theirs look bad in contrast") or simply disapproval: "In the 1960s and 1970s, when the art world was into abstraction, I was doing political art. It was politically incorrect to do political art then."

One of the prominent examples of success leading to rancor is Jules Olitski, whom the critic Clement Greenberg called "the best painter living" back in the early 1980s. Greenberg and his ideas about modern art came under heavy and sustained attack by a generation of artists, academicians, and critics starting in the late 1970s, and this extended to Olitski by association in a strong way. "I'd get told about snide comments made about me by one person or another," he said, "or I'd read poison darts in the press, if my name was ever mentioned, which happened less and less."

At a gathering of artists in the mid-1990s, Olitski was talking with some friends when the subject of Greenberg's pronouncement came up: "Suddenly, what had been a friendly and genial conversation turned ice cold," he said. "One after another artist said, in effect, 'it wasn't fair.' One of the artists said, 'He should have chosen me. He would have, but we weren't getting along at the time.' Another person, a sculptor, also said that it was unfair,

but he wouldn't have minded if he had been named the greatest living artist. We all talked for a while about it, but I could see they were still angry about it, years later."

Backbiting is not exclusive to male artists—a growing number of women artists have moved away from a notion of feminist cohesiveness to a more every-girl-for-herself outlook—nor is it confined to the fine arts. Jealousy and envy are part of the art world, because of the uneven and sometimes unfair way that the art world hands out its favors. The largest worry that artists have when they hear of negative comments is that this may be only the tip of the iceberg, that everyone is criticizing them behind their backs and turning everyone else against them. Whisper campaigns and more public denunciations do cause damage, but it is rarely fatal to a career. Since it is aimed at artists with some standing in the art world, emerging artists are less likely to be targets or affected by it.

The art world is relatively small, which allows remarks to spread quickly, but that also provides a reason to withhold comment, since one may not want to be associated with something mean-spirited. As a rule, artists succeed more often because of who their friends are rather than as a result of which enemies they have made. In addition, collectors don't want to become enmeshed in the political in-fighting of artists: They look to art to help them get away from their troubles, not to reveal to them a world as nasty as their day jobs. For artists thick in the stream of gossip and hearsay, developing discretion and a thicker skin may be the best antidote.

Chapter 6.
THE COST OF LIVING

Artists coming to New York bring a great deal to the city—ambition, ideas, hopes—but they also need to come with money. New York is the most expensive city in the United States, and what may be called a bargain in New York doesn't necessarily sound like one elsewhere ("I found this great one-bedroom for only $275,000"). The American Chamber of Commerce conducts quarterly surveys of the cost of living in more than three hundred urban and suburban areas in the United States, and New York is always overwhelmingly more expensive than any other. With the average of the cities participating in the survey charted at 100.0, Boston is above average at 136.9, Las Vegas slightly below at 98.3, Baltimore is 96.0, Atlanta is 104.3, Los Angeles is 123.1, the District of Columbia is 131.6, Chicago is 117.9, Austin (Texas) is 105.0, Philadelphia is 116.2, and Oakland (California) is 156.6. New York City is 231.8. In every category listed (groceries, housing, utilities, transportation, health care, and miscellaneous goods and services), New York leads the rest of the country, but no more so than in housing. With the housing average of 100.0, New York City comes in at 460.3. Therein lies the reason that the city is so expensive.

"There's no new building in New York or new space on which to build," said Sean A. McNamara, administrative director of the American Chamber of Commerce Research Association in Arlington, Virginia. "Older cities, such as New York, Boston, and Philadelphia, have nowhere to expand—they have infrastructured themselves out, and this places price pressure on the existing spaces. Costs break down dramatically once you get into the suburbs." He noted that the cost of the resulting high rents are transferred to the prices of everything else in New York, from the price of a plumber or the purchase of clothing to dining at restaurants and various forms of entertainment. "You don't have huge supermarkets in New York the way you do in suburbs or newer cities. There is simply no space for one, and the cost of buying land in the city is extraordinary.

Therefore, New Yorkers don't get the discount prices that people shopping at big supermarkets regularly receive. There are smaller mom-and-pop stores in the city, which can cut their prices, based on what they've got, but they probably don't have a huge inventory of items, because they don't have a large space to put them."

McNamara knows the city apart from just statistics. After graduating with an M.F.A. from the Rhode Island School of Design, where he studied architecture and interior design, he lived in an apartment on Manhattan's Upper East Side for three years, with five other people helping to pay the $2,000–per-month rent.

Apart from real estate, New Yorkers get a lot for the large prices they pay. The health care facilities, and the choice of hospitals and doctors, are the best in the world. (Competition in health care, however, doesn't keep prices down, because "health care providers are still charging you for the cost of rent," McNamara said.) "Public transportation is very good and reliable," said Richard Clarida, chairman of the economics department at New York's Columbia University. "In New York, you don't need a car, while in most other cities you do. That's one area in which New York is perhaps less expensive."

New York, he noted, may be more economical if one looks at it in a different way. "It's less expensive to see a world-class ballet in New York than in Topeka, Kansas, because there is no world-class ballet company in Topeka, Kansas, and therefore the cost is infinite. For people who live in places that don't have great restaurants and great museums, the only way that they can have those things is if they travel to New York, and that is also very expensive."

New York apartments frequently have small kitchens, and sometimes, in loft buildings where many artists live, no kitchens are allowed. The difficulty of preparing food in cramped quarters or cooking on hot plates drives many New Yorkers to restaurants frequently and, thereby, increases the overall cost of living. That has been the experience of Barbara Rachko, who moved to Manhattan from Arlington, Virginia, and who eats "out a lot, because I'm single and because I have a tiny kitchen." She found, however, that the cost of art supplies was less—sometimes, considerably less—than what she had paid back in Virginia. "I work from reference photographs," she said, "and I was used to paying $75 for a 20″ × 24″ custom C-print in Arlington. Here, I pay $50. There are custom photography labs all over West 20th Street, while there was only one within driving distance from where I lived in Virginia. The competition lets me shop around and get better prices."

THE COST OF MAKING ART

New York City is a highly competitive market for art suppliers, and the range of products is greater than anywhere else, from student grade paints to custom-made materials. Real estate costs are still high, keeping prices from dropping dramatically, but the top-of-the-line items are less costly in New York than in another city, where they would have to be specially ordered. The three largest stores—New York Central Art Supply, Pearl Paint, and Utrecht—and some of the others sell certain materials in bulk, which reduces the per-unit cost. For artists who prefer to fashion their own supplies, such as mixing their own paints, there are suppliers of ingredients, which is another way of keeping down the costs that tends not to be readily available to artists outside New York.

Catalogue suppliers of art materials also offer a wide assortment of items at reasonable prices, which is a reason that many artists outside New York and a few other major cities regularly purchase supplies from them. The telephone operators at these companies or those who process orders over the World Wide Web, however, are not likely to be able to answer specific questions about materials or offer advice about how a certain product should be used. (These operators can refer questions to the companies' technical support personnel, who will call back.) The major art supply stores in New York, on the other hand, tend to be staffed with artists who can be very helpful to buyers. These stores also occasionally hold demonstrations and workshops, enabling artists to learn about products in a far more detailed and hands-on way than from an over-the-telephone response to a specific question.

"Our goal is to have as low prices as anyone," said Jim Peters, president and chief executive officer of Utrecht, which is headquartered in Cranbury, New Jersey, and whose paints, brushes, papers, and other products are made in Brooklyn, New York. "If you check around, you will find that our prices tend to be lower on the highly competitive items, especially at back-to-school times."

Unrelated to the products and the prices for them, art supply stores in New York tend to be meeting places for artists and sometimes take on the quality of a cafe. "People like to hang out here," said Steven Steinberg, president of New York Central Supply. "I put on classical music, I offer them coffee." Bulletin boards in these stores are covered with notices for exhibitions, apartment shares, studio sublets, announcements for some meeting of artists, this or that thing up for sale. "New York is a very competitive market for art supplies," Peters said. "You have to be part of the art community in order to succeed."

Below are listings of some of the principal outlets for art supplies in the five boroughs and the surrounding commuter communities:

MATERIALS FOR PAINTERS

CONNECTICUT

Darien
Koenig Art Emporium
899 Post Road
Darien, CT 06820
(203) 655–0250

Fairfield
Corners
2000 Black Rock Turnpike
Fairfield, CT 06432
(203) 384–8635

Posters Arts and Crafts
2353 Black Rock Turnpike
Fairfield, CT 06432
(203) 372–0717

Greenwich
Barney's Place, Inc.
107 Greenwich Avenue
Greenwich, CT 06830
(203) 661–7369

Circa
255 Mill Street
Greenwich, CT 06830
(203) 531–0563

New Haven
Charrette
127 East Street
New Haven, CT 06511
(203) 624–5000

City Horse
1203 Chapel Street
New Haven, CT 06511
(203) 865–4319

Diadamo & Fitch
1203 Chapel Street
New Haven, CT 06511
(203) 865–4319

Frames by Kim
1203 Chapel Street
New Haven, CT 06511
(203) 865–4319

Hulls Art Supply & Framing
1144 Chapel Street
New Haven, CT 06511
(203) 865–4855

Hulls Hardware
1203 Chapel Street
New Haven, CT 06511
(203) 865–4319

Kaye's Art Shop
984 Chapel Street
New Haven, CT 06510
(203) 624–0034

Koenig Art Center
1162 Dixwell Avenue
Hamden, CT 06514
(203) 776–8968

Utrecht
127 East Street
New Haven, CT 06511
(203) 624–5000

Norwalk
Art Supply Warehouse
360 Main Avenue
Norwalk, CT 06851
(203) 846–2279

Mulqueen Arts & Custom Framing
281 Connecticut Avenue
Norwalk, CT 06854
(203) 853–9004

Stamford
Grande Guy Picture Framing
598 Newfield Avenue
Stamford, CT 06905
(203) 323–5554

Stratford
Colonial Square Art Shop
2420 Main Street
Stratford, CT 06615
(203) 375–3764

Westport
Max's Art Supplies
68 Post Road East
Westport, CT 06880
(203) 226–0716

NEW JERSEY

Hoboken
Wholesale Art Supply Company
& Custom Framing
265 First Street
Hoboken, NJ 07030
(201) 792–7800

Hackensack
C&E Paper Supplies
Hackensack, NJ 07601
(201) 488–1764

Jersey City
Borinquen Home Improvement Center
532 Jersey Avenue
Jersey City, NJ 07302
(201) 332–6562

Johnson Stationers, Inc.
728 Bergen Avenue
Jersey City, NJ 07306
(201) 433–2940

Paterson
A &W Studio Art Supplies
350 Union Avenue
Paterson, NJ 07502
(973) 790–1377

Trenton
Dwyers Stationers
117 North Broad Street
Trenton, NJ 08608
(609) 695–6186

Dwyers Stationers
954 Parkway Avenue
Trenton, NJ 08618
(609) 882–9551

Union City
America Stationery
4302 Bergenline Avenue
Union City, NJ 07087
(201) 348–4332

NEW YORK

Bronx

AE Art Canvas Priming
605 East 132nd Street
Bronx, NY 10454
(718) 665–3814

Bruckner Hobbies
3587 East Tremont Avenue
Bronx, NY 10465
(718) 863–3434

Shipman Concourse Stationery
2442 Grand Concourse
Bronx, NY 10458
(718) 295–5444

TATS
940 Garrison Avenue
Bronx, NY 10474
(718) 542–2324

Brooklyn

Abe's Frame Shoppe
2606 East 16th Street
Brooklyn, NY 11235
(718) 648–9090

Artists Canvas
20 Broadway
Brooklyn, NY 11211–5907
(718) 384–2300

Artworks
80 Vernon Avenue
Brooklyn, NY 11206–6503
(718) 749–3000

A Tisket A Tasket
1785 47th Street
Brooklyn, NY 11204–1273
(718) 438–7369

Barron Fine Art
302 Butler Street
Brooklyn, NY 11217–2702
(718) 797–4260

Big Genius Art Supplies
540 Metropolitan Avenue
Brooklyn, NY 11211–3542
(718) 302–4002

Big Giant Enterprises
68 Jay Street
Brooklyn, NY 11201
(718) 237–1669

David Davis Artists Materials & Services
68 Jay Street
Brooklyn, NY 11201
(718) 237–0242

Finest Art Supplies
2075 Utica Avenue
Brooklyn, NY 11234–3827
(718) 951–9523

N. Glantz & Son
218 57th Street
Brooklyn, NY 11220
(718) 439–7707

Holbro Paint & Arts Supply
7709 Fifth Avenue
Brooklyn, NY 11209–3311
(718) 745–7739

Jake's Art Supplies
305 Washington Avenue
Brooklyn, NY 11205–3712
(718) 399–2800

KC Art Supplies, Inc.
252 Court Street
Brooklyn, NY 11231–4405
(718) 852–1271

Sally Minker
302 Butler Street
Brooklyn, NY 11217–2702
(718) 254–9486

P.K. Your Arts Desire
2291 Nostrand Avenue
Brooklyn, NY 11210–3839
(718) 377–7779

Paularte Products
88 35th Street
Brooklyn, NY 11200
(718) 768–3131

Penn Shop
252 Court Street
Brooklyn, NY 11231
(718) 852–1271

Pyramid House
493 Flushing Avenue
Brooklyn, NY 11205–1610
(718) 596–4155

San Art Framing & Supplies
7 Seventh Avenue
Brooklyn, NY 11217
(718) 857–0629

Sarkana Artist Supplies
208 Bedford Avenue
Brooklyn, NY 11211–3235
(718) 599–5898

Scribbles
4403 13th Avenue
Brooklyn, NY 11219–2017
(718) 435–8711

Seventh Avenue Art Supplies
376 Seventh Avenue
Brooklyn, NY 11215–4306
(718) 369–4969

Simons LIU
645 Dean Street
Brooklyn, NY 11238
(718) 638–7292

Sims John
11 Wythe Avenue
Brooklyn, NY 11211–1037
(718) 384–3440

Toxic Arts
186 Powers Street
Brooklyn, NY 11211–4922
(718) 599–3443

WC Art & Drafting Supply Company
351 Jay Street
Brooklyn, NY 11201
(718) 855–8070

Williamsburg Art Materials
315 Berry Street
Brooklyn, NY 11211–5130
(718) 782–0888

Young's Art Supplies
305 Washington Avenue
Brooklyn, NY 11205–3712
(718) 399–2800

Zelda's Your Arts Desire
968 East 12th Street
Brooklyn, NY 11210
(718) 377–7773

Kingston
R&F Handmade Paints, Inc.
110 Prince Street
Kingston, NY 12401
(800) 206–8088
www.rfpaints.com

Long Island
Adam Art Center
1401 Northern Boulevard
Manhasset, NY 11030
(516) 627–3575

Pearl Paint
2000 Hempstead Turnpike
East Meadow, NY 11554
(516) 542–7700

Manhattan
A &W Stretcher Company
66 East Third Street
New York, NY 10010
(212) 777–0075

Amber Artist Drafting Materials
444 Madison Avenue
New York, NY 10022
(212) 371–4430

Andy's Art Supplies, Inc.
208 West 23rd Street
New York, NY 10011
(212) 675–9499

Art Pictures Company
37 East 28th Street
New York, NY 10016
(212) 686–1191

Art Station
144 West 27th Street
New York, NY 10001
(212) 807–8000
www.artstationltd.com

The Art Store
15 Bond Street
New York, NY 10012
(212) 533–2444

Art World
104 Rivington Street
New York, NY 10002
(212) 228–9217

Arts & Letters
21 West 38th Street
New York, NY 10018
(212) 921–4123

Berlin Irving, Inc.
14 East 37th Street
New York, NY 10016
(212) 532–3600

Blacker & Kooby
1204 Madison Avenue
New York, NY 10128
(212) 369–8308

Boro Art & Stationery
3328 West 15th Street
New York, NY 10011
(877) 620–0440
www.boroart.com

Arthur Brown & Brothers
2 West 46th Street
New York, NY 10036
(212) 575–5555
www.artbrown.com

Artists Stretchers & Carpentry
416 West 12th Street
New York, NY 10011
(212) 741–8921

Bullseye Art
444 Park Avenue South
New York, NY 10016
(212) 684–7900

A. Charles NYC
188 Allen Street
New York, NY 10002
(212) 777–9029

Charrette Drafting Supply Corporation
215 Lexington Avenue
New York, NY 10016
(212) 683–8822
www.charrette.com

Cheap Paint
11 Prince Street
New York, NY 10012
(212) 219–3674

Chelsea Art Supplies & Custom Framing
134 West 24th Street
New York, NY 10011
(212) 242–8856

Commercial Art Materials Company
165 Lexington Avenue
New York, NY 10016
(212) 685–6858

David Davis Artists Materials & Services
17 Bleecker Street
New York, NY 10012
(212) 260–9544

Dieu Donne Papermill
433 Broome Street
New York, NY 10012
(212) 226–0573

Digital Painter
102 Fulton Street
New York, NY 10038
(212) 571–9529

Downtown Stretcher Service
450 West 31st Street
New York, NY 10010
(212) 239–1614

EGS Graphic Supply
170 Varick Street
New York, NY 10013
(212) 206–0718

Empire Artists Materials
851 Lexington Avenue
New York, NY 10021
(212) 737–5002

Joseph Fischl
1397 East 69th Street
New York, NY 10021
(212) 288–0633

Betsy Fowler
131 East 69th Street
New York, NY 10021
(212) 744–2594

Thomas Frank
430 Broome Street
New York, NY 10013
(212) 226–6244

A.I. Friedman, Inc.
44 West 18th Street
New York, NY 10011
(212) 243–9000

Geller Artist Materials
37 East 18th Street
New York, NY 10003
(212) 673–5500

General Art Company
180 Varick Street
New York, NY 10014
(212) 255–1298

Golden Typewriter & Stationery
2512 Broadway
New York, NY 10025
(212) 749–3100

Graphic Arts Services
16 West 46th Street
New York, NY 10036
(212) 730–0713

Grand Central Artists Materials
14 East 41st Street
New York, NY 10017
(212) 679–0023

Greenwich Artists Supply Company
7 Greenwich Avenue
New York, NY 10014
(212) 243–0570

Guerra Paint & Pigment
510 East 13th Street
New York, NY 10009
(212) 529–0628

L.K. Hecht Company
1140 Broadway
New York, NY 10001
(212) 683–0805

Just Jake, Inc.
40 Hudson Street
New York, NY 10013
(212) 267–1716

Karl Art Supply
173 Madison Avenue
New York, NY 10016
(212) 752–3591

Karl Art Supply
230 East 54th Street
New York, NY 10022
(212) 752–3591

Kate's Paperie
561 Broadway
New York, NY 10012
(212) 941–9816

Kate's Paperie
8 West 13th Street
New York, NY 10011
(212) 633–0570

Kate's Paperie
1282 Third Avenue
New York, NY 10021
(212) 396–3670

Kremer Pigments
228 Elizabeth Street
New York, NY 10012
(212) 219–2394

Lee's Art Shop
220 West 57th Street
New York, NY 10019
(212) 247–0110

Legion Paper Corporation
475 Park Avenue South
New York, NY 10022
(212) 683–6990

Masterpak, Inc.
50 West 57th Street
New York, NY 10019
(800) 922–5522

National Artists Materials Company, Inc.
4 West 20th Street
New York, NY 10011
(212) 675–0100

New York Central Art Supply
62 Third Avenue
New York, NY 10003
(212) 473–7705
(800) 950–6111
www.nycentralart.com

Paper Emporium
835 Second Avenue
New York, NY 10017
(212) 697–6573

Pearl Paint
308 Canal Street
New York, NY 10013
(212) 431–7392
(800) 221–6845
www.pearlpaint.com

Pearl Paint
School of Visual Arts
207 East 23rd Street
New York, NY 10010
(212) 592–2179

Pearl Showroom
42 Lispenard
New York, NY 10013
(212) 226–3717

Plaza Artist Materials
171 Madison Avenue
New York, NY 10016
(212) 689–2870

Sam Flax
233 Spring Street
New York, NY 10013
(212) 675–3486

Sam Flax
12 West 20th Street
New York, NY 10013
(212) 620–3038
www.samflax.com

Sam Flax
425 Park Avenue
New York, NY 10022
(212) 620–3060

Saral Paper Corporation
400 East 55th Street
New York, NY 10022
(212) 223–3322

Schneider & Company, Inc.
566 Columbus Avenue
New York, NY 10024
(212) 877–8553

Seventh Avenue Stationers, Inc.
470 Seventh Avenue
New York, NY 10018
(212) 695–4900
(800) 320–5735

SoHo Art Materials, Inc.
127 Grand Avenue
New York, NY 10013–2657
(212) 431–3938

Spring Street Suppliers
433 Washington Street
New York, NY 10013
(212) 966–0110

Starofix Stretchers
154 West 18th Street
New York, NY 10011
(212) 807–9752

Stretcher Company
666 Hudson Street
New York, NY 10014
(212) 989–3939

Terre Verte
11 Prince Street
New York, NY 10012
(212) 219–3674

Turner Colours, Inc.
150 West 28th Street
New York, NY 10001
(212) 206–8888

Utrecht
111 Fourth Avenue
New York, NY 10003
(212) 777–5353
(877) UTRECHT
(800) 223–9132

Utrecht
215 Lexington Avenue
New York, NY 10016
(212) 683–8822

Village Frame and Art Shop
35 East 10th Street
New York, NY 10003
(212) 254–1095

Westside Artist & Imaging Supply
208 West 23rd Street
New York, NY 10011
(212) 675–9499

Wholesale Art Supply Company
1412 Broadway
New York, NY 10018
(212) 354–7530

Williamsburg Art Supply
125 East Fourth Street
New York, NY 10012
(212) 529–9585
(800) 293–9399

Queens

Art Cove, Ltd.
60–09 Myrtle Avenue
Ridgewood, NY 11352
(718) 381–7782

Art World
70–28 Austin
Forest Hills, NY 11375
(718) 793–6001
(800) 442–0595

Brutus Ketly
22346 103rd Avenue
Queens Village, NY 11429
(718) 468–9816

Economy Handicrafts
50–21 69th Street
Woodside, NY 11352
(718) 426–1600

Jerry's Artarama
248–12 Union Turnpike
Bellerose, NY 11431
(718) 343–0777

Masterpak
49–20 Fifth Street
Long Island City, NY 11101
(800) 922–5522

Peck's Office Supplies
36–18 Main Street
Flushing, NY 11352
(718) 353–3896

Pete & Sons
36–49 Bell Boulevard
Bayside, NY 11352
(718) 229–3378

Pinsky's Stationery
71–34 Austin Street
Forest Hills, NY 11375
(718) 263–3955

Rudy's Hobby & Art
35–16 30th Avenue
Astoria, NY 11101
(718) 545–8280

Ward's Printing & Stationery
23–08 Jackson Avenue
Long Island City, NY 11101
(718) 784–7632

Staten Island

Arts & Crafts Unlimited
330 Giffords Lane
Staten Island, NY 10308
(718) 979–8246

Island Art Center
1668 Hylan Boulevard
Staten Island, NY 10305
(718) 987–0505

Maloka
2655 Richmond Avenue
Staten Island, NY 10314
(718) 370–1880

The Goldleaf Company
27 Fort Place
Staten Island, NY 10301
(718) 815–8802

Wizard of Art & Design, Inc.
255 Nelson Avenue
Staten Island, NY 10308
(718) 227–7600

MATERIALS FOR SCULPTORS

CONNECTICUT

Casting Supply House, Inc.
130–32 Lenox Avenue
Stamford, CT 06906
(203) 359–9622

Cavalier Renaissance Foundry, Inc.
250 Smith Street
Bridgeport, CT 06607
(203) 384–6363

Connecticut Investment Casting
75 Stillman Avenue
Pawcatuck, CT 06379
(203) 599–8897

Foredom Electric Company
Zona Tool Company
16 Stony Hill Road
Bethel, CT 06801
(203) 792–8622
(800) 696–3480

Intex/ASI
93 Triangle Street
Danbury, CT 06810
(203) 792–7400
(800) 658–9610

Mystic River Foundry
P.O. Box 121
Mystic, CT 06335
(860) 536–7634

Stanley Tools
600 Myrtle Street
New Britain, CT 06050
(203) 225–5111

Waldo Brothers Company
595 Nutmeg Road North
South Windsor, CT 06074

NEW JERSEY

Alcan Powders and Pigments
901 Lehigh Avenue
Union, NJ 07083
(908) 851–4500

Anchor Tool & Supply Company
P.O. Box 625
Chatham, NJ 07928
(201) 887–8888
(800) 294–7482

Carolfi Studios
1001 Haddon Avenue
Collingswood, NJ 08108
(609) 854–5098

Ceramic Supply of New York & New Jersey, Inc.
7 Route 46 West
Lodi, NJ 07644
(800) 7–CERAMIC

Chavant, Inc.
42 West Street
Red Bank, NJ 07701
(908) 842–6272
(800) 242–8268

Design-Cast Materials
951 Pennsylvania Avenue
P.O. Box 5005
Trenton, NJ 08638
(609) 392–1922

Ingersoll Rand Tools
P.O. Box 1776
Liberty Corner, NJ 08938
(800) 847-4041

Johnson Atelier Supplies
50 Princeton-Highstown Road
Princeton Junction, NJ 08550
(800) 732-7203

Micro Mark
340 Snyder Avenue
Berkeley Heights, NJ 07922
(908) 464–6764

J.H. Monteach
P.O. Box 757
South Amboy, NJ 08879
(908) 727–4000

New Jersey Art Foundry
433 Tonnele Avenue
Jersey City, NJ 07306
(201) 653–0770

Sculpture Cast
P.O. Box 426
Roosevelt, NJ 08555
(609) 426–0942

Sculpture House, Inc.
100 Camp Meeting Road
Skillman, NJ 08558
(609) 466–2986

Smooth-On, Inc.
1000 Valley Road
Gillette, NJ 07933
(800) 762–0744

Tattersall's Building Supply
309 North Willow
Trenton, NJ 08618
(609) 393–4293

Volcano Sculpture Casting
1423 Trenton-Harbourton Road
Pennington, NJ 08530
(609) 737–2278

NEW YORK CITY

Bronx

Albert Constantine & Sons
2050 Eastchester Road
Bronx, NY 10461
(718) 792–1600

Frank Mittermeier, Inc.
3577 East Tremont Avenue
Bronx, NY 10465
(718) 828–3843

Brooklyn

Adhesive Technologies
59 Ingraham Street
Brooklyn, NY 11237
(718) 497–5462

American National Bag & Burlap Company
528–532 Bergen Street
Brooklyn, NY 11217
(718) 789–3599

Antonio Luchinelli Mold Making
40 Clinton Street
Brooklyn Heights, NY 11201
(718) 403–0571

Belmont Metal Company, Inc.
301 South Belmont Avenue
Brooklyn, NY 11207
(718) 342–4900

Bedl-Makky Art Foundry
227 India Street
Brooklyn, NY 12572
(718) 383–4191

Clover Woodworking Company, Inc.
1340 60th Street
Brooklyn, NY 11219
(718) 854–6660

Excalibur
85 Adams Street
Brooklyn, NY 11201
(718) 522–3330

Gerald Siciliano Studio Design
9 Garfield Place
Brooklyn, NY 11215–1903
(718) 636–4561

John Crawford
609 Bergen Street
Brooklyn, NY 11238
(718) 783–7172

New Foundry Company
218–220 India Street
P.O. Box 220370
Brooklyn, NY 11220
(718) 349–3592
(718) 389–8172

Polyblends, Inc.
8523 Avenue J
Brooklyn, NY 11236
(718) 241–1556

Manhattan
Arkady Fridman
P.O. Box 7061
New York, NY 10128
(917) 388–2000

Artida Atelier
56 Ludlow Street
New York, NY 10002
(212) 777–4323

Cementex Latex Corporation
121 Varick Street
New York, NY 10013
(212) 741–1440
(800) 782–9056

Ceramic Supply of New York & New Jersey, Inc.
534 La Guardia Place
New York, NY 10012
(212) 475–7236
(800) 7–CERAMIC

Compleat Sculptor, Inc.
90 Van Dam Street
New York, NY 10013
(212) 243–6074
(800) 9–SCULPTOR
(212) 367–7561 (technical support)
www.sculpt.com

David Klass
136 West 24th Street
New York, NY 10011
(212) 243–7633

Garrett Wade Company
161 Sixth Avenue
New York, NY 10013
(800) 221–2942

Peter Leggieri Sculpture Supply Company, Inc.
415 East 12th Street
New York, NY 10009
(212) 674–8067
(212) 777–1079

Pietrasanta Fine Arts
49 Bleecker Street
New York, NY 10012
(212) 477-6989

Ranieri Sculpture Casting
55 Prince Street
New York, NY 10012
(212) 982-5150

Schneider Art Supplies
566 Columbus Avenue
New York, NY 10024
(212) 877-8553

Sculptor's Supply Company
242 Elizabeth Street
New York, NY 10012
(212) 334-3272
(212) 673-3500

Sculpture House, Inc.
30 East 30th Street
New York, NY 11016
(212) 679-7474

Sculpture House Casting, Inc.
155 West 26th Street
New York, NY 10001
(212) 645-9430
(888) 374-8665
www.sculptshop.com

Queens
Art de Luxe, Inc.
43-10 23rd Street
Long Island City, NY 11101
(718) 784-2481

Empire Bronze Art Foundry
25-20 43rd Avenue
Long Island City, NY 11101
(718) 361-3006

Modern Art Foundry
18-70 41st Street
Astoria, NY 11105
(715) 728-2030

Ottavino Corporation
80-60 Pitkin Avenue
Ozone Park, NY 11417
(718) 848-7156

Rocca & Noto Sculpture Studio
10-06 38th Avenue
Long Island City, NY 11101
(718) 937-1977

New York State
Argos Art Casting
Route 312, RD #2
Brewster, NY 10509
(845) 278-2454

Coryat Casting Company, Inc.
2159 Route 9G
Rhinebeck, NY 12572
(845) 876-2553

Gnichtel Studio
154 Haver Straw Road
Montebello, NY 10901
(845) 357-2928

Joel Meisner & Co.
115 Schmidtt Boulevard
Farmingdale, NY 11375
(516) 249-0680

Peacock Memorials
P.O. Box 255
Valhalla, NY 10595
(914) 949–3240

Petrillo Stone Corp.
610 South Fulton Avenue
Mount Vernon, NY 10550
(914) 668–8561

Polich Art Works
453 Route 17–K
Rock Tavern, NY 12575
(845) 567–9327

Red Oaks Mill Machine Corp.
259 North Grand Avenue
Poughkeepsie, NY 12603
(845) 471–8560

Saunders Foundry Supply, Inc.
P.O. Box 265
Cold Spring, NY 10516
(845) 265–3631

Tallix, Inc.
175 Fishkill Avenue
Beacon, NY 12508
(845) 838–1111

Tree of Life Art Foundry
8 Pheasant Drive
Armonk, NY 10504
(914) 273–3971

FACILITIES FOR PRINTMAKERS

CONNECTICUT

Connecticut Graphic Arts Center
Matthews Park
299 West Avenue
Norwalk, CT 06850
(203) 899–7999

NEW JERSEY

Center for Visual Arts
68 Elm Street
Summit, NJ 07901
(908) 273–9121

New Jersey Printmaking Council
Station and River Roads
Branchburg, NJ 08876
(908) 725–2110

Rutgers Center for Innovative Print
and Paper
Mason Gross School of the Arts
33 Livingston Avenue
New Brunswick, NJ 08901
(732) 932–2222, ext. 838

NEW YORK

Art Students League
215 West 57th Street
New York, NY 10019
(212) 247–4510

The Center for Book Arts
28 West 27th Street
New York, NY 10001
(212) 487–0295
www.centerforbookarts.org

Dieu Donne Papermill
433 Broome Street
New York, NY 10013–2622
(212) 226–0573
www.papermaking.org

Lower East Side Print Shop
59–61 East Fourth Street
New York, NY 10003
(212) 673–5390
www.printshop.org

Manhattan Graphics Center
476 Broadway
New York, NY 10013
(212) 219–8780

The Printmaking Workshop
55 West 17th Street
New York, NY 10011
(212) 989–6125

LONG ISLAND

Universal Limited Art Editions
1446 North Clinton Avenue
Bay Shore, NY 11706
(631) 669–7484

Chapter 7.
PUBLIC ART PROGRAMS

One of the reasons that New York seems so hospitable to artists is that artwork is incorporated into the fabric of everyday life, with murals and outdoor sculpture, short- and long-term installations, at schools, fire and police stations, libraries, daycare centers, subway stations, even sewage treatment facilities. Since 1983, forty-two city agencies and the Metropolitan Transportation Authority (MTA) have commissioned hundreds of artists to create artworks at new and renovated municipal buildings throughout the five boroughs under the Percent for Art program, administered by the New York City Department of Cultural Affairs. The price range for these public art projects is wide, from $40,000 to $400,000 (the average is $200,000), of which the artist receives approximately 20 percent, with the remainder paying the costs of design, fabrication, delivery, insurance, and installation.

The first step in applying for a commission is submitting slides of one's work to the Department of Cultural Affairs, which convenes a selection committee every time a public art project is triggered by city building and renovation. The chosen artists are then asked to offer proposals for particular sites, which are then evaluated by the same committee, as well as representatives of the particular municipal agency and representatives of the community where the artwork will be on display. The majority of projects are sculptural, although murals have been created at a number of sites. The MTA does not commission painting but has worked with painters who design images that are translated into tile mosaics. Cynthia Pannucci, who created a number of large, black-and-white stencilled drawings for the MTA, found the process "easy, not cumbersome at all. I put together a package that showed what I wanted to do, how I would do it, and how it would all look in the end. They looked at it and said, 'Okay, let's go.'"

Public art is an umbrella term covering a wide group of artistic activities. Traditionally, it is a statue or other sculptural piece, which will become a permanent part of the public landscape; yet one sees a growing number of temporary (for instance, a month or two) sculptural installations and even performances, readings, or just art shows taking place in public places. Either through mandated Percent-for-Art programs (in which one percent, or half of one percent, of the money used on constructing or renovating a government building must be applied to the purchase of artwork for that building) or simply through an interest in making art available (and visible) to more people, public art programs have been growing, as has the number of pieces commissioned through various private and state agencies for public display. Most state and local public art sponsors accept applications from residents of other states and localities.

GOVERNMENTAL PROGRAMS

An artist may contact the National Endowment for the Arts or a state arts agency for information on current or upcoming federal or state governmental commissions of artworks (arts agencies are frequently involved in the selection process). However, public art projects may be sponsored by a state or municipal arts commission, the airport or transit authority, planning and development, department of parks and recreation, department of business and economic development, department of community services, or any other number of public agencies.

Almost every state has some public art program somewhere. There are various sources of information on who is commissioning public art, including *Public Art Review* [$17 for two semiannual issues, 2324 University Avenue West, St. Paul, MN 55114–1802; (651) 641–1128)]; *Art in Transit . . . Making it Happen* (Federal Transit Administration, 400 Seventh Street SW, Washington, D.C. 20590; *www.fta.dot.gov/library/program/art/index.html*); *Sculpture Magazine* [918 F Street NW, Suite 401, Washington, D.C. 20004; (202) 393–4666; $50 for ten issues per year], which lists commissions in its "Opportunities" section as well as its quarterly *Insider Newsletter; Sculpture Review* [c/o National Sculpture Society, 1177 Avenue of the Americas, New York, NY 10036; (212) 764–5645; $40 for four quarterly issues plus a bimonthly *National Sculpture Society News Bulletin,* which contains information on grants, competitions, and available commissions]; and Americans

for the Arts' *Public Art Directory* [$20 for members, $25 for nonmembers; One East 53rd Street, New York, NY 10022, (212) 223–2787, (800) 321–4510; *www.artsusa.org*), which is updated periodically. Obviously, the *Public Art Directory* will not list the latest commissions, and those listed in both *Sculpture Review* and *Sculpture Magazine* are frequently out-of-date by the time readers receive the publications. Another source of help is the General Services Administration's Web site (*www.gsa.gov*). One of the most complete listings of public art commissioning agencies is *Percent for Art and Art in Public Places Programs* [$21.25 plus $2.50 for shipping and handling; Rosemary Cellini, P.O. Box 1233, Weston, CT 06883; (203) 866–4822; e-mail: *RMCellini@aol.com*]. A Web site called "Public Art on the Internet" (*www.zpub.com/public*) lists opportunities for commissions and offers essays on public art, descriptions of individual public art programs, and images of projects by artists and sponsoring organizations.

Public art encompasses both permanent and temporary installations of artwork, and both long- and short-term exhibits have their benefits and drawbacks. Sponsors generally have higher budgets (and thereby ensure larger fees for the artists) for permanent public pieces, and their longevity adds significantly to an artist's prestige. On the other hand, the fact that the artwork will remain for the foreseeable future requires the artist to think about public safety, the public's comments, and the durability of materials, all of which may change the type of work that is created. Temporary public artworks, on the other hand, may only be on view for a matter of months or for a few years at most, which limit their long-term value to an artist. However, Donna Dennis, a New York City sculptor who has done public art projects around the United States, noted that "there is a lot more freedom" in temporary public art, because "you may not have to worry so much about the permanence of materials, the building codes may not apply, the general public's comments may not be solicited. There is often a different review process: There is generally much less at stake for everybody involved."

She said that her temporary public artworks—for instance, a fleet of floating tourist cabins in Aberdeen, South Dakota—are "much closer to the art I regularly make. My permanent public works are generally fences." With lower budgets and no fear that a bad selection will be on display permanently, sponsors have greater leeway. "Temporary projects may be the way for an artist to enter the field," Dennis added.

THE COMMISSIONING PROCESS

In general, a work of public art is created for a site that is readily accessible to the general public, such as a park or a prominent spot inside or outside a building. The commissioning body may have certain eligibility requirements for artists, such as residency in a particular state or being an American citizen, and it is also responsible for providing specific information to both artists and the public, consisting of: the reason for commissioning the artwork, the kind of artwork to be commissioned (i.e., sculpture or mural), the location of the finished work, project budget and the source of matching funds (if applicable), materials suitable for the site, and the theme or subject for the artwork. The commissioning body is also responsible for overall project coordination, advertising and promotion, site preparation, jury selection and organization, fundraising, and documentation and reporting.

The process of selecting an artist to create a public artwork consists of two or three stages. In the first stage, there is a "call to artists," a general invitation that identifies the type of artwork being sought, its location, and the project budget. This call is placed as classified advertising in art publications and selected Web sites, mailed to artists who are members of certain organizations or who are on state rosters or sent specifically to individual artists who are thought to be likely candidates for this commission. All interested artists are asked to submit their résumés, slides of current work, information concerning past commissioning experience, and a stamped, self-addressed envelope in which to return the above items. Artists do not submit proposals at this stage, and no artist's fees are paid.

In the second stage, the competition jury selects certain artists (usually between three and five), who have provided the necessary background information, to develop specific proposals which include scale models, or maquettes, or sketches for the project and an outline of materials to be used, providing technical details where necessary. Artists may be asked to do a personal presentation. It is common practice to pay each artist an honorarium (ranging from $100 to $1,000 or more for a sketch or a full-scale model) for the proposal package requested by the committee. The packages become the property of the commissioning organization. Each of the stages may take between one and three months to complete.

The winning artist will receive a contract that stipulates what the work will be, where it shall be sited, and when it must be completed; assigns liability for

injury while creating and installing the piece; requires that the piece will be durable in its setting (artists generally must warrant a permanent public work for two years); and establishes a system of payment. Usually, the artist will be paid half of the commission on the signing of the contract, which is designed to cover the purchase of materials, expenses of operating a studio, and the hiring of technical assistance where necessary. Often, another portion of the commission will be paid at a specified stage, such as a halfway point, which may be another 25 percent or more. The remaining payment will be supplied upon the completion, installation, and acceptance of the finished work by the committee.

Among the main buyers of public art on the government side are:

FEDERAL GOVERNMENT

Art in Embassies Program
U.S. Department of State
Room B258
Washington, DC 20520
(202) 647–5723

General Services Administration
Art-in-Architecture Program
Seventh and D Street SW, Room 7618
Washington, DC 20405
(202) 708–5334

Veterans Administration
Art-in-Architecture Program
110 Vermont Avenue NW
Washington, DC 20420
(202) 233–4000

CONNECTICUT

Connecticut Commission on the Arts
Art in Public Places Program
Gold Building
755 Main Street
Hartford, CT 06103
(860) 566–4770

City of Hartford
Office of Cultural Affairs
550 Main Street, Room 300
Hartford, CT 06103
(203) 722–6493

City of Middletown
Commission on the Arts and Cultural Activities
Public Art Program
P.O. Box 1300
Middletown, CT 06457
(860) 344–3520

City of New Haven
Department of Cultural Affairs
Percent for Art Program
70 Audubon Street
New Haven, CT 06510
(203) 787–8956

City of Stamford
Percent for Art Program
888 Washington Boulevard
Stamford, CT 06954–2152
(203) 977–4150

NEW JERSEY

Atlantic County Office of Cultural and Heritage Affairs
40 Farragut Avenue
Mays Landing, NJ 08330
(609) 625–2776, ext. 314

Cape May County Cultural & Heritage Commission
Arts Inclusion Program
30 Mechanic Street
Cape May Court House, NJ 08210–2222
(609) 463–6370

New Jersey State Council on the Arts
Arts Inclusion Program
20 West State Street
Third Floor, CN 306
Trenton, NJ 08625–0306
(609) 292–6130
(505) 988–1878

NEW YORK

Buffalo Arts Commission
Percent for Art Program
920 City Hall
Buffalo, NY 14202
(716) 851–5027

Battery Park City Redevelopment Authority
One World Financial Center, Eighteenth Floor
New York, NY 10281–1097
(212) 416–5300

Dormitory Authority of the State of New York
161 Delaware Avenue
Delmar, NY 12054–1398
(518) 475–3079

Metropolitan Transportation Authority
Arts for Transit
347 Madison Avenue, Fifth Floor
New York, NY 10017
(212) 878–7250

New York City Board of Education
Public Art for Public Schools
28–11 Queens Plaza North, Room 513
Long Island City, NY 11101
(718) 706–3477

New York City Department of Cultural Affairs
Percent for Art Program
330 West 42nd Street
New York, NY 10036
(212) 643–7791
www.ci.nyc.ny.us/html/dcla/html/pahome.html

New York City Health & Hospitals Corporation
Public Art Program
City Hall, Third Floor
New York, NY 10007
(212) 788–3089

New York State Council on the Arts
Public Art Grants Program
915 Broadway
New York, NY 10010
(212) 387–7000

Niagara Council of the Arts
300 Fourth Street
Niagara Falls, NY 14303
(716) 284–6188
www.niagara-usa.com/infosites/
 niagaracouncil.htm

Port Authority of New York & New Jersey
Percent for Art Program
One World Trade Center, Room 82W
New York, NY 10048
(212) 435–3387

Rockland Arts Council
Percent for Art Program
Seven Perlman Drive
Spring Valley, NY 10977
(914) 426–3660

Arts in Public Places Committee of
Rockland County
7 Perlman Drive
Spring Valley, NY 10977
(914) 426–3660

Westchester Public Art
271 North Avenue
New Rochelle, NY 10804
(914) 995–2548

PRIVATE INITIATIVES

There are also a number of private, nonprofit organizations within the greater metropolitan region that sponsor permanent or temporary public works of art. In large measure, public art projects are open to all artists regardless of where they live; some provide payment to artists, while others do not. Operation Greenthumb, for instance, accepts proposals from artists for works that would be sited in a community garden—there are a number of them around the five boroughs—with the selection made by the gardener in charge. Artists are paid a stipend of $100 per day during the installation, and there is no time limit on how long the artwork may stay up. On the other hand, the Broadway Windows program solicits proposals for temporary (one month long) installations for its two window spaces (the first at 80 Washington Square East, the second at Broadway and 10th Street). There is no payment for the artists. Among the privately sponsored public art organizations are:

NEW JERSEY

City Without Walls
One Gateway Center, Plaza Level
Newark, NJ 07102–5311
(201) 622–1188

NEW YORK

Area
500 East 83rd Street
New York, NY 10028
(212) 288–7650

Operation Greenthumb
49 Chambers Street
New York, NY 10007
(212) 788–8070
(800) 201–PARK

Broadway Windows
New York University
80 Washington Square East
New York, NY 10003
(212) 998–5751

Bronx River Arts Center
1087 East Tremont Avenue
Bronx, NY 10460
(718) 589–5819

Cityarts, Inc.
525 Broadway, Suite 700
New York, NY 10012
(212) 966–0377

Creative Time, Inc.
307 Seventh Avenue, Suite 1904
New York, NY 10001
(212) 206–6674

Food Center Sculpture Park at Hunt's Point
The Bronx Council on the Arts
1738 Hone Avenue
Bronx, NY 10461
(718) 931–9500

Health and Hospitals Corporation
Public Art Program
City Hall
New York, NY 10007
(212) 788–3089

Lower Manhattan Cultural Council
One World Trade Center, Suite 1717
New York, NY 10048
(212) 432–0900

Organization of Independent Artists
19 Hudson Street, Room 412
New York, NY 10013
(212) 219–9213

Projects for Public Spaces, Inc.
153 Waverly Place
New York, NY 10014
(212) 620–5660

Prospect Park Alliance
95 Prospect Park West
Brooklyn, NY 11215
(718) 965–8951

Public Art Fund
1 East 53 Street
New York, NY 10022
(212) 980–4575

The Sculpture Center
167 East 69 Street
New York, NY 10021
(212) 879–3500

Snug Harbor Cultural Center
1000 Richmond Terrace
Staten Island, NY 10301
(718) 448–2500

Socrates Sculpture Park
P.O. Box 6259
Long Island City, NY 11106
(718) 956–1819

Storm King Art Center
Old Pleasant Hill Road
Mountainville, NY 10953
(914) 534–3190
(215) 546–2117

A number of government agencies and municipal arts councils provide space for temporary public art installations:

Brooklyn Arts Council
195 Cadman Plaza West
Brooklyn, NY 11201
(718) 625–0080

Bronx Council on the Arts
1738 Hone Avenue
Bronx, NY 10461
(718) 931–9500

Lower Manhattan Cultural Council
5 World Trade Center
New York, NY 10048
(212) 432–0900

Queens Council on the Arts
79–01 Park Lane South
Woodhaven, NY 11421–1166
(718) 647–3377
www.queenscouncilarts.org

Staten Island Coalition on Arts and
Humanities
1000 Richmond Terrace
Staten Island, NY 10301
(718) 447–3329

Metropolitan Transportation Association
Arts for Transit Program
347 Madison Avenue
New York, NY 10017
(212) 878–7225

New York City Department of
Parks & Recreation
The Arsenal
830 Fifth Avenue
New York, NY 10021
(212) 360–8163

New York City Department of Transportation
40 Worth Street
New York, NY 10013
(212) 442–7647

Port Authority of New York and New Jersey
One World Trade Center, 82 West
New York, NY 10048
(212) 435–3387

Although there is a growing number of public artworks being commissioned around the country, there is no regularity to the process: Proposals by artists to build artworks aren't due in a government agency's offices on certain dates each year. Instead, there is usually a call for proposals that, for municipalities and states with Percent-for-Art laws, takes place when a government building is to be built or renovated. Private businesses in the market for public art may not even publicize their search. They use art consultants instead. This makes having up-to-date information on who is doing what all the more crucial.

A number of associations and organizations keep tabs on developments and make that information available to artists. They include:

International Sculpture Center
1050 Potomac Street NW
Washington, DC 20007
(202) 965–6066
The Center's *International Sculpture* publication lists opportunities in public art.

Partners for Livable Places
1429 21st Street NW
Washington, DC 20036
(202) 887–5990
Has a visual artist database of public art grants that have been awarded.

National Conference of Mayors
1620 Eye Street NW
Washington, DC 20006
(202) 293–7330
Referral information on city public arts programs.

Project for Public Spaces, Inc.
153 Waverly Place
New York, NY 10014
(212) 620–5660
Assists city agencies, community groups, private developers, and planners in commissioning, installing, and maintaining public art projects.

National Conference of State Legislatures
1125 17th Street, Suite 1500
Denver, CO 80202
(303) 623–7800
Publishes *Arts in the States,* offering an overview of arts-related legislation.

There are also two foundations that specifically provide funding for public arts projects around the country:

Gunk Foundation/Critical Press
P.O. Box 333
Gardiner, NY 12525
(914) 255–8252
E-mail: gunk@mhv.net
www.mhv.net/ffgunk/welcome.html
Up to $5,000 for public art projects integrated into daily life.

LEF Foundation
P.O. Box 382866
Cambridge, MA 02238–2866
(617) 492–5333
or
1095 Lodi Lane
St. Helena, CA 94574
(707) 963–9591

Not specifically focusing on public art but certainly related is the Nancy H. Gray Fund for Art in the Environment (5128 Manning Drive, Bethesda, MD 20814), which makes grants up to $5,000 for artists who work outdoors and address environmental problems.

TAKING CARE OF PUBLIC ARTWORK

While Percent-for-Art statutes have meant money to pay for a growing number of public artworks, there has not been as strong a commitment to paying for the upkeep and conservation care of these works. A five-year study by the Washington, D.C.–based nonprofit organization Save Outdoor Sculpture, completed in 1995, identified 32,000 artworks throughout the United States, half of which were in need of significant conservation treatment and 10 percent of which were in urgent need. The main causes of the deterioration are: vandalism (for instance, graffiti or, in the case of a Beverly Pepper sculpture in Toledo, Ohio, called "Major Ritual," serious damage by skateboarders); pollution (such as acid rain) or the climate in general (intense sun, heat, dryness, or humidity); cars or trucks that crash into works; the fragility of the art materials (a Lucas Samaras sculpture in New Orleans made of unfinished Cor-ten steel was placed in storage at the General Services Administration after a conservation treatment failed to stop rust); and failure to provide regular and appropriate maintenance (including repainting, cleaning off bird droppings or rust, and filling in cracks or repairing damaged areas).

"They never kept my work in good repair," New York City sculptor Nancy Holt said about her 1984 "Waterwork" installation on the grounds of Gallaudet College in Washington, D.C., which finally removed the piece in 1995. "They just slowly let it fall apart." Another New York sculptor, Judy Pfaff, found that a 1992 public piece anchored to a Miami police station, which had been commissioned by the Dade County Percent for Art ordinance, was badly damaged by a roof leak at the station. That work, ironically entitled "Aqua Vitae," was taken down and destroyed.

Art is not thought of as having a life expectancy, but the growing maintenance issues raise the question of just how permanent is permanent public art. "Personally, I'm a proponent of temporary public works of art," said Jack Becker, editor of *Public Art Review,* the leading journal in this field. "The owners of too many of these works just don't accept responsibility for them."

Tom Eccles, director of the Public Art Fund in New York City, which primarily commissions temporary, or short-term, installations of public works of art, agreed. "Contractually, twenty years is as far as anyone can go," he said "A private developer may commission a work and be very enthusiastic about it, but buildings change hands over time, and no one wants to be tied to a work in perpetuity." That is certainly the problem faced by Forrest Myers, an artist in Brooklyn, New York, whose 1972 sculptural installation on the exterior wall of

a building at the intersection of Houston and Broadway in Manhattan became a source of contention with the property's new owner. In 1997, the owner announced that he wanted to remove the sculpture, replacing it with billboard signage through which he could earn thousands of dollars. The city's Landmarks Preservation Commission, however, stopped the owner from taking down Myers' piece and required that the work be repaired.

The condition of a public artwork affects the artist's reputation, maintaining his or her ties to the piece and requiring a commitment to advocate for the work's upkeep. "You make something, you put it out in the world and hope that people will respond," said New York City sculptor Mary Miss. "Certainly, you hope at the very least that it will not be so damaged or neglected that it's no longer the same piece you created. Under the [federal Visual Artists Rights Act of 1990], you can remove your name from it—that's not much consolation."

The key to insuring that one's installed public artwork is properly maintained, lawyers for artists claim, is to write maintenance instructions clearly into the commissioning agreement. Contracts should ideally include clauses requiring: a budget for maintenance and repairs; periodic inspections of the work (with photographs taken of the piece and a condition report written up by the inspector); regular maintenance (such as cleaning, regrouting, or repainting, as needed); immediate notification of the artist in the event of damage; a requirement that the artist meet with someone to discuss the best response to the damage; mediation if there are disagreements over how best to conserve the work; and monetary damages to the artist if the owner fails to live up to the maintenance agreement.

A number of public and private groups have made it their mission to restore existing outdoor artworks, either through raising money for this purpose or by providing information and referrals on reputable conservators and conservation techniques, including:

CONNECTICUT

City of New Haven
Department of Cultural Affairs
770 Chapel Street
New Haven, CT 06510
(203) 787-8956
Conserves public artworks in New Haven, Connecticut.

Connecticut Historical Commission
State Historic Preservation Office
59 South Prospect Street
Hartford, CT 06106–5110
(203) 566-3005
Adopt-a-Sculpture program.

NEW YORK

Municipal Art Society
457 Madison Avenue
New York, NY 10022
(212) 935–3960
Conserves public artworks in New York City.

STATE ARTS COMMISSIONS

Artists who live and work in New York, of course, do not only create public art projects within the state (or within the five boroughs of New York City). Many local and state public art commissioning agencies around the United States have as a criterion for selection that the artist is a resident of the state. However, others permit out-of-state artists to participate in their programs. Among these are:

Arizona Commission on the Arts
417 West Roosevelt
Phoenix, AZ 85003
(602) 255–5882
www.az.arts.us.asu.edu/artscomm/

Arkansas Arts Council
1500 Tower Building
323 Center Street
Little Rock, AR 72201
(501) 324–9348
www.heritage.state.ar.us/aac

Colorado Council on the Arts
Art in Public Places
750 Pennsylvania Street
Denver, CO 80203
(303) 894–2617
www.coloarts.state.co.us

Connecticut Arts Commission
Public Art Coordinator
One Financial Plaza
755 Main Street
Hartford, CT 06103
(860) 566–4770
www.ctarts.org

District of Columbia Commission on the Arts
and Humanities
Art in Public Places Coordinator
410 Eighth Street NW
Washington, DC 20004
(202) 724–5613
www.capaccess.org/ane/dccah/

Florida Division of Cultural Affairs
Art in State Buildings Program
Department of State
The Capitol
Tallahassee, FL 32399–0250
(850) 487–2980
www.dos.state.fl.us/dca/

Hawaii State Foundation on Culture and the Arts
44 Merchant Street
Honolulu, HI 96813
(808) 586–0304
www.hawaii.gov/sfca/

Illinois Art in Architecture Program
401 South Spring Street
Springfield, IL 62706
(217) 782–9561
www.cdb.state.il.us

Iowa Arts Council
Art in State Buildings
600 East Locust
Des Moines, IA 50319–0290
(515) 281–4006
www.state.ia.us/government/dca/iac

Maine Arts Commission
55 Capitol Street
25 Statehouse Station
Augusta, ME 04333–0025
(207) 287–2726
www.mainearts.com

Michigan Council for Arts and Cultural Affairs
Arts Projects Program
P.O. Box 30705
Lansing, MI 48909
(517) 241–4011
www.cis.state.mi.us/arts

Minnesota State Arts Board
Percent for Arts in Public Places Program
400 Sibley Street
St. Paul, MN 55101–1928
(651) 215–1618
www.arts.state.mn.us

Montana Arts Council
P.O. Box 202201
Helena, MT 59620
(406) 444–6430
www.arts.state.mt.us

Nebraska Arts Council
Public Art Coordinator
3838 Davenport Street
Omaha, NE 68131–2339
(402) 595–2122
www.nebraskaartscouncil.org

New Jersey State Council on the Arts
Public Art Coordinator
P.O. Box 306
Trenton, NJ 08625
(609) 292–6130
www.njartscouncil.org

New Mexico Art in Public Places
P.O. Box 14501
Santa Fe, NM 87504–1450
(505) 827–6493
www.museumsstate.nm.us/nmarts

Ohio Arts Council
Percent for Art
727 East Main Street
Columbus, OH 43205
(614) 466–2613
www.oac.ohio.gov

Oregon Arts Commission
775 Summer Street, N.E.
Salem, OR 97310
(503) 986–0084
http://arts.acom.state.or.us

Rhode Island State Council on the Arts
95 Cedar Street
Providence, RI 02903–1062
(401) 222–3880
www.risca.state.ri.us

South Carolina Arts Commission
Art in Public Places
1800 Gervais Street
Columbia, SC 29201
(803) 734–8696
www.state.sc.us/arts

Tennessee Arts Commission
401 Charlotte
Nashville, TN 37243–0780
(615) 741–1701
www.arts.state.tn.us

Texas Commission on the Arts
P.O. Box 13406
Austin, TX 78711–3406
(512) 463–5535
www.arts.state.tx.us

Utah Arts Council
Public Art Coordinator
617 East South Temple Street
Salt Lake City, UT 84102
(801) 533–4039
www.dced.state.ut.us//arts//

Washington State Arts Commission
P.O. Box 42675
Olympia, WA 98504–2675
(360) 753–5894
www.wa.gov/art

Wisconsin Arts Board
Public Art Coordinator
101 East Wilson Street
Madison, WI 53702
(608) 266–9737
www.arts.state.si.us

Wyoming Arts Council
Art in Public Places
2320 Capitol Avenue
Cheyenne, WY 82002
(307) 777–7742
http://soswy.state.wy.us/director/boards/
arts.htm

Chapter 8.
INSURANCE PLANS FOR ARTISTS

Obtaining adequate and affordable health care and health insurance has become a major problem for a sizable portion of the population. Artists of all media and disciplines are among the most likely groups not to have any health insurance coverage. According to a survey sponsored by the National Endowment for the Arts, less than 75 percent of the composers, filmmakers, photographers, and video artists questioned have any form of coverage. Of all artists in larger cities, the survey found that 30 percent lacked health insurance. One of the reasons for this is the fact that most artists earn too little money to afford insurance; 68 percent of the artists in the survey had household incomes of $30,000 or less.

Perhaps the ongoing debate in the United States on how to provide coverage for the millions of people without health insurance will result in significant improvements. Perhaps the increasing prevalence of health maintenance organizations (or HMOs) may put out of business many of the arts service organizations that currently offer group-rate plans to their members, as artists may believe that they have less of a need to join such organizations. In this latter scenario, a lot of the career services that only service organizations provide will be lost to artists as well.

Until the health care situation is improved to include all citizens of the United States, regardless of their ability to pay, artists will continue to rely on their own sources of help and coverage. A number of literary, media, performing, visual arts, and crafts organizations provide group-rate health insurance plans for their members. Membership in the health insurance plan of some of these organizations is confined to artists residing permanently within the particular city or state, while extending nationwide in others. For example, the Chicago Artists' Coalition's health insurance program is available throughout Illinois and in some of the peripheral states around Illinois, such as Michigan

and Wisconsin. Iowa, which also borders Illinois, is not eligible unless there are enough Coalition members seeking health insurance to warrant creating a group-rate program there. On the other hand, seven organizations—Artists Talk on Art, Editorial Freelancers Association, National Association of Teachers of Song, National Sculpture Society, New York Artists Equity, New York Circle of Translators, and the Organization of Independent Artists —all use the same health maintenance organization, which is limited to the states of Florida, New Jersey, and New York. "That's where our network is," said Phyllis Goodwin, sales representative for RBA Insurance Strategies, which negotiated the health insurance policy. Participants in this plan are billed quarterly, paying $583.95 for an individual, $1,392 for a family consisting of a single parent with children, $2,262 for a two-parent family with children.

The insurance industry is regulated by each state, and rates are higher in some states than in others. Massachusetts and New York, for instance, are "guaranteed insured" states, meaning that those wanting insurance coverage cannot be denied policies because of their health (preexisting condition), age, or sex. Some insurance carriers refuse to provide policies in these states because of their inability to weed out potentially higher-cost customers; insurance programs are likely to be more costly in these states than in others as a result of the presumed pool of expensive-to-care-for group members. Medical care and services in New York are also more expensive than in most other states. Those higher costs and mandated coverage are factored into the prices of policies; as a result, New York policy holders are likely to pay more than their counterparts in Illinois or California. The states themselves make analyses of the medical costs in their counties, determining rate areas (by zip code) that are used by insurance carriers when establishing premiums.

Other factors that drive up or down the cost of health insurance are:

• Age: Health insurance becomes more expensive as one becomes older.

• Sex: Men are generally less expensive to insure, because they do not have babies (prenatal and maternity costs are high), nor do they require mammograms and Pap smears. As a group, men also use medical services more sparingly than women. Even after their childbearing years, women remain more expensive to insure. In life insurance, on the other hand, the policies for women are less expensive, because they live longer.

• Group or individual policies: "Group rate" sometimes means less expensive, but many group policies include families and offer extensive prenatal and

maternity benefits, which increases the costs. A single male may get a better rate with an individual plan, but if he plans to marry and have children, the group plan is likely to offer the types of coverage that are more expensive to purchase individually.

• City or suburb: Cities tend to have more elaborate medical care facilities and equipment, raising the costs for insurance carriers, and their policies to urban-dwelling individuals, couples, and families reflect that increase. To a lesser extent, the degree to which there is a higher incidence of crime in a city may also be factored in.

• Deductible: The deductible, the amount that the policyholder agrees to pay before the insurance carrier steps in, ranges widely, from $0 to $5,000 and sometimes more. Lower deductibles increase the annual, monthly, or quarterly costs of a policy.

• Number of dependents: The more children one has, the higher the premiums. Insurance carriers generally cut off coverage for children over the age of nineteen, although some will continue coverage up to age twenty-three (finishing college) and even twenty-five (graduate school); however, lengthened terms of coverage increase the costs.

• Add-ons: The more options one attaches to a policy, the more expensive it becomes. Insurance coverage for experimental treatments, cosmetic surgery, optometry, dentistry, foot care, organ transplants, drugs not included in the insurance carrier's formulary, assistance with daily living, ambulance service, mental health, and a variety of other concerns is frequently not included in basic and group plans.

Many of the organizations offering health insurance programs rarely ask detailed questions about what prospective members do in the arts or otherwise, and it is unlikely that, say, a musician would be denied a medical insurance claim for belonging to a primarily visual-artist group. The American Craft Association, an arm of the American Crafts Council, wants its members to be involved in "the crafts or some related profession," and the Maine Writers and Publishers Alliance requires members to be self-employed.

Membership itself is usually not free, and annual dues range from $25 to $50, sometimes more. The costs of individual or group insurance coverage range widely, depending upon the particular plan and its benefits, the insurance carrier, state laws, and the number of people enrolled in the plan. Artists generally have been a more difficult group to insure because of industry concerns

that they do not earn enough money to pay their premiums, as well as that they do not generally take adequate preventive care—a result of their poverty—and require more expensive treatments. A number of insurance carriers also believe that artists as a whole are more likely to contract acquired immunodeficiency syndrome, or AIDS, than other occupational groups, which has led to companies greatly raising premiums for, or completely dropping, plans that cover artists of all media and disciplines. There is no factual basis for this belief, but the subject of AIDS and negative ideas about artists in our society generally tend to exist well outside rational discussion.

Becoming a member does not immediately enroll an artist in an organization's health care program, and insurance carriers are permitted to deny coverage to any individual. Insurance carriers usually require new members to complete a questionnaire or take a physical, and enrollment in a health plan sometimes must wait for a period of months. The reason for this is that, over the years, insurance companies have seen people join a group's insurance program in order that someone else pay for a needed operation, and then drop the health plan after they have recovered. Artists need to look at health insurance as a long-term commitment, and they also should shop around for the most suitable membership groups that they are eligible to join.

A reason to buy insurance through an arts organization is that the coverage plans may be tailored to a particular group. Lenore Janacek, an insurance agent who has crafted insurance plans for artists' groups, noted that she looks for "companies that are sympathetic to artists. Artists, for instance, are users of mental health, so that should be part of the area of coverage. Artists are also interested in alternative forms of health care, so I look for companies that provide coverage in that area." Because artists may not have a lot of money, she noted that some artists are offered the choice of a basic Blue Cross plan, with some premiums as low as $35 per month.

Here's an example of what you might expect to pay for coverage. If you join the National Sculpture Society, its insurance plan will cost you $256 per month for single coverage and $720 per month for family coverage. The coverage provides access to approximately 20,000 physicians in New York City and covers hospitalization and tests. Included in the plan is a dental rider that covers cleanings and x-rays, with discounted rates for other dental procedures. Psychological counseling (up to twenty visits with a $25 co-payment) is part of the package, but not alternative medicine (acupuncture and aromatherapy, among others).

Various types of health insurance plans are available, all with their own rules and enrollment requirements and procedures. Beyond the fee-for-service and HMO possibilities are also hospitalization (base plan, medical, surgical) and major medical insurance plans. Hospitalization insurance generally pays for bed and board (usually in semiprivate rooms), nursing care, and hospital staff physicians' services for a period of between one month and one year. Some hospitalization plans also cover:

- The use of operating and recovery rooms and equipment

- Intensive care rooms and equipment

- X-rays, laboratory, and pathological examinations

- Drugs, medicines, and dressings

- Blood, blood transfusion equipment, and the cost of a hospital employee administering the transfusion

- Oxygen, vaccines, sera, and intravenous fluids

- Cardiographic and endoscopic equipment and supplies

- Anesthesia supplies and equipment

- Physical and occupational therapy

- Radiation and nuclear therapy

- Any additional medical services customarily provided by the hospital

Most hospitalization plans, however, tend to be limited in terms of the services covered, requiring individuals to purchase major medical or "catastrophic" insurance. This type of plan picks up 80 percent of the costs that the basic hospitalization does not cover, less a deductible (the first $500, for instance), up to $1 million or more.

Among the questions to keep in mind when shopping for insurance coverage are:

- Who in your family is covered (someone with a preexisting condition, dependents, and to what age)?

- What services are covered?

- Is there a waiting period (and, if so, what is it) before coverage begins for someone with a preexisting condition?

- Are there limitations on the choice of health care providers or where health care may be obtained?

• Is the policy renewable (guaranteed renewable: the company cannot cancel a policy as long as premiums are paid on time; optionally renewable: the company may terminate the policy on specified dates; conditionally renewable: the company may refuse to renew a policy for specified reasons)?

• What are the family and individual deductibles or co-payments?

• What is the average annual premium increase for the plan, and how high and under what conditions will premiums increase?

A valuable source of information on health care options for the arts community is the Artists' Health Insurance Resource Center (*www.actorsfund.org*), which was established by the Actors' Fund of America with support from the National Endowment for the Arts. Among the databases are individual and group insurance plans available by state, how to select an appropriate plan, and links to other sources of information. The organizations offering health (and perhaps accident, dental, life, liability, studio, and disability) insurance include:

PERFORMING ARTS

United Scenic Artists
Pension & Welfare Department
575 Eighth Avenue, Third Floor
New York, NY 10018
(212) 736–6260
Membership in the union is open to scenic, costume, and lighting designers.

VISUAL ARTS AND CRAFTS

American Association of Museums
1225 Eye Street NW
Washington, DC 20005
(202) 218–7673
(800) 323–2106
E-mail: marketing@aam-us.org
Health insurance available to independent curators, consultants, professional staff, artists, and volunteers working for museums. Membership fees range from $35 to $140.

American Institute of Graphic Arts
164 Fifth Avenue
New York, NY 10010
(212) 807–1990
(800) 548–1634
E-mail: membership@aarp.org
www.aiga.org

American Society of Interior Decorators
608 Massachusetts Avenue, N.E.
Washington, DC 20002–6006
(202) 546–3480
E-mail: communications@asid.org
www.asid.org

Artists Talk on Art
19 Hudson Street
New York, NY 10013
(212) 965–9515
www.nearbycafe.com

College Art Association of America
275 Seventh Avenue
New York, NY 10001
(212) 691–1051
(800) 323–2106
(800) 503–9230
E-mail: nyoffice@collegeart.org
www.collegeart.org
Offering major medical, hospital indemnification, professional liability, cancer, and disaster insurance coverage. Membership fees start at $25 annually.

Graphic Artists Guild
90 John Street
New York, NY 10038
(212) 791–3400
E-mail: PaulAtGAG@aol.com
www.gag.org

International Sculpture Center
1050 17th Street NW
Washington, DC 20036
(202) 785–1144
www.sculpture.org
Group-rate health insurance available nationally, except for those living in Washington, D.C., Maine, New Hampshire, New Jersey, Puerto Rico, and the Virgin Islands. Membership is $95 annually.

National Art Education Association
1916 Association Drive
Reston, VA 20191–1590
(703) 860–8000
Group-rate health insurance available to residents of Connecticut, but not New York or New Jersey.

National Artists Equity Association
P.O. Box 28068 Central Station
Washington, DC 20038–8068
(202) 628–9633

National Association of Artists' Organizations
918 F Street NW
Washington, DC 20005
(202) 347–6350
E-mail: naao2@artswire.org
www.naao.org

National Sculpture Society
1177 Avenue of the Americas
New York, NY 10036
(212) 764–5645
(800) 722–0160
www.sculptor.org/nss
Membership is $40 annually.

New York Artists Equity Association
498 Broome Street
New York, NY 10013
(212) 941–0130
E-mail: reginas@anny.org
www.anny.org
Group insurance coverage currently available only to residents of New Jersey, New York, and southern Florida. Membership is $35 annually.

Society of Illustrators
128 East 63rd Street
New York, NY 10021
(212) 838–2560

CRAFTS

American Craft Association
21 South Eltings Corner Road
Highland, NY 12528
(914) 883–5218
(800) 724–0859
Health insurance plan was discontinued but
will be restored with a new carrier. Continues
to offer casualty and liability insurance.

Empire State Crafts Alliance
501 West Fayette Street
Syracuse, NY 13204
(315) 472–4245
Membership is $30 annually.

**Association of Independent Video
and Filmmakers**
304 Hudson Street
New York, NY 10003
(212) 807–1400
E-mail: aivffivf@aol.com
www.aivf.org
Insurance available only to those working a
minimum of 30 hours per week in the field of
film and video.

Group-rate health insurance plans are also
offered by organizations of self-employed people,
and artists may be qualified for membership:
ABG Business Associates, Ltd.
154 Commack Road
Commack, NY 11724
(516) 499–6100

American Association of Retired Persons
601 E Street NW
Washington, DC 20049
(800) 523–5800
(800) 424–3410
E-mail: membership@aarp.org
www.aarp.org

National Association for the Self-Employed
P.O. Box 612067
Dallas, TX 75261
(800) 232–6273
www.nase.org
Group-rate health insurance available for resi-
dents of Connecticut and New Jersey, but not
New York. Membership fees dependent on a
choice of three insurance plans: $72, $240, or
$360 annually.

**National Association of Socially Responsible
Organizations**
3204 18th Street NW
Washington, DC 20010
(800) 638–8113
www.nasro-co-op.com

National Small Business United
1156 15th Street NW, Suite 1100
Washington, DC 20005
(202) 293–8830
(800) 345–NSBU
www.NSBU.org
Membership is $75 annually.

Small Business Service Bureau
P.O. Box 15014
Worcester, MA 01615–0014
(508) 756–3513
(800) 343–0939
Membership varies by state, starting at
$85 annually.

Support Services Alliances
P.O. Box 130
Schoharie, NY 12157
(800) 836–4772
www.ssainfo.com
Membership is restricted to residents of
New York State. Membership fees are deter-
mined by the number of people in the group.

United States Federation of Small Businesses
249 Greene Street
Schenectady, NY 12305
(800) 637–3331
www.usfsb.com

Working Today
P.O. Box 1261, Old Chelsea Box Station
New York, NY 10113–9998
(212) 366–6066
E-mail: Working1@tiac.net
www.WorkingToday.org

Chapter 9.
APPLYING FOR GRANTS, FELLOWSHIPS, AND COMMISSIONS

Andy Warhol spent his whole life and career without ever once applying for a grant or fellowship. However, through his will he created the Andy Warhol Foundation for the Visual Arts (located on Bleecker Street), which provides grants to museums and other arts organizations and institutions that display contemporary art. This is largely par for the course: Most artists don't apply for grants or fellowships (most certainly don't receive them), and most philanthropic foundations that support the arts don't give money to individual artists (institutions get it). The support system for artists in the United States is largely the jobs that artists get to support themselves and the money they earn from selling their own artwork.

This is not to say that no artists ever receive monetary awards or that they are not eligible receive them; many artists have been recognized for their previous work, their current projects, or their potential for doing something important and valuable with fellowships and project grants. No one makes a career out of applying for money, however.

A distinction needs to be made early on: A fellowship is a no-strings-attached award of money (or something worth money, such as a residency in an artist community), based on an appreciation of an individual's past achievements. There is no specific requirement that anything be produced. A project grant, on the other hand, is a payment towards the completion of a specific event (a lecture, an art demonstration, or a community mural project, for instance) or a particular artwork (publication of a print series, for example). The artist will be reimbursed for his or her expenses, including labor, and there is usually a need to write a proposal (or fill out an application) for the grant, as well as a final report after the project has been completed that reveals what had been

accomplished and how the money has been spent. Fellowships tend to go directly to artists, whereas project grants are usually administered by nonprofit organizations. Everyone wants a fellowship; however, artists who get involved in the grants game have to learn how to find appropriate sources of funding and how to apply to them.

FISCAL SPONSORSHIP

The Andy Warhol Foundation for the Visual Arts is not permitted under the law to make awards to individuals. The same is true for most other foundations. A number of governmental agencies and almost all corporations also make grants only to nonprofit organizations rather than to individuals (businesses only receive tax deductions for money donated to nonprofits), and artists who seek project grants from any of these need to align themselves with a not-for-profit organization that will act as its fiscal sponsor. The organization, if it agrees to represent the artist, will formally submit the application; it will receive the grant funding, disperse the money to the artist, and supervise the artist while the project is taking place. For its efforts, the fiscal sponsor (sometimes called an umbrella organization) generally takes a percentage of the grant award, usually no more than 10 percent.

The New York State Council on the Arts refuses to provide funding for any umbrella organization that charges an artist more than 10 percent. The New York Foundation for the Arts, which holds a free seminar the third Friday of every month on how to choose a fiscal sponsor, takes 8 percent of the money raised by individual artists, although the group also charges a $100 initiation fee "in order to start the paperwork," according to Penelope Dannenberg, director of Artists' Services and Programs. On the other hand, colleges and universities regularly take 50 percent of the research grants that their professors and scientists are given. Of course, they provide the facilities in which the actual work can be done.

Any number of organizations may agree to act as fiscal sponsor, including professional societies, educational associations and institutions, religious organizations, social and recreational clubs. Ideally, artists would look to organizations and associations to which they are currently affiliated or with which they have some relationship, because their knowledge of the artists and of their reputations will make them more willing to extend themselves in this way. Otherwise, artists should look for nonprofit organizations that have demon-

strated an interest or programs similar to what they are planning, whose mission will be enhanced or furthered by the planned project or that will benefit in some way from being associated with the project. A YMCA, for instance, may have no specific history of creating artworks, but a mural project that involves at-risk teenage boys may fall within its overall mission and be acceptable.

Third World Newsreel is an arts service organization in Manhattan that provides financial assistance, equipment, and facilities for short and feature-length documentaries involving social and political issues by or about people of color. The organization promotes itself in brochures and on its Web site as a fiscal sponsor for filmmakers, providing "consultation and limited access to its own administrative, financial and technical resources. TWN will also accept, acknowledge, and disburse financial contributions for each sponsored project. There is a $25 one-time registration fee per project. . . . Additional fees will be charged to individual projects for specific services such as messengers, mailings, cash advances, etc. Fees charged against contributed income are based on a uniform sliding scale."

There are a variety of ways to identify potential fiscal sponsors: One may inquire directly of the corporation, foundation, or governmental agency which organizations they have worked with and which they might recommend for a particular project. Preliminary contact with the funding sources helps artists to learn how interested they are in the planned project and if they have any suggestions on how to tailor it in a way to make it more apt to be approved; their involvement in helping locate a fiscal sponsor (usually one with which they have worked in the past) creates an investment of time and interest on their part, which also makes approval more likely.

Artists may also discuss their project with other area nonprofit organizations for their suggestions as to appropriate fiscal sponsors. Additionally, they may examine the *Encyclopedia of Associations* (Gale Research) and the *National Directory of Nonprofit Organizations* (The Taft Group), both of which are usually found in public libraries, or visit Web sites providing searchable databases on nonprofit organizations, such as Action Without Borders (*www.idealist.org*) or GuideStar (*www.guidestar.org*). Preferably, the nonprofit organization will have some experience as a fiscal sponsor and, ideally, will have a track record with the granting agency.

Finding a fiscal sponsor, however, does not free the artists to devote themselves to their projects. Some umbrella organizations are willing to do a large share of the proposal writing and additional fundraising (most grants are not

for the entire cost of completing the project but are "matching" grants, requiring one, two, three, or four dollars raised from other sources for every dollar they give). Many others simply agree to handle the money when it comes in, take their cut, and let the artist do all the work of applying for the grant, submitting a proposal and a budget, submitting reimbursement statements, and writing any midterm or final reports that the funding source requires.

The process by which an organization chooses to sponsor an artist's project may also winnow out those who need more guidance and staff time. Both CityArts and the New York Foundation for the Arts agree to sponsor only between 20 and 30 percent of their applicants. Organizations that frequently sponsor artists' projects attempt to ascertain whether or not applicants understand fully what is involved in garnering financial support and completing the proposed work, and they prefer working with those who have undergone this experience in the past—more experienced artists will know to do more of the legwork and how to do it, lessening the amount of work for the sponsor. Psipy Ben-Haim, director of CityArts, stated that artists should "do their homework before coming to an organization you want to be an umbrella for your project. You should study the organizations you are approaching and learn about potential funding sources. You will have to do most of the work."

GOVERNMENTAL AGENCIES

There are a variety of funding categories available at governmental arts agencies on the local, state, and federal levels. These agencies are also useful sources of information on where else to turn for assistance of all kinds. A reasonable starting point is the National Endowment for the Arts, which you can contact at the Nancy Hanks Center, 1100 Pennsylvania Avenue NW, Washington, D.C. 20506–0001, (202) 682–5400; *www.arts.endow.gov/federal.html*. The NEA lists and provides links to agencies in the federal government that make grants and awards to arts organizations and artists. If one looks at recipients of grants and fellowships from the National Endowment for the Arts over the past two decades, a disproportionate number of New York City institutions and individuals will be found, a reflection of the abundance of arts organizations, institutions, and artists there who submit applications and of the high esteem with which these individuals and institutions are seen.

LOCAL ARTS AGENCIES. In general, when looking for funds, artists should begin at the local level, inquiring about who has supported arts projects from their town's chamber of commerce, town hall, or arts center. Connecticut, New Jersey, and New York all have assemblies of local arts agencies from which one may seek ideas for fundraising:

CONNECTICUT

Connecticut Statewide Assembly
c/o Middletown Commission on the Arts
P.O. Box 1300
Middletown, CT 06457
(203) 344–3520

NEW YORK

Alliance of New York State Arts Organizations
P.O. Box 96
245 Love Lane
Mattituck, NY 11952–1101
(516) 298–1234

The specific local arts agencies for
New York City are:

New York City Department of Cultural Affairs
330 West 42nd Street
New York, NY 10036
(212) 643–7770
www.ci.nyc.ny.us/html/dcla/home.html

Bronx Council on the Arts
1738 Hone Avenue
Bronx, NY 10461–1468
(718) 931–9500
www.bronxarts.org

Brooklyn Arts Council
195 Cadman Plaza West
Brooklyn, NY 11201
(718) 625–0080
www.artswire.org/baca

**Council on the Arts and Humanities
for Staten Island**
Snug Harbor Cultural Center
1000 Richmond Terrace, Room 315
Staten Island, NY 10301
(718) 447–3329
www.statenislandarts.org

Flushing Council on Culture and the Arts
137–35 Northern Boulevard
Flushing, NY 11354
(718) 463–7700

Lower Manhattan Cultural Council
5 World Trade Center
New York, NY 10048–0202
(212) 432–0900
www.artswire.org/downtown/index.htm

Queens Council on the Arts
79–01 Park Lane South
Woodhaven, NY 11421–1166
(718) 647–3377
www.queenscouncilarts.org

NEW JERSEY

Among the local arts agencies for
New Jersey within commutable distance
to New York City are:

Bergen County Division of Cultural and
Historical Affairs
20 Main Street
Hackensack, NJ 07601
(201) 646–2780

Burlington County Cultural and Heritage
Commission
P.O. Box 6000
Easthampton, NJ 08060
(609) 265–5068

Camden County Cultural and Heritage
Commission
250 South Park Drive
Haddon Township, NJ 08108
(609) 858–0040

Essex Area Arts Council
40 South Fullerton Avenue
Montclair, NJ 07042
(973) 744–1717

Hudson County Cultural and Heritage
Commission
583 Newark Avenue
Jersey City, NJ 07306
(201) 459–2070

Hunterdon County Cultural and Heritage
Commission
Administrative Building
Flemington, NJ 08822
(908) 788–1256

Mercer County Cultural and Heritage
Commission
640 South Broad Street
Trenton, NJ 08650
(609) 989–6701

Middlesex County Cultural and Heritage
Commission
703 Jersey Avenue
New Brunswick, NJ 08901
(732) 745–4489

Monmouth County Cultural and Heritage
Commission
99 Monmouth Street
Red Bank, NJ 07701
(732) 224–8778

Morris Area Arts Council
Box 370
Madison, NJ 07940
(973) 377–6622

Passaic County Cultural and Heritage
Commission
One College Boulevard
Paterson, NJ 07505
(973) 684–6555

Salem County Cultural and Heritage
Commission
98 Market Street
Salem, NJ 08079
(609) 935–7510

Somerset County Cultural and Heritage
Commission
P.O. Box 3000
Somerville, NJ 08876
(908) 231–7110

Sussex County Arts and Heritage Council
49 High Street
Newton, NJ 07860
(973) 383–0027

Union County Cultural and Heritage
Commission
633 Pearl Street
Elizabeth, NJ 07202
(908) 558–2550

Warren County Cultural and Heritage
Commission
8 Belvedere Avenue
Oxford, NJ 07863
(908) 453–4381

Not all local arts agencies have discretionary funds—that is, money that may be applied for by organizations or individual artists (those agencies without discretionary funds simply administer a city's annual appropriation to an institution, such as a museum or historic home or an event). Many of them do not have full-time staff and, instead, rely on volunteers. Before applying for any funding, one should check to see what they actually spend their money on.

STATE ARTS AGENCIES. The next avenue for available public funds is state arts agencies. State arts agencies provide a number of important services to artists, arts organizations, and arts institutions. On the most basic level, they receive applications for funding and provide financial support for projects they deem worthy. In addition, and increasingly, they seek to act as a clearinghouse of information for the arts community, providing job and housing listings, information on other opportunities for artists, publishing resource guides, and referrals to lawyers and accountants who volunteer their services. That information is made available through their Web sites and by contacting staff in writing or by telephone.

One of the most innovative state arts agency programs in career development is the Urban Arts Initiative out of the Connecticut Arts Commission, available to those who reside in the state. The agency provides sixteen workshops for individual artists and directors of arts organizations on a variety of topics (arts management, fundraising, law and business issues, among others) during the first year of the program. In the second and third years, the participating artists and organizations who have attended at least twelve of those workshops are matched with mentors, who provide counseling, referrals, experience, and an entry into a larger network, and who are eligible for small project grants from the state arts commission.

The New York State Council on the Arts, as noted previously, does not directly give fellowships to individual artists. However, the agency provides a host of other services that specifically benefit artists, such as technical assistance and travel grants (enabling an artist to learn a new technique or travel to a professional conference), as well as a Workspace Facilities program that provides funding for organizations offering equipment, expertise, and other resources to emerging and mid-career artists who are experimenting with new materials. (Those organizations apply for that money directly.)

Connecticut Commission on the Arts
755 Main Street
Hartford, CT 06103
(860) 566–4770
www.cslnet.ctstateu.edu/cca/

New Jersey State Council on the Arts
P.O. Box 306
Trenton, NJ 08625–0306
(609) 292–6130
www.njartscouncil.org

New York State Council on the Arts
915 Broadway
New York, NY 10010
(212) 387–7000
E-mail: nysca@tmn.com
www.nysca.org

The New York State Council on the Arts is not permitted by state law to make direct grants to individuals. Instead, the state arts agency provides money for individual fellowships to the New York Foundation for the Arts for "regranting," and it is there that one applies:

New York Foundation for the Arts
155 Avenue of the Americas
New York, NY 10013–1507
www.nyfa.org
(212) 366–6900

HUMANITIES COUNCILS. All fifty states and United States territories, as well as the federal government, have humanities councils, which provide grants to organizations that sponsor cultural activities, such as documentaries, oral histories, historical research, and other projects that have an educational purpose. Visual artists, especially photographers and filmmakers, are eligible for project grants under the aegis of an umbrella organization. There are individual fellowships awarded by the federal government and by some states, but these are almost exclusively intended for historians, usually associated with a college or university. Some humanities councils also publish directories of cultural organizations within the states and provide help on how and where one may submit a proposal for a project. For more information on state councils, contact:

Federation of State Humanities Councils
1600 Wilson Boulevard, Suite 902
Arlington, VA 22209
(703) 908–9700

National Endowment for the Humanities
1100 Pennsylvania Avenue NW
Washington, DC 20506
(202) 606–8400
(800) NEH-1121
www.neh.gov/

Connecticut Humanities Council
955 South Main Street
Middletown, CT 06457
(203) 685–2260
www.cthum.org

New Jersey Committee for the Humanities
28 West State Street
Trenton, NJ 08608
(609) 695–4838
www.njch.org

New York Council for the Humanities
150 Broadway, Suite 1700
New York, NY 10038
(212) 233–1131
www.culturefront.org

FOUNDATIONS

Figuring out where to apply for funding, in some cases, takes as much time and energy as preparing a specific project. One needs to know what types of individuals or projects the funding source has sponsored in the past: A foundation that has a long history of supporting medical research is unlikely to finance an artists-in-the-schools program; however, it might help underwrite an art class for patients in a hospital if the proposal can describe (and back up with evidence) the health benefits of the project. It is important for those seeking grant money to learn exactly to whom and for what a given foundation has money: A foundation may claim that it provides funding for the arts, but, on examination, it only provides money for a particular art event in another state.

A foundation's history may be examined through the publications and CD-ROM of the Foundation Center (79 Fifth Avenue, New York, NY 10010; (212) 620–4230; *www.fdncenter.org*) or through the Foundation Center's 213 cooperating libraries around the United States, where these same publications are available. These regularly updated publications will also indicate future funding commitments of a given foundation. For a Foundation Center Web search of grant-giving organizations, there are four basic addresses:

Private foundations: *www.fdncenter.org/grantmaker/priv.html*

Corporate grantmakers: *www.fdncenter.org/grantmaker/corp.html*

Public charities: *www.fdncenter/grantmaker/pubch.html*

Community foundations: *www.fdncenter/grantmaker/comm.html*

Two other organizations also monitor the activities of private foundations: The Council on Foundations (*www.cof/org/links*) and Grant Advisor (*www.grantadvisor.com/tgaplus.links.htm#foundations*) include information on hundreds of foundations, both large and small.

Most states, including New York, publish a directory of their private foundations, which can be helpful for those seeking financial support for local or statewide projects. These directories are often available at the cooperating libraries of the Foundation Center, or one may contact the Foundation Center directly to learn where they may be found. Another source of information about foundations, particularly on the local level (where most of their charitable giving is focused), is:

Regional Associations of Grantmakers
1828 L Street NW
Washington, DC 20036–5168
(202) 467–0472
http://rag.org

Members include community foundations (the Greater Hartford Community Foundation, for example), federated charities (United Way, Junior League, among others), private foundations, and business charities. Few of these are likely to focus exclusively on the arts, but they may be willing to sponsor arts projects that fit into their overall plan of giving. These regional associations of grantmakers are:

CONNECTICUT

Connecticut Council for Philanthropy
85 Gillett Street
Hartford, CT 06105
(860) 525–5585
www.Ctphilanthropy.org

NEW JERSEY

Council of New Jersey Grantmakers
101 West State Street
Trenton, NJ 08608
(609) 341–2022
www.cnjg.org

NEW YORK

New York Regional Association of
Grantmakers
505 Eighth Avenue, Suite 1805
New York, NY 10018
(212) 714–0699
www.nyrag.org

CORPORATIONS

One also needs to know the goals of the funding source: A corporation may be looking to improve its relationship with the community in which it is based or make itself look more attractive to potential employees. Like foundations, corporate contributors generally have specific areas in which they target their giving; unlike foundations, the giving often reflects the particular interests of specific individuals within the company and may further the interests of the corporation indirectly. For example, the charitable giving arm of the New York City law firm of Brauner, Baron, Rosenzwieg, & Klein has given grants to a number of synagogues on Long Island, which, in turn, have given their legal work to the law firm. Other grants by the firm have gone to schools that the partners' children have attended and institutions in the towns where the partners live.

On the other hand, Consolidated Edison, the large utility company in New York City, is less personal in its awards, focusing its grantmaking in two major areas: education and the environment. The arts, however, are not outside of its plans for giving, and many artists have been hired for projects at the Brooklyn Children's Museum, the Staten Island Children's Museum, the Children's Museum of the Arts in Manhattan, the Queens Council on the Arts, and the Rye Arts Center in Westchester. The process of researching potential funding sources requires one to find out not only what a company claims it supports but what it actually sponsors: Sometimes, a corporation advertises itself as an arts supporter but only gives money to Lincoln Center or to a specific dance school in the Bronx; at other times, such as with Consolidated Edison, the focus area for its giving is elastic enough to encompass a sizable number of artistic ventures.

One might determine what corporations actually sponsor by reading their annual reports, inquiring of the trade associations or Chamber of Commerce to which they belong and finding articles about the companies in business maga-

zines or newspaper business sections. Additionally, one must learn about how the funding sources decide what they will sponsor—through an application process or simply a letter making a proposal, by one person within the organization (chief executive officer, director of marketing, press officer, president) or through a panel—and what, if any, deadlines there are for proposals.

Unlike governmental agencies and foundations, private businesses often do not have an established procedure for charitable giving, and they may not make donations every year. Artists may simply have to call individual companies to inquire whether or not they provide funding and, if so, to whom they have made donations in the recent past, who makes funding decisions, and what is the process by which a nonprofit organization requests a contribution.

The search for financial support for a project may take an artist far and wide, examining books that list the staff and earnings of major corporations (*Standard & Poor's Register of Corporations, Executives, and Industries; Ward's Business Directory of U.S. Private and Public Companies; Dun & Bradstreet Million Dollar Directory; Thomas Register; Macrae's State Industrial Directories; Directory of Corporate Affiliations*), company financial reports and Web sites, directories of corporations that buy art or provide funding to the arts (such as *ARTnews's International Directory of Corporate Art Collections* and R.R. Bowker's *Annual Register of Grant Support*), and any listing of wealthy individuals. Some Internet sources for information about who gives money and to which charities are:

GrantsWeb: *www.fie.com/cws/sra/resource.htm*
Search for funding sources.

Helping.Org: *www.helping.org*
Fundraising assistance and access to funders.

Internet Nonprofit Center: *www.nonprofits.org*
Search for funding sources.

Joseph and Matthew Payton Philanthropic Studies Library
IUPUI University Library
755 West Michigan Street, UL 0135
Indianapolis, IN 46202–5195
(317) 278–2311
www-lib.iupui.edu/special/ppsl.html
Search for funding sources.

Foundation Center: *http://fdncenter.org/onlib/lnps/index.html*
Bibliography of articles on fundraising.

Philanthropy News Digest: *http://fdncenter.org/pnd/current/index.html*

BIBLIOGRAPHY OF ARTICLES ON FUNDRAISING:
Thomas Register: *www.thomasregister.com*

For clubs, societies, trade and other associations that offer awards and grants, one should consult the *American Art Directory* and the *Directory of Associations* (both published by R.R. Bowker). For individuals who might be approached for grants, one might examine social registers and club rosters. Individuals, by the way, are responsible for between 80 and 90 percent of all charitable giving, far exceeding the amounts provided by corporations, foundations, and governmental agencies.

MAKING A PITCH

Preparing a proposal affords an artist the greatest control over the presentation of his or her project, because the proposal will detail a specific area of need (for instance, children-at-risk with too few outlets for their creative energy) and how the project will solve the problem (a participatory mural project will involve these children-at-risk in an activity that gives them pride in their community and in their own achievement), how the project will be accomplished (finding the children to be served, helping them develop a design for the mural, supervising the children throughout the project period), what materials and other resources will be used in completing the project, the budget for the project, how the project fits into the general grantmaking goals of the funding source, and the artist's own credentials and experience in successfully carrying through this type of endeavor. The most extensive part of a proposal is usually the appendix, which contains endorsements or letters of support for the project by people who have some standing in the arts or in the community, information about the artist (newspapers or magazine clippings of reviews, profiles, feature articles) or about other projects accomplished by the artist or similar projects that have taken place elsewhere, sketches of what the project will look like, and any other reference material that supports the claims made by the artist on behalf of the value of the project.

Application forms, on the other hand, require artists to answer someone else's questions, which may result in important information being left out. Artists, however, should not reformulate the questions on the applications—this usually irritates those reading the application—but answer them as fully and clearly as possible. It is often wise to have someone else look over the completed application or the proposal to ensure clarity and the absence of jargon.

A growing amount of fundraising is being carried on over the Internet, as applicants may learn about a foundation's pattern of giving (*www.guidestar.com* accesses the 990 forms that foundations and other charities submit to the government to show that they are in accordance with the law and their own bylaws) and occasionally fill out a foundation's applications online. This offers benefits and some possible hazards. Information about sources of funding has never been more accessible, yet it may also make the need for personal contact seem less necessary. A thank-you note, for example, should be as personal as possible—the envelope addressed by hand or the note itself handwritten—even if it is only a few lines. E-mail responses or even computer-generated thank-you's in which different names are inserted at the top do not suggest real gratitude, and they don't inspire loyalty on the part of the charitable donor, who is apt to be asked for more money at a later time. Individual contributors, foundation and corporate directors don't just give money for projects that fit their usual pattern, but rather help support organizations (and the individuals within them) with whom they feel most comfortable and by whom they feel most appreciated.

Online applications, by their very nature, are not going to include all of the appendix material that proposals traditionally have (write-ups, illustrations, endorsements, examples of past accomplishments); one cannot make a general description and say, "See Appendix B," for a visual assist. As a result, the writing must be far more concise (people don't read from a screen nearly as long as they will look at the words on a piece of paper) and on target. Before hitting that "send" key, show an online proposal to one or more people for comment.

Over the last quarter century, an entire breed of people called grant writers has been created, whose expertise in fundraising gets them hired as consultants or as full-time employees at nonprofit institutions. Without devoting their lives to the subject, artists may also develop the skills to research potential funding sources and apply successfully for grants. Many of New York's colleges and universities offer adult education and for-credit classes in fundraising, proposal-, and grantwriting. Among the organizations that specifically offer courses in these areas are:

The Foundation Center
79 Fifth Avenue
New York, NY 10003–3690
(800) 424–9836
www.fndcenter.org
Offers one-day proposal-writing seminars at
various locations around the country for $175.

The Fund Raising School
79 Fifth Avenue
New York, NY 10003–3690
(317) 274–7063
(800) 962–6692

FELLOWSHIPS

Some awards, fellowships, and grants in the arts are limited to individuals and
organizations living and working within a defined geographical area. Others are
open to all applicants. Below are a number of grants and fellowships from
(largely) New York City–based organizations that are especially targeted toward
emerging artists:

ARTISTS—GENERAL

Art Matters
187 East Fourth Street
New York, NY 10009
(212) 539–3120
Awards for visual artists involved in experimental work.

Artists Space
Independent Projects Grant
38 Greene Street
New York, NY 10013
(212) 226–3970
www.artistsspace.org
Grants up to $500 for individual artists and
groups of artists to help realize projects.

ArtsLink
CEC International Partners
12 West 31st Street
New York, NY 10001–4415
(212) 643–1985
Awards of between $2,500 and $10,000 for
projects enabling U.S. artists to work with
artists of Eastern Europe and the former Soviet
Union.

Blanche E. Colman Trust
c/o Boston Safe Deposit & Trust Company
One Boston Place
Boston, MA 02108
(617) 722–6818
Grants to professional artists in Connecticut.

Creative Capital
65 Bleecker Street
New York, NY 10012
(212) 598–9900
www.creative-capital.org
Awards of $5,000 to $20,000 to fifteen
projects in the categories of media arts,
visual arts, performing arts, and emerging
fields.

Do Something
423 West 55th Street
New York, NY 10019
(212) 523–1175
www.dosomething.org
Grants up to $500 for new or ongoing projects
focusing on community building by artists
under the age of thirty.

Geraldine R. Dodge Foundation
163 Madison Avenue
Morristown, NJ 07962–1239
(201) 540–8442
Awards of $5,000 to art teachers in New Jersey to pursue artistic interests and later implement visual arts projects in their schools.

Elizabeth Foundation for the Arts
P.O. Box 2670
New York, NY 10108
(212) 956–6633
Awards from $2,500 to $12,000 for professional artists who are working toward becoming self-supporting but are experiencing genuine financial need.

Francis Greenburger Foundation
55 Fifth Avenue
New York, NY 10003
(212) 206–6092
$6,000 grants to painters and sculptors

John Simon Guggenheim Memorial Foundation
90 Park Avenue
New York, NY 10016
(212) 687–4470
www.gf.org
Awards.

Alfred Jurzykowski Foundation
21 East 40th Street
New York, NY 10016
(212) 689–2460
Awards to artists of Polish ethnic background, regardless of place of residence or citizenship.

Richard Kelly Grant
c/o Illuminating Society of North America
120 Wall Street
New York, NY 10005
(212) 248–5000, ext. 118
Awards up to $2,000 for artists thirty-five or younger creating work that utilizes light.

Emory and Ilona Ladanyi Foundation
12 Ranch Place
Merrick, NY 11566
Awards to young American artists.

Manhattan Center Graphics Scholarship Committee
481 Washington Street
New York, NY 10013
(212) 228–4186
Grants to artists who have not previously worked at the Graphics Center. Printmaking experience not required.

Memorial Foundation for Jewish Culture
15 East 26th Street, Room 1703
New York, NY 10010
(212) 679–4074
Fellowships up to $7,500 for art projects with Jewish themes.

MICA Foundation
450 Park Avenue
New York, NY 10022
(212) 724–3069
Grants to artists.

Mid Atlantic Arts Foundation
22 Light Street
Baltimore, MD 21202
(410) 539–6656
www.midatlanticarts.org
Fellowships for artists in Maryland, New Jersey, New York, and Pennsylvania.

Martha Boschen Porter Fund
145 White Hollow Road
Sharon, CT 06069
Awards to financially needy artists in Connecticut and New York (including New York City).

Project on Death in America
Humanities & Arts Initiative
Open Society Institute
400 West 59th Street
New York, NY 10019
www.soros.org/death/eligibility.htm
Fellowship for artists who bring creativity to
bear on the issues of death and dying.

Puffin Foundation Ltd.
Department B
20 East Oakdene Avenue
Teaneck, NJ 07666–4111
(201) 836–8923
Grants up to $25,000 for younger artists whose
projects might find funding difficult because of
their genres or social philosophy.

Surdna Foundation
330 Madison Avenue
New York, NY 10017
(212) 557–0010, ext. 256
Awards to art teachers.

EMERGENCY ASSISTANCE

Adolph & Esther Gottlieb Foundation
380 West Broadway
New York, NY 10012
Emergency financial assistance for mature
visual artists.

Aid to Artisans
14 Brick Walk Lane
Farmington, CT 06032
(860) 677–1649
E-mail: atausa@aol.com

Artist Fellowship
Emergency Aid
47 Fifth Avenue
New York, NY 10003
Emergency financial assistance for mature
visual artists.

Artists Welfare Fund
498 Broome Street
New York, NY 10013
(212) 226–3970
Emergency grants.

Change, Inc.
Box 705, Cooper Station
New York, NY 10276
(212) 473–3742
Emergency grants of between $100 and $500.

Craft Emergency Relief Fund
P.O. Box 838
Montpelier, VT 05601–0838
(802) 229–2306
www.craftemergency.org
Interest-free loans up to $2,000 to professional
craftspeople.

Indian Artist Relief Fund
www.indianartistofamerica.com

New York Foundation for the Arts
Special Arts Fund for Emergencies
155 Avenue of the Americas
New York, NY 10013–1507
(212) 366–6900
www.nyfa.org
Emergency grants.

Pollack-Krasner Foundation
863 Park Avenue
New York, NY 10021
(212) 517–5400
www.pkf.org
Grants to needy artists.

The Herbert and Irene Wheeler Foundation
P.O. Box 300507
Brooklyn, NY 11230–0507
Fellowships and emergency grants to artists
of color.

The Wheeler Foundation
126 West 11th Street
New York, NY 10011
(212) 807–1915
Fellowships and emergency grants to artists of color.

FILM AND VIDEO

Lyn Blumenthal Memorial Fund
P.O. Box 3514, Church Street Station
New York, NY 10007
Grants up to $3,000 for video productions that test the limits of technology, question aesthetic conventions, or explore issues of gender, sexuality, and identity.

Roy W. Dean East Coast Film Grant
630 Ninth Avenue
New York, NY 10036
(212) 977–9330
(800) 444–9330
Award of $3,000 in film stock, $3,500 of film processing, $2,000 of film editing time, and a 16mm camera package.

The Funding Exchange
666 Broadway
New York, NY 10012
(212) 529–5300
www.fex.org/robeson
Awards up to $15,000 for independent media productions with a progressive political focus.

Jerome Foundation
West 1050, First National Bank Building
532 Minnesota Street
St. Paul, MN 55101–1312
(612) 224–9431
Grants for film and video projects by artists residing in New York City.

P.O.V.
220 West 19th Street
New York, NY 10011
(212) 989–8121
Awarding $425 per minute for nonfiction film and video to air on public television.

Soros Documentary Fund
Open Society Institute
Community Fellowships
Individual Project Fellowships
400 West 59th Street
New York, NY 10019
(212) 887–0657
www.soros.org
Grants for documentary films and videos on current issues in human rights, freedom of expression, social justice, and civil liberties.

PERFORMANCE ART

Franklin Furnace Fund for Performance Art
Franklin Furnace Archive, Inc.
45 John Street
New York, NY 10038–3706
(212) 766–2740
www.franklinfurnace.org/money/
 moneywork.html
Up to $5,000 for performance artists to produce works anywhere in New York State.

PHOTOGRAPHERS

Aaron Siskind Foundation
73 Warren Street
New York, NY 10007
Up to $5,000 for individuals working in photography.

Buhl Foundation
114 Greene Street
New York, NY 10012
(212) 274–0100
Grants of $2,500, $5,000, and $10,000 for artists working in photography.

Center for Photography at Woodstock
The Photographers' Fund
59 Tinker Street
Woodstock, NY 12498
(914) 679–9957
www.cpw.org
Awards to photographers.

En Foco, Inc.
New Works
32 East Kingsbridge Road
Bronx, NY 10468
(718) 584–7718
www.nearbycafe.com
Honorarium to photographers of color.

Work-Scholar Program
Aperture Foundation
20 East 23rd Street
New York, NY 10010–4463
(212) 505–5555
www.aperture.org

W. Eugene Smith Memorial Fund
c/o International Center of Photography
1130 Avenue of the Americas
New York, NY 10128
(212) 860–1777, ext. 186
Grant of $20,000 to a photographer whose past work and proposed project follows in the tradition of W. Eugene Smith.

SCULPTORS

The Gunk Foundation
P.O. Box 333
Gardiner, NY 12525
(914) 255–8252
www.gunk.org
Awards up to $5,000 for artists' projects in the public domain.

Alex J. Ettl Grant
National Sculpture Society
1177 Avenue of the Americas
New York, NY 10036
(212) 764–5645
www.nationalsculpture.org
Award of $4,500.

WOMEN ARTISTS

Astraea National Lesbian Action Foundation
116 East 16th Street
New York, NY 10003
(212) 529–8021
www.astraea.org
Awards up to $10,000 for film and video projects addressing issues relating to lesbians.

Money for Women
Barbara Deming Memorial Fund
P.O. Box 630125
Bronx, NY 10463
Grants up to $1,000 for feminist women in the arts whose work in some way focuses upon women.

National Museum of Women in the Arts
1250 New York Avenue NW
Washington, DC 20005–3920
(202) 783–5000
www.nmwa.org
Library Fellows Grant for Book Artists, open to women artists only.

Thanks Be to Grandmother Winifred
Foundation
P.O. Box 1449
Wainscott, NY 11975
(516) 725–0323
Grants up to $5,000 to women artists age fifty-four and over working in the visual arts.

Women's Studio Workshop
P.O. Box 489
Rosendale, NY 12472
(914) 658–9133
www.wsworkshop.org
Two types of artist's book grants, including a
residency at the workshop, a stipend, materials,
and housing.

Chapter 10.
HUMAN AND OTHER RESOURCES IN THE ART WORLD

Historically, artists have met each other in workshops, studios and art schools, at taverns, art openings, and loft parties—but almost always in cities. Having more artists, art galleries, art buyers, art critics, and artwork than anywhere else in the world, New York City draws artists from throughout the United States and the rest of the world to be part of an ongoing explosion of art activity. Cities, however, and New York in particular, are also very lonely, isolating places to live, because of their size and the ease with which one may get lost in the crowd. Newcomers learn quickly to keep their eyes down in subways ("What are you looking at?") and their voices hushed in elevators. Even in a city full of artists, no one wants to be too conspicuous. With so many people around, people always seem to be in everyone's way. New Yorkers are often, and often rightful-ly, portrayed as hardened and pushy, treating their fellow passengers in life not as individuals but as obstacles who slow them down and must be circumnavi-gated. How precisely to meet other artists can seem a daunting challenge.

"When I first moved here, I was lonely and wanted to be part of a group of artists, to talk about what's going on in our work or just commiserate," said Barbara Rachko, a painter who moved to Manhattan from Alexandria, Virginia, in 1997 at the age of forty-four. Being in New York City, she noted, has led to an improvement in her work ("Art is in the air here") and to some exhibitions at commercial galleries and alternative spaces. Back in Alexandria, she had rent-ed a workspace in the open-to-the-public studio facility called The Torpedo Factory for three years, but "I was constantly interrupted there. Really, I came to New York for some solitude." Still, she wanted a circle of artists and happened upon an advertisement in the monthly magazine *Art Calendar* placed by a woman artist in New York who sought other women artists there to form a sup-

port group. Although members come and go, an average of nine women now meet once a month to "bounce ideas off each other, occasionally provide critiques, and generally help each other feel less alone."

ARTISTS NETWORKS

Some artists who move to New York City, especially those who are younger, may have friends from school already there who can be helpful in finding a place to live and work, a job, and a network of other artists. Sculptor John Monti, who studied painting at Portland State University in Oregon before moving to Brooklyn in 1980 in order to earn an M.F.A. at Pratt Institute ("I thought about going to CalArts, but I felt challenged by New York, and knew I had to participate in the art scene there," he said), stayed with artist friends from Portland State who were already living in New York before he found his own apartment. With some of these same friends, who worked as contractors, he worked as a part-time carpenter, with which skills he later took to a job at The Clocktower as an art handler for four years. As related in chapter 4, Monti ultimately got a teaching job at Pratt because of his friendly relations with the chairman of the painting department.

Similarly, a curator friend that SoHo painter Jim Bohary made through one of his teachers at New York University included him in a show that this person organized, and another NYU teacher—a printmaker—helped Bohary obtain a teaching position at the Printmaking Workshop. Eventually, one's network of friends, associates, and contacts expand to form a community in which information is shared and through which additional contacts are made. Bohary took some classes at the New York Studio School in 1969, where he learned of studio space sublets in a building on Broadway between 12th and 13th streets. The lease was owned by artist Elaine de Kooning, who had convinced the building owner to let artists use the space for their work. "She was very kind to younger artists and invited me to lots of events," he said. "We became friends, and she was my son's godmother." Through de Kooning, he met Bud Bishop, the director of the Hunter Museum in Chatanooga, Tennessee, who in 1976 gave him his first one-person exhibition there.

Ethnic and religious affiliations also have been helpful to artists who move to New York without a social network in place. When Alex Stolyarov, who had emigrated with his parents from Russia to Chicago in 1988, moved to New York in 1992, other Russian nationals whom his parents knew found him an apart-

ment in Queens for only $300 per month. Lex Braes, who left Scotland for Brooklyn in 1979, full of condemnation of Scottish art as "parochial" and lacking "ambition," gravitated to other Scottish and British artists he met in taverns and on jobs, forming a loose-knit group. "As a group," he said, "we started going to gallery openings. We'd look at the work, we'd look at the scene, we'd talk later about what we saw, and it helped me become less scared of the art world. When you go alone, you feel very isolated and threatened, but in a group it makes the whole thing more comfortable, like you're going to a pub. I started to feel, 'Okay, this isn't so scary,' and I think that was a breakthrough for me in becoming an artist."

The Church of Jesus Christ of Latter-Day Saints, better known as the Mormons, provided valuable assistance to Michael Peery, who moved from Idaho Falls, Idaho, to New York City in 1994 in order to attend the New York Academy of Art. A Mormon friend, who had similarly received a degree in painting from Utah State University in 1991 and who had moved to New York before him, gave Peery a place to stay while he looked for his own apartment. That apartment also came from Mormons living in New York who were moving back to Salt Lake City and were interested in subletting to others of their religion. Periodically, Peery travels back to Idaho for a few months at a time in order to earn some money working for his father, a mason-contractor, and Peery invariably sublets his apartment to students from Brigham Young University. "I know already their lifestyle, and I know that they are good, honest people," he said.

Additionally, friends he has made through the church in New York have arranged portrait commissions, as well as generated sales of his landscape paintings to other Mormons in the east.

ARTIST ASSOCIATIONS

Artists gravitate to each other for a variety of reasons—for support or because they are pursuing similar artistic ideas, among others—and, sometimes, those gatherings become more formalized and have a specific purpose. While her women's artists group was useful to Rachko in terms of helping her feel less isolated, "the work of the other members was not at the same level as mine," she said. "The others all have families—I don't—and those families were their main priorities. I'm more motivated and ambitious than the other women." At a point when she was beginning to feel frustrated with this group, one of the

members mentioned another group that has more of a business-of-art orientation, which Rachko also joined. This group, called The Artist Breakfast, meets once a month at Tribakery, a cafeteria-style restaurant on Franklin Street in Lower Manhattan, to share information about upcoming exhibitions, available studios, where not to show one's work, and other purely business matters.

An average of forty visual artists take part in these breakfast gatherings, according to Barbara Ellman, a painter who started the group in 1995. "I used to spend summers in New Mexico," Ellman said, "and a friend there invited me to a kind of breakfast group of artists. There was some talk about business, but it was mostly complaint-oriented. It occurred to me that it would be a great idea to get together a group of artists in New York on a regular basis and have it be very business-focused." When she returned to Manhattan, she began calling "all the visual artists I knew" to meet monthly and talk business ("we don't discuss aesthetics"). The group consists primarily of women ("we all know that the art world is male-dominated"), but men are not excluded.

Conversations each month are shaped by whatever is on the minds of the people taking part: "It may be, 'Do you know a good shipper?' or 'Would you read my artist statement?' or 'I need help writing a grant proposal' or whatever else," Ellman said. As members get to know each other's interests more, they pass on information directly. "Someone in the group heard of a show being organized at a museum that she felt was appropriate for me," Ellman. "I sent my slides there and was included." Another member knew a museum curator who was putting together an exhibition, and six others in the group were able to get their work into that. Ellman herself once announced that she was losing the studio she had rented for twenty years in Chelsea, because the landlord was converting the space for other purposes. "I asked the other artists if they knew of any studios available, and one of them knew of this one," her current studio in Long Island City, which has more space, more light, and costs less. "It's all networking here."

While the larger group meets once a month, many of the women have formed friendships and social relationships. "When I have an opening," Ellman noted, "I know that I can expect at least fifteen people from the breakfast group, and they often bring other people with them."

Not all business and career information for artists comes through word-of-mouth, although that is the most common form it takes. Many art schools offer workshops and seminars on business subjects (marketing, law and the arts, taxes, finding jobs, and finding a gallery, among others) that are open to

current students and alumni, as well as the general public. The New York Foundation for the Arts, in collaboration with the Brooklyn Arts Council [195 Cadman Plaza West, Brooklyn, NY 11201; (718) 625–0080], conducts an annual "Professional Development Seminar for the Arts" series. The Foundation also works with the New Jersey Council on the Arts [P.O. Box 306, Trenton, NJ 08625–0306; (609) 292–6130; www.njartscouncil.org] to stage a yearly "How Do I Make Art & Hold It All Together" seminar. The Bronx Museum of the Arts [1040 Grand Concourse, Bronx, NY 10456–3999; (718) 681–6000; attention AIM] runs a twice-yearly seminar series entitled "Artists in the Marketplace," consisting of four programs in which artists learn basic how-to's in establishing themselves as professionals. An average of 350 artists apply to take part in the series, and 11 are selected. Similarly, Aljira, A Center for Contemporary Art in Newark, New Jersey ["Emerge," P.O. Box, Newark, NJ 07107; (973) 643–6877] sponsors a series of twelve workshops for between 18 and 20 emerging artists living and working in the greater metropolitan area of New York and New Jersey. For that program, artists must also apply, submitting six slides of their work, and finalists will be individually interviewed. After completing the series of workshops, which focus on such issues as financial planning, alternative spaces, commercial galleries, copyright, public relations, the Internet, grants, and fellowships, participants will have their work featured in a group show at Aljira. The "Emerge" series was conceived and is run by Judith Page, a mixed-media sculptor and installation artist in New York City, who wanted "to give to artists what I wish I had received, basically some idea of how to make a career as an artist. I stumbled through my art career." She moved to Manhattan in 1992 after working for thirteen years as the director of Valencia Community College's gallery in Orlando, Florida. "For a long time, I believed—I still believe, really—that art should be decentralized and that you could develop your own art scene where you live," she said. "But, after a while, I realized my work was playing for the same audience over and over again. If I was serious about being an artist, I knew I had to go to New York."

While in Florida, she curated a number of exhibitions of New York artists for Vanderbilt University in Nashville, Florida State University in Tallahassee, and Atlantic Center for the Arts in New Smyrna Beach, Florida, and had developed a large group of contacts. "When I moved to New York, I called everyone I had been in touch with in Florida" about where to live, where to exhibit, where to work, Page said. "I found a loft through an artist I had put in an exhibition."

Page added that, through word-of-mouth and recommendations from many artists she has met and befriended, she has gotten her work into a number of exhibitions. "Your network is the most important thing you have."

Contrary to the romantic myth, artists have never spent their careers alone and unknown, closeted in garrets and only communing with their muse. To succeed, artists need to be known in the art world and enter into what is sometimes called the "favor pool." Organizations help in this process by introducing artists to a wider circle of people working in the same media or subject matter, allowing access to a broad range of information. Among the groups existing in the tristate region are:

CONNECTICUT

Artists Collective
35 Clark Street
Hartford, CT 06120
(203) 527–3205
Newsletter, referrals, career consultations.

Arts & Crafts Association of Meriden
53 Colony Street
P.O. Box 348
Meriden, CT 06450
(203) 235–5347

Brookfield Crafts Center
P.O. Box 122
Brookfield, CT 06804
(203) 775–4526
www.brookfieldcraftcenter.org

Connecticut Alliance of Black & Hispanic Visual Artists
981 Winchester Avenue
Hamden, CT 06517
(203) 776–9912
Workshops, referrals.

Connecticut Guild of Craftsmen
P.O. Box 155
New Britain, CT 06050
(860) 225–8875
Newsletter.

Creative Arts Workshop
80 Audubon Street
New Haven, CT 06510
(203) 562–4927

Glastonbury Art Guild
P.O. Box 304
Glastonbury, CT 06033
Newsletter.

Handweavers Guild of America
120 Mountain Avenue
Bloomfield, CT 06002
Newsletter.

Latino Youth Development
154 Minor Street
New Haven, CT 06519
(203) 776–3649
Workshops, career consultations, referrals.

Office of Cultural Affairs
25 Stonington Street
Hartford, CT 06106
(203) 722–6488
Referrals, career consultations.

Ridgefield Guild of Artists
P.O. Box 552
Ridgefield, CT 06877
(203) 438–8863
www.rgoa.org
Newsletter, seminars, exhibitions.

Society for Connecticut Crafts
P.O. Box 615
Hartford, CT 06142
(860) 423–5532

Southern Connecticut Polymer Clay Guild
1355 North High Street
East Haven, CT 06512
(203) 467–7090
Newsletter.

Washington Art Association
P.O. Box 173
Washington Depot, CT 06794
(860) 868–2878

Wesleyan Potters
350 South Main Street
Middletown, CT 06457
(860) 347–5925

NEW JERSEY

Creative Glass Center of America
1501 Glasston Road
Millville, NJ 08332–1566
(609) 825–6800

Hudson Artists of New Jersey
c/o Upstairs Art Gallery
896 Bergen Avenue
Jersey City, NJ 07306
(201) 963–6444

Montclair Craft Guild
Department CR
Box 538
Glen Ridge, NJ 07028
(201) 783–4110
E-mail: montclaircraftguild@hotmail.com

New Jersey Designer Craftsmen
65 Church Street
New Brunswick, NJ 08901
(908) 246–4066

Passaic County Cultural and Heritage Council
One College Boulevard
Paterson, NJ 07505
(201) 684–6555
Newsletter, directory, referrals, workshops, career consultations.

Pro Arts
229 Bay Street
Jersey City, NJ 07302
(212) 475–5831
(201) 433–4194
(201) 610–1280
www.jcat2000.org
Advocacy, exhibition sponsorship.

Studio Montclair
300 Highland Avenue
Upper Montclair, NJ 07043
(973) 744–7761
(973) 783–9609
Newsletter, sponsors the annual open studio tour.

NEW YORK

Brooklyn

Artists League of Brooklyn
7922 11th Avenue
Brooklyn, NY 11228
(718) 934–6703
www.a-l-b.org

Brooklyn Arts Council
200 Eastern Parkway
Brooklyn, NY 11238–4205
(718) 783–4469
Workshops, information referrals.

Brooklyn Watercolor Society
305 Vanderbilt Avenue
Brooklyn, NY 11205
(718) 789–2545
www.bws.org

Brooklyn Working Artists Coalition
P.O. Box 020072
Brooklyn, NY 11202–0002
(718) 596–2507
www.bwac.org

International Society of Copier Artists
759 President Street, Suite 2H
Brooklyn, NY 11215
(718) 638–3264
Newsletter, meetings, lectures.

South of the Navy Yard Artists
305 Vanderbilt Avenue
Brooklyn, NY 11205
(718) 789–2545
www.sonya.org

Bronx

American Society of Contemporary Artists
130 Gale Place
Bronx, NY 10463
(718) 548–6790
Exhibitions, lectures.

En Foco, Inc.
32 East Kingsbridge Road
Bronx, NY 10468
(718) 584–7718
Newsletter, seminars, portfolio reviews, slide registry.

Manhattan

Allied Artists of America
c/o National Arts Club
15 Gramercy Park South
New York, NY 10003
(212) 582–6411
Newsletter, exhibitions.

American Abstract Artists
470 West End Avenue
New York, NY 10024
(212) 874–0747
Newsletter, exhibitions.

American Artists Professional League
47 Fifth Avenue
New York, NY 10003
(212) 645–1345
Newsletter.

Americans for the Arts
1 East 53 Street
New York, NY 10022
(212) 223–2787
Information clearinghouse, publications, public policy development.

American Craft Council
72 Spring Street
New York, NY 10012
(212) 274-0630
(800) 724-0859
E-mail:amcraft@mindspring.com
Resource library, information referral.

American Institute of Graphic Arts
164 Fifth Avenue
New York, NY 10010
(212) 807-1990
(800) 548-1634
Newsletter, exhibitions.

American Jewish Congress
15 East 89th Street
New York, NY 10028
(212) 879-0450
"Jewish Art Annual" exhibition.

American Society of Media Photographers
419 Park Avenue South
New York, NY 10016
(212) 889-9144
www.asmp.org
Seminars, publications.

American Watercolor Society
47 Fifth Avenue
New York, NY 10003
(212) 206-8986
Newsletter, exhibitions, lectures.

Art Directors Club
250 Park Avenue
New York, NY 10003
(212) 674-0500
Newsletter, exhibitions, lectures.

Art Information Center
148B Duane Street
New York, NY 10013
(212) 227-0282
www.artinfo.com

Artists Talk on Art
19 Hudson Street
New York, NY 10013
(212) 965-9515
Lectures, exhibitions.

Artists Space
38 Greene Street
New York, NY 10013
(212) 226-3970
Professional assistance.

Asian American Arts Alliance
339 Lafayette Street
New York, NY 10012
(212) 979-6734
Newsletter, registry, referrals, directory, workshops, career consultations.

Association of Artist-Run Galleries
591 Broadway
New York, NY 10012
(212) 249-4423
Newsletter.

Association of Hispanic Arts
173 East 116th Street
New York, NY 10029
(212) 860-5445
www.artswire.org/aha/aha.htm
Information clearinghouse, newsletter, referrals, directory, workshops, career consultations.

**Association of Independent Video
and Filmmakers**
625 Broadway, Ninth Floor
New York, NY 10012
(212) 473–3400
www.aivf.org
Information clearinghouse, health insurance,
newsletters, workshops.

Audubon Artists
32 Union Square East
New York, NY 10003
(212) 260–5706
Exhibitions.

Bead Society of Greater New York
P.O. Box 427
New York, NY 10116–0427
(212) 591–1127
http://nybead.org
Newsletter.

Catharine Lorillard Wolfe Art Club
802 Broadway
New York, NY 10003
(212) 254–2000
Exhibitions, newsletter for women painters,
sculptors, and graphic artists.

Center for Book Arts
626 Broadway
New York, NY 10012
(212) 460–9768
E-mail: bookarts@pipeline.com

Ceres
584 Broadway
New York, NY 10012
(212) 226–4725
Exhibitions, workshops, and other events for
contemporary women in the arts.

Chinese-American Arts Council
456 Broadway
New York, NY 10013
(212) 431–9740
Exhibitions.

Collage and Assemblage Society
504 West 111th Street
New York, NY 10025
(212) 662–5430
Meetings, newsletter.

College Art Association
275 Seventh Avenue
New York, NY 10001
(212) 691–1051
www.collegeart.org
Annual conference, publications.

Council of American Minority Artists
254 East 4th Street
New York, NY 10009
(212) 598–0654
Exhibitions, lectures.

Creative Coalition
1100 Avenue of the Americas
New York, NY 10036
(212) 512–5515
Seminars on social, political, and freedom-of-
speech issues.

El Museo del Barrio
1230 Fifth Avenue
New York, NY 10029
(212) 831–7272
Newsletter, registry, referrals, directory.

Federation of Modern Painters & Sculptors
234 West 21st Street
New York, NY 10011
(212) 568–2981
Exhibitions, lectures.

The Field
161 Avenue of the Americas
New York, NY 10013
(212) 691–6969
www.thefield.org
Grant-writing consultations and workshops-for-artists conference.

Fotografica
484 West 43rd Street
New York, NY 10036
(212) 244–5182
Newsletter.

Graphic Artists Guild
91 John Street
New York, NY 10011–3704
(212) 791–3400
E-mail: pbasista@NAC.net
Workshops, newsletter, advocacy.

Grupo de Artistas Latino Americanos, Inc.
21 West 112th Street
New York, NY 10026
(212) 369–3401
Newsletter, workshops, meetings.

Hatch-Billops Collection
491 Broadway
New York, NY 10012
Newsletter, registry, referrals.

Heresies
P.O. Box 1306, Canal Street Station
New York, NY 10013
(212) 227–2108
Heresies is a feminist journal examining issues in, and the relationship of, art and politics.

Hispanic Academy of Media Arts and Sciences
P.O. Box 3268
New York, NY 10163
(212) 686–7030
Newsletter, workshops.

International Agency for Minority Artist Affairs
163 West 125th Street
New York, NY 10027
(212) 749–5298
(212) 873–5040
Job bank, counseling, training workshops.

International Center for Advanced Studies in Art
c/o New York University Department of Art and Art Professions
34 Stuyvesant Street
New York, NY 10003
Lectures.

International Print Center of New York
526 West 26th Street
New York, NY 10001
(212) 989–5090
www.ipcny.org
Newsletter, workshops, exhibitions.

Kenkeleba House
214 East Second Street
New York, NY 10009
(212) 674–3939
Registry, referrals, career consultations.

Latino Collaborative
280 Broadway, Suite 412
New York, NY 10007
(212) 732–1121
Newsletter, information clearinghouse, referrals, workshops.

Lower Manhattan Loft Tenants
P.O. Box 276
New York, NY 10018
(212) 539–3538
www.lmlt.org

Media Alliance
c/o Thirteen/WNET
356 West 58th Street
New York, NY 10019
(212) 560–2919
Publications, workshops, low-cost editing.

Midmarch Associates
Box 3304, Grand Central Station
New York, NY 10163
(212) 666–6990
Information clearinghouse, resource library,
publishes books for women artists and
women's arts organizations.

National Association of Women Artists
41 Union Square West
New York, NY 10003
(212) 675–1616
Meetings, newsletter, lectures.

National Cartoonists Society
P.O. Box 20267, Columbus Circle Station
New York, NY 10023–1484
(212) 627–1550
Newsletter, lectures, Milton Gross Fund for
needy cartoonists.

National Sculpture Society
Dept. AA
1177 Avenue of the Americas
New York, NY 10036
(212) 764–5645
www.sculptor.org/NSS/
Publications, conferences, listings of foundries,
sculpture supply stores, tools, and equipment.

National Society of Mural Painters
c/o American Fine Arts Society
215 West 57th Street
New York, NY 10019
(212) 941–0130
Newsletter, exhibitions.

New York Artists Equity Association
498 Broome Street
New York, NY 10013
(212) 941–0130
Newsletter, information clearinghouse.

New York City Department of Cultural Affairs
2 Columbus Circle
New York, NY 10019
(212) 841–4100
Materials for the Arts program, arts manage-
ment counseling.

New York Foundation for the Arts
155 Avenue of the Americas
New York, NY 10013–1507
www.nyfa.org
(212) 366–6900
(800) 232–2789
Artist "hotline," newsletter, Artswire (online
information service), loans to organizations,
financial management, grants.

Organization of Independent Artists
19 Hudson Street, Suite 402
New York, NY 10013
(212) 219–9213
Publications.

Pastel Society of America
c/o National Arts Club Gallery
15 Gramercy Park South
New York, NY 10003
(212) 533–6931
Newsletter, lectures.

Salmagundi Club
47 Fifth Avenue
New York, NY 10003
(212) 255–7740
Publications, exhibitions.

Sculptors Guild
47 Fifth Avenue
New York, NY 10003
(212) 431–5669
Newsletter, exhibitions.

Society of American Graphic Artists
32 Union Square, Room 1214
New York, NY 10003
(212) 260–5706
Newsletter, exhibition, lectures.

Society of Illustrators
128 East 63rd Street
New York, NY 10021
(212) 838–2560
Lectures, exhibitions.

Society of Photographer and Artist
Representatives, Inc.
60 East 42 Street
New York, NY 10165
(212) 779–7464
Directory, meetings.

Visual Artists and Galleries Association
521 Fifth Avenue
New York, NY 10017
(212) 808–0616
www.vaga.org
Information clearinghouse, protects artists'
copyright.

Women in the Arts Foundation
1175 York Avenue
New York, NY 10021
(212) 751–1915
Newsletter, lectures.

Women Make Movies
462 Broadway
New York, NY 10013
(212) 925–0606
Distributes films (including animation and
video) for sale and rental by women.

Women's Caucus for Art
P.O. Box 1498, Canal Street Station
New York, NY 10013
(212) 634–0007
www.nationalwca.com
Newsletter.

Queens

Alliance of Queens Artists
99–10 Metropolitan Avenue
Forest Hills, NY 11375
(718) 520–9842

Marquetry Society of America
32–34 153rd Street
Flushing, NY 11354
(718) 463–8749

National Institute of American Doll Artists
Box 656693
Fresh Meadows, NY 11365
(970) 824–8407
Newsletter.

Ollantay Art Heritage Center
P.O. Box 720636
Jackson Heights, NY 11372
(718) 565–6499
Newsletter, registry, referrals, directory.

Rockaway Artists Alliance
60 Beach 116th Street
Rockaway Beach, NY 11694
(718) 474–0861

Long Island

Long Island Arts Council
130 East Merrick Road
Freeport, NY 11520
(516) 223–2522
Newsletter, referrals, workshops, career consul-
tations, directory.

Long Island Crafts Guild
Box 170
Woodbury, NY 11797–0170
E-mail: licraft@hotmail.com

ART SCHOOLS

New York City has an abundance of art schools, as well as college and universi-
ty art departments, where one may earn undergraduate and graduate degrees in
fine arts and design. The focus of each program varies, with some institutions
offering B.A., B.F.A., or B.S. degrees on the undergraduate level. For students
who have previously earned a bachelor's degree elsewhere, art schools and uni-
versities provide diplomas in studio art or allow students to take courses on a
more informal basis. R.R. Bowker's *American Art Directory* ($195, but available
in many libraries) and *Peterson's Professional Degree Programs in the Visual &
Performing Arts* ($24.95) are among the publications that describe these schools
and their programs. On the graduate level, the College Art Association's
Directory of M.F.A. Programs in the Visual Arts [$12.50; 275 Seventh Avenue, New
York, NY 10011; (212) 691–1051] lists degree requirements and faculty. Other
schools, such as the Art Students League and the Lower East Side Print Shop,
are not degree-granting. Many of them, however, are members of the National
Guild of Community Schools of the Arts, which is located at 40 North Van
Brunt Street, P.O. Box 8018, Englewood, NJ 07631; (201) 871–3337; (*www.nat-
guild.org*), from which one may request information.

ART SCHOOLS IN AND AROUND NEW YORK

Aesthetic Realism Foundation
141 Greene Street
New York, NY 10012–3201
(212) 777–4490

Art Students League of New York
215 West 57th Street
New York, NY 10019
(212) 247–4510

Bard Graduate Center for Studies in the Decorative Arts
18 West 86th Street
New York, NY 10024
(212) 501–3056

Bernard M. Baruch College of the City University of New York
Art Department
46 East 26th Street
New York, NY 10010
(212) 802–2287

City College of New York
Art Department
138th Street and Convent Avenue
New York, NY 10031
(212) 650–7000

Cooper Union
Cooper Square
New York, NY 10003
(212) 353–4200

Education Alliance
197 East Broadway
New York, NY 10002
(212) 780–2300

Fashion Institute of Technology
Art & Design Division
Seventh Avenue at 27th Street
New York, NY 10001–5992
(212) 217–7999

Fordham University
Art Department
113 West 60th Street
New York, NY 10023
(212) 636–6000

Greenwich House Pottery
16 Jones Street
New York, NY 10014
(212) 242–4106

Henry Street Settlement Arts
for Living Center
466 Grand Street
New York, NY 10002
(212) 598–0400

Hofstra University
Department of Fine Arts
Hempstead, NY 11550
(516) 463–5474

Hunter College
Art Department
695 Park Avenue
New York, NY 10021
(212) 772–4000

John Jay College of Criminal Justice
Department of Art, Music, and Philosophy
899 Tenth Avenue
New York, NY 10019–1029
(212) 237–8325

Johnson Atelier Technical Institute
60 Ward Avenue
Mercerville, NJ 08619
(609) 890–7777

Lower East Side Printshop
59–61 East Fourth Street
New York, NY 10003
(212) 673–5390

Manhattan Graphics Center
481 Washington Street
New York, NY 10013
(212) 219–8783

Marymount Manhattan College
Fine and Performing Arts Department
221 East 71st Street
New York, NY 10021
(212) 517–0400

National Academy School of Fine Arts
5 East 89th Street
New York, NY 10128
(212) 996–1908

New School University
66 West 12th Street
New York, NY 10011
(212) 229–5600

New York Academy of Art
Graduate School of Figurative Art
111 Franklin Street
New York, NY 10013
(212) 966–0300

New York Institute of Photography
211 East 43rd Street
New York, NY 10017
(212) 867–8260

New York School of Interior Design
170 East 70th Street
New York, NY 10021
(212) 472–1500

New York Studio School of Drawing,
Painting, and Sculpture
8 West Eighth Street
New York, NY 10011
(212) 673–6466

New York University
Institute of Fine Arts
One East 78th Street
New York, NY 10021
(212) 772–5800

Pace University
Theatre and Fine Arts Department
Pace Plaza
New York, NY 10038
(212) 346–1352

Parsons School of Design
66 Fifth Avenue
New York, NY 10011
(212) 229–8910

Pratt Institute
200 Willoughby Avenue
Brooklyn, NY 11205
(800) 331–0834

Pratt Institute
Pratt Manhattan
295 Lafayette Street
New York, NY 10012
(212) 925–8481

School of Visual Arts
209 East 23rd Street
New York, NY 10010
(212) 592–2000

Sculpture Center School
167 East 69th Street
New York, NY 10021
(212) 737–9870

Wood Tobe-Coburn School
8 East 40th Street
New York, NY 10016
(212) 686–9040

VOLUNTEER LAWYERS FOR THE ARTS

When the first Volunteer Lawyers for the Arts group was created in New York City in 1969, the idea was simple: help artists (fine, literary, media, and performing) and arts organizations understand their legal rights and obligations through workshops and one-on-one consultations. If necessary, one of the volunteer attorneys may draft a letter to an offending party, describing the problem and the legal remedies available. Over the years, VLA staff has helped thousands of artists through problems with their dealers, their landlords, their publishers, and their record companies, and educated thousands more about their legal rights. Since 1969, there has been a vast amount of publishing in the field of art and the law.

Volunteer Lawyers for the Arts provides free legal counsel on specifically arts-related problems for free or a small fee to individual artists with low gross incomes (generally between $10,000 and $20,000, and between $15,000 and $30,000 in household income, which must be validated by past tax returns) and for arts organizations with annual operating budgets as large as $500,000. VLA answers many basic legal questions over the telephone, setting up appointments in their offices for those with more complicated problems, while others simply take information and make referrals to lawyers who would be willing to meet with the artist or organization official at some point.

VLA groups, which now exist in twenty-eight states and the District of Columbia, are actually information clearinghouses, which is both their greatest strength and shortcoming. It is quite rare that these volunteer lawyers ever assist an artist in bringing a lawsuit. Lawyers are reluctant to get into a situation where they have to take time away from their paying clients. Instead, the volunteer lawyer may refer the artist to an outside attorney who will take the case, sometimes on a pro bono basis, sometimes accepting artwork in lieu of a fee, occasionally on a contingency basis, usually requiring a retainer and charging hourly fees. Going to trial is an expensive proposition, with court costs and a lawyer's fees that add up to thousands (or tens of thousands) of dollars. If artists had that kind of money, they wouldn't need charitable organizations in the first place.

Recognizing this gap between free legal advice and costly legal representation, a third approach has been developed by Volunteer Lawyers for the Arts organizations in California, Chicago, Colorado, Oregon, St. Louis, Texas, New York City, and the District of Columbia: mediation. In mediation, the two parties are brought together in order to resolve differences amicably. Mediation is

efficient and inexpensive, priced on a sliding fee scale for artists, and many peo-ple feel better after it is over than when they go through litigation or through the small claims court system. The purpose of mediation is to come to a con-sensus of opinion, with each side compromising towards that end, and the peo-ple who come to mediation understand this. The purpose of litigation, on the other hand, is to win.

Mediation works in this way: Someone with an arts-related problem, who fits the VLA's low income guidelines, comes to the offices of the volunteer lawyers group upset and looking for help. Perhaps a painter's work has been damaged at the art gallery where it was consigned; maybe the landlord is refus-ing to repair water damage at the rehearsal space of a dance troupe; or an adver-tising agency assumes all rights to the artwork subcontracted out to a graphic artist without specifically paying for those rights.

The VLA staff person directs the angered artist to the mediator, or to the person in charge of the mediation program, and an effort is made to bring in that art gallery owner, landlord, or advertising agency executive for a mediation session. The mediators may be practicing lawyers, professional artists, arts administrators, or accountants who have received special training in problem resolution. The mediators are not advocates; rather, they are facilitators of a dis-cussion. For many artists, the appeal of mediation is obvious: It is far less expensive than litigation, and it enables them to resolve a problem without burning their bridges behind them. Many artists worry that they will alienate their dealers if they pursue their rights too aggressively: Even if they win in court, they lose, because the gallery will drop them.

Mediation may solve a problem for artists, who have a safe and controlled environment in which to get something off their chests, and for Volunteer Lawyers for the Arts organizations, settling disputes that their member attor-neys don't have time to resolve through traditional legal avenues. Unfortunately, it is still a small world of problems that mediation will resolve, because, as Ruth Cogen, executive director of Washington Area Lawyers for the Arts, noted, "both sides have to be interested in settling a dispute amicably and fairly. Mediation won't work with people who think that artists have no rights or assume that artists are too poor to bring them to court—and there are far more of those cases than ones involving parties who want to settle disputes fairly. However, the courts are increasingly insisting on mediation, and, don't forget, legal fees are also expensive for art dealers and landlords and publishing com-panies and whoever else may treat artists unfairly."

Volunteer Lawyers for the Arts organizations in the greater New York metropolitan area are:

CONNECTICUT

Connecticut Volunteer Lawyers for the Arts
Connecticut Commission on the Arts
227 Lawrence Street
Hartford, CT 06106
(203) 566-4770

NEW JERSEY

New Jersey does not have a Volunteer Lawyers for the Arts organization, although legal referrals can be made through the New Jersey State Bar Association [One Constitution Square, New Brunswick, NJ 08901-1500; (732) 249-5000] and through the county bar associations of Burlington County at (609) 261-4542, of Camden County at (609) 964-4520, of Gloucester County at (609) 848-4589 and Mercer County (609) 585-6200. Additionally, free legal representation for qualifying artists and arts organizations with arts-related issues in central and southern New Jersey is available through:

Philadelphia Volunteer Lawyers for the Arts
251 South 18th Street
Philadelphia, PA 19103
(215) 545-3385
www.libertynet.org/pvla

NEW YORK

Huntington Arts Council, Inc.
213 Main Street
Huntington, NY 11743
(516) 271-8423

Volunteer Lawyers for the Arts
1 East 53rd Street, Sixth floor
New York, NY 10019
(212) 319-ARTS/2910
www.vlany.org

The state bar associations may also provide referrals to individuals and officials who need a lawyer with a particular area of knowledge. These attorneys may or may not maintain policies about lowering their standard fees, not charging anything, or accepting art objects in lieu of cash. These issues likely will need to be negotiated individually between lawyer and client.

BUSINESS VOLUNTEERS FOR THE ARTS

In addition to free or low-cost legal help, artists and arts organizations may be eligible for accounting, business, and tax assistance. These accountants and businesspeople usually do not take over an organization's bookkeeping or fill out an artist's tax forms for free (although some will offer these services at a discount); rather, they will explain how to set up a workable accounting system and what deductions may be declared on one's tax returns. Artists should also keep in mind that the period between February and April 15th is the busiest of the year for accountants. Even those accountants who will fill out an artist's tax forms for free are unlikely to take on the job during this time, generally advising the artist to file for an extension.

Among the volunteer groups that work exclusively with nonprofit arts organizations are:

NEW JERSEY

Business Volunteers for the Arts
Arts Council of Morris Area
P.O. Box 370
Madison, NJ 07940
(201) 377–6133

NEW YORK

Arts & Business Council
Business Volunteers for the Arts
121 West 27th Street
New York, NY 10001
(212) 727–7146
www.artsandbusiness.org

Business Volunteers for the Arts
Westchester Arts Council
31 Mamaroneck Avenue
White Plains, NY 10601
(914) 428–4220

ARTISTS' CAREER ADVISORS

Artists throughout the world generally find themselves needing to build a career on two different tracks: The first is a salaried (preferably benefited) job or some other means of supporting themselves; the other is developing a presence in the art world, by means of exhibitions and commissions, eventually leading to private or gallery sales. Most everyone on the planet needs to find a job, and the ways in which to find one are described in brief earlier in this book and can be discovered in countless other books, Web sites, and job counseling services. Trying to establish oneself in the fine art world, especially while maintaining a job, however, is not such a common concern, and it is not at all easy.

Help is available to artists, but it isn't free. They can hire artists' career advisors, who charge between $75 and $175 per hour and offer a range of services, among which are reviewing an artist's portfolio, preparing a press package, providing marketing advice, locating appropriate exhibition sites (in New York and elsewhere) for specific artists, and even acting as an agent to create shows or sell works.

There are a variety of these career advisors around the country, many of them advertising in art magazines, working with clients by mail, e-mail, and over the telephone, charging by the hour. Artists' advisors in New York City, on the other hand, primarily work with clients face-to-face, with only occasional discussions over the telephone. Of course, one should contact a number of advisors in order to determine compatibility, how they prefer to work with artists, and the specific services they provide. Simply being close by is no reason to choose one person over another. In fact, face-to-face meetings generally take longer (and are, thereby, more expensive) than over-the-telephone conversations. Caroll Michels asks $100 per hour for the initial consultation and $75 an hour (prorated) subsequently, with a minimum fee of $18.75. Another New York City advisor, Katherine T. Carter, frequently works with out-of-town artists who are looking to have their work exhibited in Manhattan galleries.

Advisors are primarily selling their knowledge of the art world and art market, a knowledge that is presumably large enough to encompass the different media and styles of work that their artist clients may bring in. Still, advisors have their preferences and dislikes, and artists should ask questions in order to be certain that they will be well served for the money. In general, artists should ask various questions, including:

• How long have you been working with artists?

• How many other artists have you worked with over this period (get names and addresses of some, and contact them about their experience with the advisor)?

• Will you provide a general marketing strategy for my artwork, specific contacts at galleries, or both?

• Are there certain media (oil painting, ceramics, collage, sculpture, for example) or styles of art (abstract, realist, portraiture, surrealist, for instance) that you have found to be more or less difficult to market?

• Have you written any books or magazine articles about career development for artists (most of them have, and purchasing a book or magazine may be a far less expensive way to obtain the same general advice, as well as providing a sense of the type of approach taken)?

Some advisors are practicing artists themselves, while others are not. Artists, however, should not assume that nonartist advisors are less knowledgeable about what it takes to succeed in the art world because they've never done what they are recommending (if they're so smart, why aren't they rich?). Successful—that is, self-supporting—artists, however, generally don't counsel those who are younger or lesser-known on how to get ahead in their careers. In some instances, they do not wish to recall their own trial-and-error efforts at receiving recognition; it is also possible that they know little more than their own experience, which may not be applicable to many others.

Some advisors in the New York area include:

NEW JERSEY

Susan Schear
879 Amaryllis Avenue
Oradell, NJ 07649–1300
(201) 599–9180
www.artisin.com

NEW YORK

Dan Concholar
Art Information Center
55 Mercer Street
New York, NY 10013
(212) 966–3443

Artists' Advisors: The Art Planning Group
12 White Street, Dept. I
New York, NY 10013–2446
(212) 388–7298

Katherine T. Carter
24 Fifth Avenue
New York, NY 10011–8817
(212) 533–9530
E-mail: ktcassoc@icanect.net
www.ktcassoc.com

Contemporary Artists' Services
Sylvia White
560 Broadway, Room 206
New York, NY 10012
(800) 239–6450
E-mail: artadvice@aol.com
www.sylviawhite.com

Gene Kraig
Individual Artist's Marketing
67 Hudson Street
New York, NY 10013
(212) 349–4381

Caroll Michels
19 Springwood Lane
East Hampton, NY 11937
(631) 329–9105
E-mail: carollmich@aol.com
www.carollmichels.com

Renee Phillips
200 East 72nd Street, Apartment 26L
New York, NY 10021
(212) 472–1660
www.manhattanarts.com

Thea Westreich
114 Greene Street
New York, NY 10012
(212) 935–1272

A FINAL WORD

There are no guaranteed how-to's for artists, because no one method works for everyone. In this book, I have described the experiences of artists who have been able to find jobs, apartments, lofts, studios, commissions, exhibition opportunities, or gallery relationships. Few of them could be described as rich or wildly successful, but they have overcome some of the basic hurdles facing any artist beginning a career in the greater metropolitan New York area. The art world (especially the New York art world) places a premium on who-you-know, and it is possible to show how artists meet each other and how meetings lead to other meetings that become friendships or professional associations that may eventually help artists in their careers or in finding a place to live and work. However, there is an element of serendipity in all this and a requirement that temperaments are well matched. People are helpful to others whom they like: You can't make someone else like you. Ultimately, in any field of endeavor, from the business world and civic activities to the political arena, establishing one's

talent and commitment, developing and then expanding a network of like-minded colleagues are key ingredients in success, and not just in New York. Because of its wealth of art museums, art galleries, art buyers, art writers and art publications, fine artists, and artistic resources (not to mention its wealth), New York is the biggest challenge that artists can undertake, and those who are most successful tend to seek out opportunities and others like themselves.

BIBLIOGRAPHY

There has been a growing quantity of information that has been compiled in various sources that may be of great help to artists. No one book can tell artists everything they need to know anymore; artists whose long-term goal is to support themselves solely through the sale of their art probably should begin to assemble a library of career-oriented books and other publications.

SOURCES OF PUBLIC AND PRIVATE GRANTS

American Art Directory. R. R. Bowker, 1999.

American Council for the Arts: Money for Film and Video Artists. American Council for the Arts, 1991.

American Council for the Arts: Money for Performing Artists. American Council for the Arts, 1991.

American Council for the Arts: Money for Visual Artists. American Council for the Arts and Allworth Press, 1991.

Annual Register of Grant Support. R. R. Bowker, 1994.

Brunner, Helen, ed. *Money to Work.* Art Resources International, 1992.

Directory of Grants in the Humanities. Oryx Press, 1999.

Fandel, Nancy A., ed. *A National Directory of Arts and Education Support by Business and Corporations.* Washington International Arts Letters, 1989.

Fandel, Nancy A., ed. *A National Directory of Grants and Aid to Individuals in the Arts.* Washington International Arts Letters, 1993.

Gullong, Jane, Noreen Tomassi, and Anna Rubin. *Money for International Exchange in the Arts.* American Council for the Arts and Arts International, 1992.

Hale, Suzanne, ed. *Foundation Grants to Individuals.* The Foundation Center, 1991.

Klein, Kim. *Fundraising for Social Change.* Chardon Press, 1996.

Oxenhorn, Douglas, ed. *Money for Visual Artists.* American Council for the Arts, 1993.

Roosevelt, Rita K., Anita M. Granoff, and Karen P.K. Kennedy. *Money Business: Grants and Awards for Creative Artists.* The Artists Foundation, 1985.

White, Virginia P. *Grants for the Arts.* Plenum Press, 1980.

OTHER SOURCES OF FINANCIAL SUPPORT FOR ARTISTS

ARTnews: *ARTnews's International Directory of Corporate Art Collections.* ARTnews, 1992.

Christensen, Warren, ed. *National Directory of Arts Internships.* National Network for Artist Placement, 1998.

Jeffri, Joan. *ArtsMoney: Raising It, Saving It, and Earning It.* University of Minnesota Press, 1983.

Jeffri, Joan, ed. *Artisthelp: The Artist's Guide to Human and Social Services.* Neal-Schuman, 1990.

Kartes, Chery. *Creating Space: A Guide to Real Estate Development for Artists.* American Council for the Arts and Allworth Press, 1993.

Kruikshank, Jeffrey L., and Pam Korza. *Going Public: A Field Guide to the Developments of Art. Amherst.* Arts Extension Service, University of Massachusetts, 1989.

Porter, Robert, ed. *Guide to Corporate Giving in the Arts.* American Council for the Arts, 1987.

CAREER SKILLS FOR ARTISTS

Abbott, Robert J. *Art & Reality: The New Standard Reference Guide and Business Plan for Actively Developing Your Career as an Artist.* Steven Locks Press, 1997.

Abbott, Susan. *Corporate Art Consulting.* Allworth Press, 1999.

Abbott, Susan, and Barbara Webb. *Fine Art Publicity: The Complete Guide for Galleries and Artists.* Allworth Press, 1996.

Alliance of Artists' Communities. *Artists Communities: A Directory of Residencies in the United States that Offer Time and Space for Creativity.* Allworth Press, 2000.

ArtCalendar. *Making a Living as an Artist.* ArtCalendar, 1993.

Brabec, Barbara. *Handmade for Profit: Hundreds of Secrets to Success in Selling Arts & Crafts.* M. Evans & Co., 1996.

Brabec, Barbara. *The Crafts Business Answer Book & Resource Guide.* M. Evans & Co., 1998.

Caplan, Evan, Tom Power, and Livingston Biddle, eds. *The Business of Art.* Prentice Hall, 1998.

Caputo, Kathryn. *How to Start Making Money with Your Crafts.* Betterway Publishing, 1995.

Cochrane, Diana. *This Business of Art.* Watson-Guptill, 1988.

Cummings, Paul. *Fine Arts Market Place.* R. R. Bowker, 1977.

Davis, Sally Prince. *The Fine Artist's Guide to Showing and Selling Your Work.* North Light Books, 1990.

Davis, Sally Prince. *Graphic Artists Guide to Marketing and Self-Promotion.* North Light Books, 1987.

Egan, Dorothy. *How to Start Making Money with Your Decorative Painting.* North Light Books, 1998.

Frascogna, Xavier M., and J. Lee Hetherington. *This Business of Artist Management.* Watson-Guptill, 1997.

Gerhard, Paul. *How to Sell What You Make: The Business of Marketing Crafts.* Stackpole Books, 1996.

Goldfarb, Roz. *Careers by Design: A Business Guide for Graphic Designers.* 3rd Ed. Allworth Press, Jan. 2002.

Goodman, Calvin J. *Art Marketing Handbook.* GeePeeBee, 1985.

Gordon, Elliott, and Barbara Gordon. *How to Sell Your Photographs and Illustrations.* Allworth Press, 1990.

Grant, Daniel. *The Artist's Resource Handbook.* Allworth Press, 1997.

Grant, Daniel. *The Business of Being an Artist*. Allworth Press, 2000.

Grant, Daniel. *The Fine Artist's Career Guide*. Allworth Press, 1998.

Grant, Daniel. *How to Start and Succeed as an Artist*. Allworth Press, 1997.

Graphic Artists Guild Handbook. *Pricing and Ethical Guidelines*. Graphic Artists Guild, 1984.

Hadden, Peggy. *The Artist's Guide to New Markets*. Allworth Press, 1998.

Hill, Elizabeth, Catherine O'Sullivan, and Terry O'Sullivan. *Creative Arts Marketing*. Butterworth-Heinemann, 1996.

Holden, Donald. *Art Career Guide*. Watson-Guptill, 1983.

Hoover, Deborah A. *Supporting Yourself as an Artist*. Oxford University Press, 1989.

Indian Arts and Crafts Board. *Potential Marketing Outlets for Native American Artists and Craftspeople*. Indian Arts and Crafts Board (U.S. Department of the Interior, 1849 C Street, N.W., MS-4004, Washington, D.C. 20240-0001), 1993.

Janecek, Lenore. *Health Insurance: A Guide for Artists, Consultants, Entrepreneurs & Other Self-Employed*. American Council for the Arts, 1993.

Katchen, Carole. *How to Get Started Selling Your Art*. North Light Books, 1996.

Klayman, Toby and Cobbett Steinberg. *The Artist's Survival Manual*. Charles Scribner's Sons, 1987.

Landman, Sylvia. *Crafting for Dollars: Turn Your Hobby into Serious Cash*. Prima Publications, 1996.

Langley, Stephen, and James Abruzzo. *Jobs in Arts and Media Management*. New York: American Council for the Arts, 1992.

Manolis, Argie, ed. *Crafts Market Place: Where and How to Sell Your Crafts*. Betterway Publications, 1997.

MFA Programs in the Visual Arts: A Directory. College Art Association of America, 1987.

Michels, Caroll. *How to Survive & Prosper as an Artist*. Henry Holt and Company, 1998.

Muth, Marcia. *How to Paint and Sell Your Work*. Sunstone Press, 1984.

NAAO Directory, National Association of Artists Organizations, 1989.

Oberrecht, Kenn. *How to Start a Home-Based Crafts Business.* Globe Pequot Press, 1997.

Pratt, Nina. *How to Find Art Buyers.* Succotash Press, 1994.

Pratt, Nina. *How to Sell Art.* Succotash, 1992.

Ramsey, Dan. *The Crafter's Guide to Pricing Your Work.* Betterway Publications, 1997.

Rosen, Wendy. *Crafting as a Business.* Sterling Publications, 1998.

Sager, Susan Joy. *Selling Your Crafts.* Allworth Press, 1998.

Shaw Associates. *The Guide to Arts & Crafts Workshops.* Shaw Associates, 1991.

Shaw Associates. *The Guide to Photography Workshops & Schools.* Shaw Associates, 1992.

Shaw Associates. *The Guide to Writers Conferences.* Shaw Associates, 1992.

Shipley, Lloyd W. *Information Resources in the Arts.* Library of Congress, 1986.

Shiva, V. A. *Arts and the Internet: A Guide to the Revolution.* Allworth Press, 1996.

Shiva, V. A. *The Internet Publicity Guide: How to Maximize Your Marketing and Promotion in Cyberspace.* Allworth Press, 1997.

Stolper, Carolyn L., and Karen Brooks Hopkins. *Successful Fundraising for Arts and Cultural Organizations.* Oryx Press, 1989.

Viders, Sue. *Producing and Marketing Prints.* Color Q, Inc., 1992.

West, Janice. *Marketing Your Arts & Crafts: Creative Ways to Profit from Your Work.* Summit Publishing Group, 1994.

ART AND THE LAW

Conner, Floyd, et al. *The Artist's Friendly Legal Guide.* North Light Books, 1988.

Crawford, Tad and Susan Mellon. *The Artist-Gallery Partnership: A Practical Guide to Consigning Art.* Allworth Press, 1998.

Crawford, Tad. *Business and Legal Forms for Crafts.* Allworth Press, 1998.

Crawford, Tad. *Business and Legal Forms for Fine Artists.* Allworth Press, 1999.

Crawford, Tad. *Business and Legal Forms for Graphic Designers.* Allworth Press, 1999.

Crawford, Tad. *Business and Legal Forms for Illustrators.* Allworth Press, 1998.

Crawford, Tad. *Business and Legal Forms for Authors and Self-Publishers.* Allworth Press, 1996.

Crawford, Tad. *Legal Guide for the Visual Artist.* Allworth Press, 1999.

Crawford, Tad and Eva Doman Bruck. *Business and Legal Forms for Graphic Designers.* Allworth Press, 1990.

Duboff, Leonard D. *The Law (in Plain English) for Crafts.* Allworth Press, 1998.

Leland, Caryn. *Licensing Art and Design.* Allworth Press, 1995.

Messman, Carla. *The Artist's Tax Workbook.* Lyons & Burford, 1992.

Norwick, Kenneth P., and Jerry Simon Chasen. *The Rights of Authors, Artists, and Other Creative People.* Southern Illinois University Press, 1992.

Wilson, Lee. *Make It Legal.* Allworth Press, 1990.

HEALTH AND SAFETY IN THE ARTS AND CRAFTS

Enteen, Robert. *Health Insurance: How to Get It, Keep It, or Improve What You've Got.* Paragon House, 1992.

Mayer, Ralph. *The Artist's Handbook.* Viking, 1982.

Mayer, Ralph. *The Painter's Craft.* Penguin Books, 1977.

McCann, Michael. *Artist Beware.* Lyons & Burford, 1993.

Rossol, Monona. *The Artist's Complete Health and Safety Guide.* Allworth Press, 1994.

Shaw, Susan D., and Monona Rossol. *Overexposure: Health Hazards in Photography.* American Council for the Arts and Allworth Press, 1991.

Silver Lake Editors. *Hassle-Free Health Coverage: How to Buy the Right Medical Insurance Cheaply and Effectively.* Silver Lake Publishing, 1999.

Spandorfer, Merle. *Making Art Safely.* John Whiley & Sons, 1997.

OF RELATED INTEREST

Baumol, William J., and William G. Bowen. *Performing Arts: The Economic Dilemma.* M.I.T. Press, 1966.

Benedict, Stephen, ed. *Public Money and the Muse: Essays on Government Funding for the Arts.* W.W. Norton, 1991.

Cockcroft, Eva, John Weber, and James Cockcroft. *Toward a People's Art: The Contemporary Mural Movement.* E.P. Dutton, 1977.

Conrad, Barnaby III. *Absinthe: History in a Bottle.* Chronicle Books, 1988.

Dardis, Tom. *The Thirsty Muse: Alcohol and the American Writer.* Ticknor & Fields, 1989.

Feld, Alan L., Michael O'Hare, and J. Mark Davidson Schuster. *Patrons Despite Themselves: Taxpayers and Arts Policy.* New York University Press, 1983.

Jeffri, Joan. *The Emerging Arts: Management, Survival and Growth.* Praeger, 1980.

Misey, Johanna L., ed. *National Directory of Multi-Cultural Arts Organizations.* National Assembly of State Arts Agencies, 1990.

Mitchell, W.J.T., ed. *Art and the Public Sphere.* University of Chicago Press, 1992.

Naude, Virginia, and Glenn Wharton. *Guide to the Maintenance of Outdoor Sculpture.* American Institute for Conservation of Historic and Artistic Works, 1995.

Netzer, Dick. *The Subsidized Muse: Public Support for the Arts in the United States.* Cambridge University Press, 1978.

Shore, Irma, and Beatrice Jacinto. *Access to Art: A Museum Directory for Blind and Visually Impaired People.* American Foundation for the Blind, 1989.

Snyder, Jill. *Caring for Your Art: A Guide for Artists, Collectors, Galleries, and Art Institutions.* Allworth Press, 1990.

Whitaker, Ben. *The Philanthropoids: Foundations and Society.* William Morrow, 1974.

ART PUBLICATIONS

A number of magazines and journals are published for artists that include news in the field, trends and opinions, listings of upcoming juried art shows, art workshops, and other opportunities, technical information, and career advice as well as feature articles. Among these are:

ACTS Facts
Arts, Crafts and Theater Safety
181 Thompson Street
Room 23
New York, NY 10012
(212) 777–0062
$10 a year

American Artist
One Color Court
Marion, OH 43305
(800) 347–6969
$24.95 a year

Art Hazards News
Center for Safety in the Arts
5 Beekman Street
Room 1030
New York, NY 10038
(212) 227–6220
$21 annually

The Artist's Magazine
P.O. Box 2120
Harlan, IA 51593
(800) 333–0444
$24 a year

ArtJob
236 Montezuma Avenue
Santa Fe, NM 87501
(505) 988–1166
$24 a year

ARTnews
P.O. 2083
Knoxville, IA 50197-2083
(800) 284-4625
$32.95 a year

Art Now Gallery Guide
Art Now, Inc.
P.O. Box 888
Vineland, NJ 08360
(201) 322–8333
$35 a year

The Chronicle of Philanthropy
1225 23rd Street, N.W.
Washington, D.C. 20037
(202) 466–1200
$67.50 a year

Fairs and Festivals in the Northeast
Fairs and Festivals in the Southeast
Arts Extension Service
Division of Continuing Education
604 Goodell
University of Massachusetts
Amherst, MA 01003
(413) 545–2360
$7.50 apiece; $13 for both

Institute Items
Art & Craft Materials Institute
100 Boylston Street
Suite 1050
Boston, MA 02116
(617) 426–6400
$20 a year (for individual artists)
$50 a year (for companies)

New Art Examiner
1255 South Wabash
Fourth floor
Chicago, IL 60605
(312) 786–0200
$35 a year

Pen, Pencil & Paint
National Artists Equity Association
P.O. Box 28068
Washington, DC 20038
(800) 727–6232
$12 a year

Sunshine Artists USA
2600 Temple Drive
Winter Park, FL 32789
(407) 539–1399
$22.50 a year

INDEX

Sculpture Magazine, 160, 161

Sculpture Review, 160, 161

Sharpe Art Foundation, Marie
Walsh, 15, 56

Sherrod, Phillip, 15–16

SONYA, 128–9, 131, 133, 134, 212

State arts agencies, 171–73

State humanities agencies,
192–93

Studio space, 53–62

Studio tours, 128–34

T

Thiebaud, Wayne, 3–4

Tyler, Dread Scott, 63–64

U

Utrecht, 141

V

Very Special Arts, 81

Volunteer Lawyers for the Arts, 53,
221–24, 223

and mediation, 221–22

W

Westbeth, 31, 62

Wilkin, Karen, 104

Y

YMCAs, 11–12

Young Audiences, 81, 90

Z

Zimmerman, Elyn, 77

Zucker, Barbara, 68, 69

BOOKS FROM ALLWORTH PRESS

The Artist's Complete Health and Safety Guide, Third Edition by Monona Rossol (paperback, 6 × 9, 408 pages, $24.95)

The Business of Being an Artist, Third Edition by Daniel Grant (paperback, 6 × 9, 352 pages, $19.95)

Caring for Your Art: A Guide for Artists, Collectors, Galleries, and Art Institutions, Third Edition by Jill Snyder (paperback, 6 × 9, 192 pages, $19.95)

Artists Communities: A Directory of Residencies in the United States That Offer Time and Space for Creativity, Second Edition by the Alliance of Artists' Communities (paperback, 6¾ × 9⅞, 256 pages, $18.95)

The Artist's Guide to New Markets: Opportunities to Show and Sell Art Beyond Galleries by Peggy Hadden (paperback, 5½ × 8½, 252 pages, $18.95)

The Fine Artist's Guide to Marketing and Self-Promotion by Julius Vitali (paperback, 6 × 9, 224 pages, $18.95)

Corporate Art Consulting by Susan Abbott (paperback, 11 × 8½, 256 pages, $34.95)

The Fine Artist's Career Guide by Daniel Grant (paperback, 6 × 9, 224 pages, $18.95)

Historic Photographic Processes: A Guide to Creating Handmade Photographic Images by Richard Farber (paperback, 8½ × 11, 256 pages, $29.95)

How to Start and Succeed as an Artist by Daniel Grant (paperback, 6 × 9, 240 pages, $18.95)

The Artist's Resource Handbook, Revised Edition by Daniel Grant (paperback, 6 × 9, 248 pages, $18.95)

Legal Guide for the Visual Artist, Fourth Edition by Tad Crawford (paperback, 8½ × 11, 272 pages, $19.95)

Business and Legal Forms for Fine Artists, Revised Edition with CD-ROM by Tad Crawford (paperback, 8½ × 11, 144 pages, $19.95)

The Artist-Gallery Partnership: A Practical Guide to Consigning Art, Revised Edition by Tad Crawford and Susan Mellon (paperback, 6 × 9, 216 pages, $16.95)